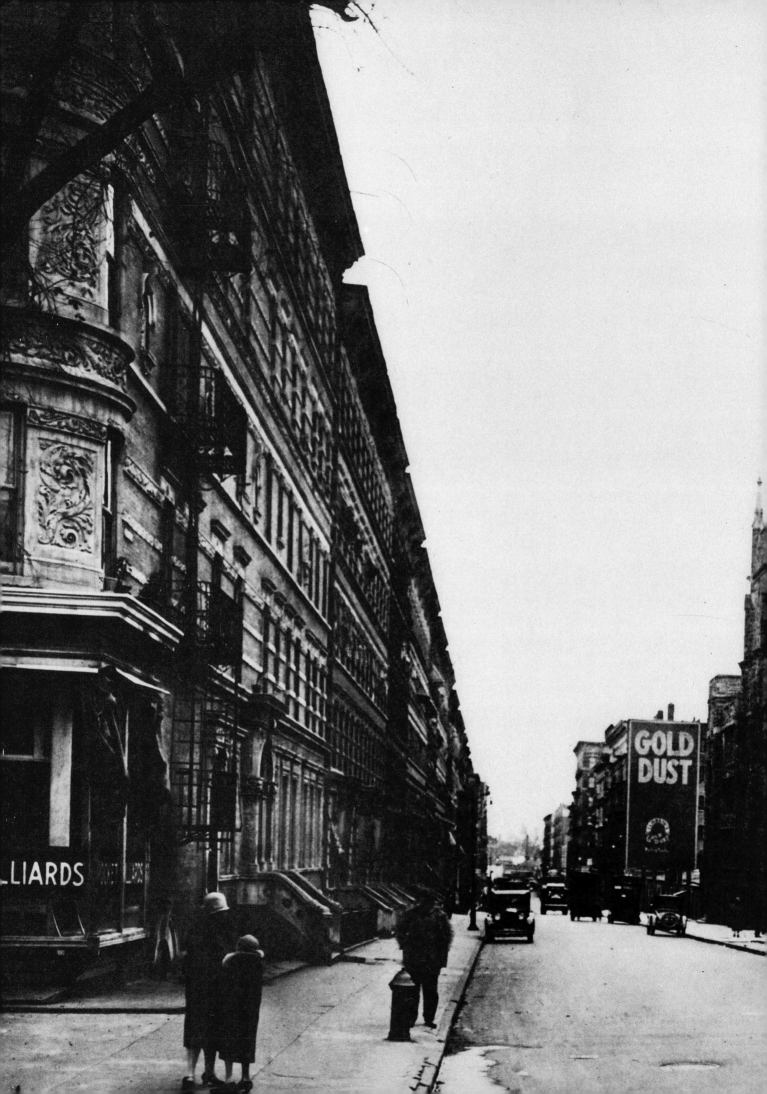

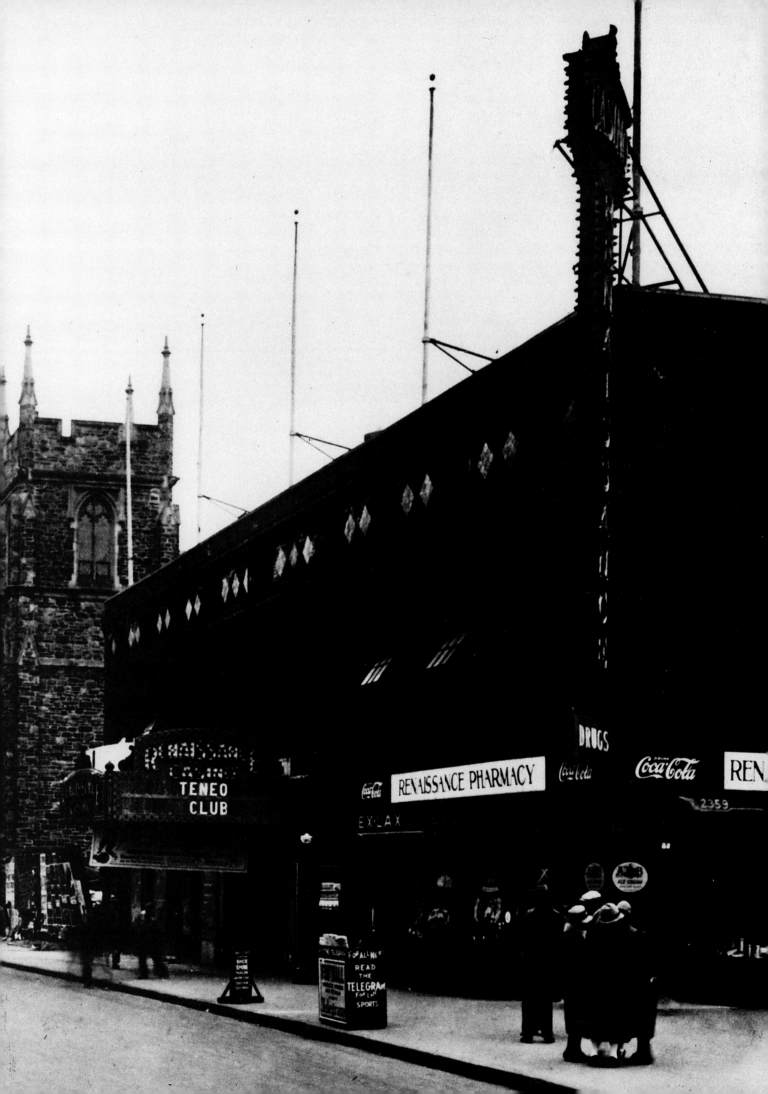

Harlem Renaissance Art of Black America

Harlem Renaissance Art of Black America

Introduction by Mary Schmidt Campbell
Essays by David Driskell,
David Levering Lewis, and Deborah Willis Ryan

■

THE STUDIO MUSEUM
IN HARLEM, NEW YORK

HARRY N. ABRAMS, INC.
PUBLISHERS, NEW YORK

Harlem Renaissance: Art of Black America
is published in honor of The Studio Museum in Harlem's patrons and donors:

Patrons

Edward R. Bradley
Mrs. Johnson Garrett
Paul Giddings
Bertina Carter Hunter
Henry W. McGee, III
David Rockefeller
David Rockefeller, Jr.
Herbert and Irene Wheeler
Lorenza and Dr. Yenwith Whitney
Mr. and Mrs. E. Thomas Williams
Anonymous patron

Donors

George and Mary Campbell
George L. Knox
Nancy Lane
Therese Molloy
John D. Smith, Jr.
Mr. and Mrs. Martin V. Waters

The exhibition *Harlem Renaissance: Art of Black America* and the accompanying book are made possible through a generous grant from **Philip Morris Companies Inc.**

Additional funding is provided by the National Endowment for the Arts and the National Endowment for the Humanities.

Operation of The Studio Museum in Harlem's facility is supported in part by public funds provided through the New York City Department of Cultural Affairs.

The exhibition will be circulated nationally under the auspices of The Art Museum Association of America (AMAA). The AMAA is a national, not-for-profit art museum service organization, founded in 1921 and supported by more than five hundred member institutions, representing each of the fifty states.

The Studio Museum in Harlem gratefully acknowledges the assistance of the New York State Museum in producing this exhibition.

Acknowledgments for permission to reprint excerpts in the text are on p. 199.

PROJECT DIRECTOR: MARGARET L. KAPLAN
EDITOR: CHARLES MIERS
DESIGNER: RAYMOND P. HOOPER

Library of Congress Cataloging-in-Publication Data

The Harlem Renaissance.

 Bibliography: p.188
 Includes index.
 1. Harlem Renaissance—Exhibitions. 2. Afro-American
art—New York (N.Y.)—Exhibitions. 3. Art, Modern—20th
century—New York (N.Y.)—Exhibitions. I. Studio Museum in
Harlem. II. Driskell, David C. III. Lewis, David L. IV. Ryan, Deborah Willis.
N6538.N5H287 1986 704'.039607307471 86–17229

Published in 1987 by Harry N. Abrams, Incorporated, New York

Times Mirror Books

Printed and bound in Japan

Contents

Foreword
7

Acknowledgments
8

Introduction
Mary Schmidt Campbell
11

Harlem My Home
David Levering Lewis
57

The Flowering of the Harlem Renaissance: The Art
of Aaron Douglas, Meta Warrick Fuller, Palmer Hayden,
and William H. Johnson
David Driskell
105

James Van Der Zee
Deborah Willis Ryan
155

Chronology of the Harlem Renaissance (1919–29)
Jeffrey Stewart
168

Chronologies of the Artists
180

Selected Bibliography
188

Bibliography of Books and Magazines Illustrated by Aaron Douglas
Richard Powell
192

Index
194

Photograph Credits
199

Foreword

As the Jazz Age dawned in 1919, Black artists, writers, and musicians flocked to a little-known part of Manhattan called Harlem. Soon their talent and faith in the future began to demolish any views about the artistic limits of Black creativity as they etched a Black neighborhood onto the cultural map of the world.

The Harlem Renaissance, the name given to this fertile period of creativity, left a rich cultural legacy. The exhibition *Harlem Renaissance: Art of Black America* explores the visual aspects of that legacy, taking a comprehensive look at the compelling images of the era through a hundred and fifty works of a small, yet representative group of painters, sculptors, and photographers.

Philip Morris is pleased to be the corporate sponsor of this exhibition, because drawing attention to key aspects of American culture is a Philip Morris tradition.

There could be no better example of this tradition than *Harlem Renaissance: Art of Black America* and no more appropriate place to launch this exhibition than The Studio Museum in Harlem, whose growth and vigor, scholarship, and depth of vision have proved that the vitality, creativity, and dreams of the Harlem Renaissance are very much with us today.

Hamish Maxwell
Chairman of the Board and Chief Executive Officer,
Philip Morris Companies Inc.

Acknowledgments

Organizing an exhibition and publication of this scope requires the commitment of many people. The Studio Museum in Harlem extends its heartfelt appreciation to David Driskell, Professor of Art at the University of Maryland at College Park, who joins me as co-curator of the exhibition and fellow contributor to the catalogue. Driskell's considerable experience in organizing surveys of Black American art was extremely helpful in locating key works for this exhibition. As a student of James Porter at Howard University, as a professor at Fisk University during Aaron Douglas's years there, and as an associate of Mary Beattie Brady, Executive Director of The Harmon Foundation, Driskell was personally acquainted with many active participants in the Harlem Renaissance. His catalogue essay, which focuses on the visual artists featured in the exhibition, is complemented by David Levering Lewis's survey of the literary, social, and political developments that constituted the Harlem Renaissance. The Martin Luther King, Jr., Professor of History at Rutgers University, Lewis is the author of *When Harlem Was in Vogue*, one of the most important studies of Harlem in the 1920s and 1930s. Deborah Willis Ryan, Photographic Specialist and Exhibition Coordinator at The Schomburg Center for Research in Black Culture, provided the museum with considerable assistance for the exhibition as well as an informative essay on James Van Der Zee, Harlem's premier photographer. The comprehensive chronology was prepared by Jeffrey Stewart, an Alain Locke Scholar from Yale University and formerly a Smithsonian Postdoctoral Fellow, who is now Commonwealth Professor at George Mason University; and the list of Aaron Douglas's illustrations was compiled by Richard Powell, a graduate student in the Department of Art History at Yale University and a Smithsonian Fellow.

In recent years the Harlem Renaissance has received a great deal of scholarly attention. The Studio Museum in Harlem has been extremely fortunate in having many of the outstanding scholars of Black American culture as members of our National Advisory Council. They assisted in planning the exhibition, its catalogue, and the extensive public programs which accompany the exhibition. In addition to David Driskell, David Levering Lewis, Deborah Willis Ryan, and Jeffrey Stewart, we also thank Henry Louis Gates, Professor of English, Comparative Literature, and Africana Studies at Cornell University; Robert Hill, Professor of History and editor of the Marcus Garvey and UNIA papers at the University of California, Berkeley; Nathan Huggins, Director of the W.E.B. Du Bois Institute for Afro-American Research at Harvard University; Bruce Kellner, Professor of English at Millersville University, Pennsylvania;

Albert Murray, educator and author; Charles Nichols, Professor of English at Brown University; Charles Scruggs, Professor of English at the University of Arizona; and Mrs. Hale A. Woodruff, widow of the Harlem Renaissance artist Hale Woodruff.

An exhibition of this range is only possible with the very generous support of several contributors. We are especially grateful for a major grant from Philip Morris Companies, Inc., since it was their initial funding and extraordinary enthusiasm which allowed us to initiate the project. Their contribution was joined by grants from both the National Endowment for the Arts and the National Endowment for the Humanities. We are also very grateful to the Art Museum Association of America for agreeing to sponsor the national tour of the exhibition. Harold Nelson, Exhibition Program Director at the Association, must be singled out for his extraordinary efforts on behalf of the tour. The museum is particularly pleased, too, with the decision of Harry N. Abrams, Inc., to publish the catalogue, and we extend a special word of thanks to Margaret Kaplan, Executive Editor and Senior Vice-President at Abrams, for her commitment to and faith in our project. Our thanks also go to Charles Miers, whose meticulous and attentive editing of each essay and insightful consideration of the overall layout have been invaluable. Ray Hooper's superb design and organization of the book deserves special recognition. This is the first catalogue from the museum to be produced and published by a trade publisher, therefore allowing us to circulate the material to a broad public.

The Studio Museum in Harlem extends a special word of thanks to all lenders for making the show possible. The museum has been very fortunate to have several lenders work especially hard to see this exhibition come about: Solomon Fuller and his sister-in-law, Harriet Fuller (who oversees the Fuller estate); Evelyn N. Boulware, the chief lender of Palmer Hayden's works; The Schomburg Center for Research in Black Culture, The New York Public Library, which allowed us the rare opportunity to exhibit Aaron Douglas's murals; The Museum of Art, Rhode Island School of Design, which loaned very fragile drawings by Aaron Douglas; and Mrs. James Van Der Zee, who worked closely with the museum in the selection and identification of photographs for the show.

Several colleagues have provided invaluable assistance. We thank Deirdre Bibby, Art Collections Manager at The Schomburg Center for Research in Black Culture, Edmund Barry Gaither, Director of the Museum of the National Center of Afro-American Artists, and John Kinard at the Anacostia Museum.

Several staff members at The Studio Museum in Harlem worked particularly hard to make the exhibition a success: Grace Stanislaus, Associate Curator, coordinated the tasks of the curatorial department and supervised the catalogue's bibliography and artists' chronologies; Registrar Joan Hendricks worked very closely with several lenders, traveling extensively and negotiating the terms of the loans; the bibliography was researched and organized by Grace Matthews and, at the museum, by intern Deirdre Scott. Interns Helen Shelton and

Christina Wheeler researched and compiled the artists' chronologies. Their activities were coordinated by Deputy Director Kinshasha Holman Conwill, who was Acting Director during my leave of absence when much of the exhibition's preliminary work was completed. The museum thanks Joseph R. Sanders, Exhibition Designer, and Al Cucci, Art Director, who designed the printed material. To Carol Lewis and Carol Martin, members of the museum's support staff, a warm word of thanks for their assistance in typing the catalogue's several drafts. Our thanks also go to Rosemary Fallat, who typed and copyedited parts of the manuscript.

Special words of gratitude must be extended to The Studio Museum's board of trustees, a stellar group of volunteers who enthusiastically encouraged this project from start to finish. We acknowledge the assistance of Charles Shorter, Chairman of the Board at the time the project was conceived and initiated; Marie Brown, who as an editorial consultant on the board guided the museum deftly through the publishing process; and George Knox, who as Director of Corporate Communications at Philip Morris was an avid supporter of the project.

As with all of The Studio Museum in Harlem's major exhibitions on which I have worked, this is just a beginning, a point of departure, for what we hope will be an ongoing and productive dialogue.

Mary Schmidt Campbell
Director
The Studio Museum in Harlem

Introduction

If after absorbing the new content of American life and experience, and after assimilating new patterns of art . . . then the Negro may well become what some have predicted, the artist of American life.

—Alain Locke in "The Legacy of the Ancestral Arts," The New Negro, 1925

T he Studio Museum in Harlem's exhibition *Harlem Renaissance: Art of Black America* adds a new chapter to the story of this hotly debated period in American cultural history. From 1919 to 1929, as the poet Langston Hughes wrote, "Harlem was in vogue." Black painters and sculptors joined their fellow poets, novelists, dramatists, and musicians in an artistic outpouring that established Harlem as the international capital of Black culture. Almost as soon as the Renaissance announced itself, however, the artistic merits of Black America's great cultural awakening came under sharp attack. Although scathing criticism greeted all of the participants, contemporary critics accused painters and sculptors, in particular, of cultural isolationism and hopeless conventionalism.

Sixty years later, Harlem's writers, at least, have been vindicated: Langston Hughes, Zora Neale Hurston, and Jean Toomer now occupy a firm place in the American literary canon. The visual artists, on the other hand, remain virtually unknown not only to the general public but also to many scholars of American art. Students of Black American art may be familiar with the names Aaron Douglas, Meta Warrick Fuller, William H. Johnson, or Palmer Hayden, but most comprehensive studies of the Harlem Renaissance mention them only peripherally, and surveys of American art usually omit them altogether. Only in the past fifteen years have a few of the Harlem Renaissance artists been the subjects of serious critical studies or major retrospective exhibitions. The historical neglect of these figures raises many questions. Do the Harlem Renaissance artists justly deserve to be forgotten? Is their art "hackneyed" and "uninspired," as Romare Bearden, the illustrious Black artist of the 1930s, suggested as a young man (he later radically revised his views)? Do they constitute just an exotic interlude in the history of American art, or do their images provide the seeds of an authentic artistic tradition? Are their visions of American life as essential as those industrial landscapes of Charles Sheeler or the haunted, desolate tableaux of Edward Hopper (figs. 16 and 17)?

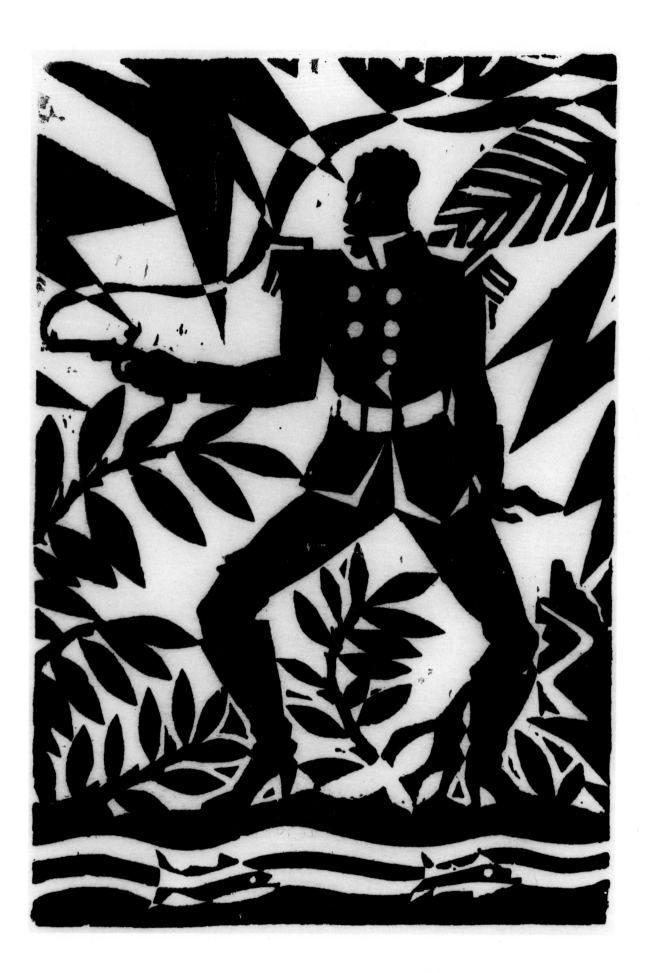

Building on recent scholarship and exhibitions that have begun to examine carefully the oeuvres of individual Harlem Renaissance artists, The Studio Museum in Harlem has assembled for *Harlem Renaissance* a core of over one hundred works by a small but representative group of artists—sculptor Meta Warrick Fuller, painters Aaron Douglas, Palmer Hayden, and William H. Johnson, and photographer James Van Der Zee—in order to take an in-depth look at some of the most compelling images by artists whose work first came to prominence in Harlem during the 1920s. It was this period of intense creative activity by Black Americans that gave the artists an identifiable artistic context for their work, propelled them to the forefront of the New Negro Movement, and inspired their art for the remainder of their careers.

Fig. 1.
Aaron Douglas.
DEFIANCE, *from* The Emperor Jones *series.*
c. 1926. Woodcut, 8½ × 5½". Collection Stephanie E. Pogue, Hyattsville, Maryland

Aaron Douglas, whose association with leading Black writers and whose illustrations for their works established him as the "official" artist of the Renaissance, and James Van Der Zee, whose photographs documented the world of 1920s Harlem, are inextricably linked to the era. Meta Fuller had already produced many of her finest sculptures and strongest statements well before the Renaissance, and Palmer Hayden and William H. Johnson would not reach full artistic maturity until the 1930s. Yet, the Renaissance was undoubtedly their aesthetic matrix. It was through the exhibitions of The Harmon Foundation, a major patron of Harlem Renaissance artists, that their work was first introduced to a national audience. Moreover, they were true Harlem Renaissance artists in spirit. Each developed a vital aspect of the Renaissance ethos—be it glorification of the Black American's African heritage, the tradition of Black folklore, or interest in the details of Black life. Each broke dramatically with earlier Black art and earlier representations of Blacks in art. They were among the first Americans to celebrate Black history and culture and they were the first artists to define a visual vocabulary for Black Americans. *Harlem Renaissance,* therefore, brings together artists who represented the dominant themes of that age in their work. By examining their entire careers, the exhibition also demonstrates the way in which Renaissance ideals shaped the art of these pioneers and the tradition they established for Black American art.

The exhibition is ambitious. In providing a forum for the works, it seeks to restore some critical balance to the reputations of the Harlem Renaissance artists and to consider the urgent issues of cultural identity and social and political tensions so often implicit in their images. These tensions, which percolated beneath the carefree surface of the Jazz Age, were evident in the very manner in which the Harlem Renaissance artists were patronized, exhibited, and presented to the American public. What this exhibition makes painfully evident is that the Harlem Renaissance artists were the victims of a segregated culture, a culture that separated its artists as emphatically as it segregated its public schools. For the most part, the artists were represented by a White philanthropy, The Harmon Foundation, which held national competitions exclusively for Black artists. After it halted its programs in the 1930s, private support for the artists virtually disappeared.

In organizing *Harlem Renaissance,* it was all too clear that except for the few Black colleges that had the foresight to collect the works of Black artists, and the National Museum of American Art, which was given the works of William H. Johnson after the Renaissance, the bulk of these artists' works remained in the hands of their families and friends. Until the late 1960s, when the civil rights movement aggressively resurrected the cultural artifacts of the African American past, their art usually had not been documented or exhibited since the time of the Renaissance. The Harlem artists emerged at a time when museums (including the fledgling Museum of Modern Art and the Whitney Museum of American Art), major collectors, art critics, and galleries were attempting to define what was American in American art. But, given the decidedly separatist nature of American society, the art establishment paid only the most cursory attention to Black artists. This exhibition, then, is an important reminder that the historical process is, by necessity, an ongoing inquiry into the past and our assumptions about the past. It is also a reminder that the tradition of separate exhibitions for Black American artists has a long history, deeply entrenched in the American cultural psyche. Finally, the exhibition strives to place the Harlem Renaissance artists within a broad cultural context, thereby inaugurating a critical dialogue that incorporates the work of the Harlem Renaissance artists into discussions of the art of the 1920s and 1930s, a process which will undoubtedly enlarge and enrich the history of the era as well as the history of American art.

At the outset of the Harlem era, the artists featured in *Harlem Renaissance* were scattered across the country and hardly knew one another. As the years passed, however, there developed a slender skein of connections, a group consciousness, at first tenuous and indefinite but binding nonetheless. It was a consciousness driven by intense ethnic pride, political activism, and a sense of a unique cultural lineage which cut across geographic regionalism, inspiring Black artists to produce as they never before dared.

Before the Harlem Renaissance, painting and sculpture were not professional options for Black Americans. Most Blacks lived in the South and were constrained by Jim Crow laws which disenfranchised Black citizens and separated them from Whites in virtually every aspect of public life. There was also the very real and very constant threat of violence. In the years after the turn of the century, the South witnessed the rising power of the Ku Klux Klan, the Knights of the White Camelia, and the White Citizens' Council, whose self-appointed role was to enforce the Jim Crow laws and mete out their own brand of vengeance when a transgression was perceived. Race riots and ceremonial executions by lynching occurred with alarming regularity. In such an environment, Black people were not encouraged to make fine art.

Yet, even as the South grew increasingly oppressive, an artistic fervor at the popular level, at least, took root. The separate traditions and circumstances of a segregated, largely agrarian, and oftentimes feudal existence cultivated an aes-

thetic spawned by the experience of slavery and seeded with the half-remembered fragments of an African past. In the grass-roots music, religion, and oral traditions of the Black South, a distinctive brand of American culture was flourishing. As the cultural identity of the Black American citizen emerged, so too did his sense of political and social hegemony. By the 1920s a "New Negro" had evolved, with a personality crystallized by two major events: World War I and the mass migration of Blacks from the South to the cities of the North.

World War I, the war to end all wars, rallied many Black Americans with patriotic appeals to democratic ideals. Although some remained suspicious about the war's relevance to their condition, others saw it as a sign that in the international arena there was finally a forum to address racial injustice. For the Black infantrymen who fought overseas, the war provided an opportunity to experience firsthand the rising importance of African cultures and to learn about the burgeoning popularity of negritude, a philosophy created by African and Caribbean poets that promoted the unity and beauty of peoples of African descent. In London, Paris, and Berlin, they could also witness the extraordinary appeal of jazz—the new Black American music—and an international appreciation of the depth and complexity of Black culture that was unimaginable in the provinces of their hometowns. At home, the war spurred the industrial economy of the North and created an almost desperate need for manpower to fill factory jobs left vacant by the lack of European immigrants. Economic opportunity, coupled with a newly established sense of pride and self-worth, brought a flood of migrants from the South to the North. Between World War I and World War II over two million Black Americans migrated. The pursuit of a new life in the North gave rise to the concept and identity of the New Negro. In his classic anthology of the era, *The New Negro,* Alain Locke, the leading Black philosopher and cultural arbiter of the Harlem Renaissance, described the metamorphosis of migration as "shedding the old chrysalis of the Negro problem" and "achieving something like a spiritual emancipation."

The impact of the New Negro Movement was enormous. Politically, the decision to migrate in and of itself was an act of defiance against the social order and political constraints of the South, and a vote cast for the liberating possibilities of the North. The new sense of political activism was reflected in the massive shift in Black affiliation from the Republican to the Democratic party and in the increasing influence of Black organizations. The National Association for the Advancement of Colored People (NAACP) was founded in 1909 and dedicated to securing full civil and political rights for Black Americans. The Urban League was founded in 1910 with the goal of acclimating recent migrants to the rigors of urban life. Perhaps the most dramatic evidence of the newfound sense of purpose and activism was the popularity of the Universal Negro Improvement Association (UNIA). Driven by the charismatic zeal of Marcus Garvey, a Jamaican who had migrated to New York, the Harlem-based UNIA captured the grass-roots sensibility of the New Negro in much the same way the civil rights movement under the visionary leadership of Martin

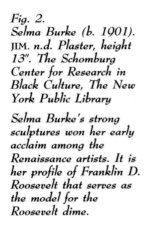

Fig. 2.
Selma Burke (b. 1901).
JIM. *n.d. Plaster, height*
13". The Schomburg
Center for Research in
Black Culture, The New
York Public Library

Selma Burke's strong
sculptures won her early
acclaim among the
Renaissance artists. It is
her profile of Franklin D.
Roosevelt that serves as
the model for the
Roosevelt dime.

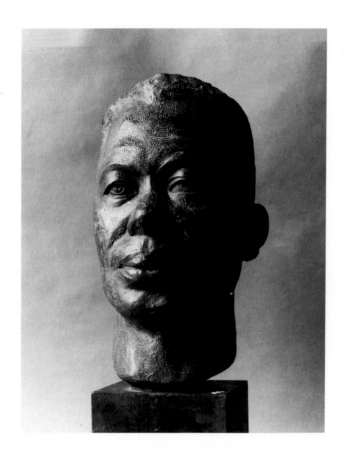

Luther King, Jr., or the presidential bid of Jesse Jackson inspired hundreds of thousands of Black Americans. The UNIA's goals were romantically ennobling. The association planned to raise money to buy a ship and return Black Americans to Africa, the land of their origins. Garvey's movement, replete with an elaborate organizational hierarchy, parades, pageantry, uniforms, emblems, and other regalia, raised several hundred thousand dollars and actually purchased a steamship. More important, it symbolized the militant ethnic pride of the New Negro, the fervent belief in the beauty and nobility of an African homeland, and the deep cultural cleft between Black and White America.

If Garvey's movement was evidence of a breach between the races in the promised land of the North, art was the hope for a reconciliation. For intellectuals like Locke and W.E.B. Du Bois, a Harvard-educated historian and the brilliant editor of *The Crisis* magazine (the organ of the NAACP during the Renaissance), art could bridge the gap between the Black and the White worlds if only the Black artist was allowed the opportunity to hone his talents. Given his rich folk background, his African heritage, and his ethnic pride, the Black artist had an aesthetic and a message to impart. Art, the essence of the civilized man, would be final proof that the New Negro not only had something positive to contribute to American life but had, indeed, ascended to new cultural heights. Harlem, the center of the New Negro Movement and the capital of Black America during the 1920s, was naturally the center of the artistic movement as well.

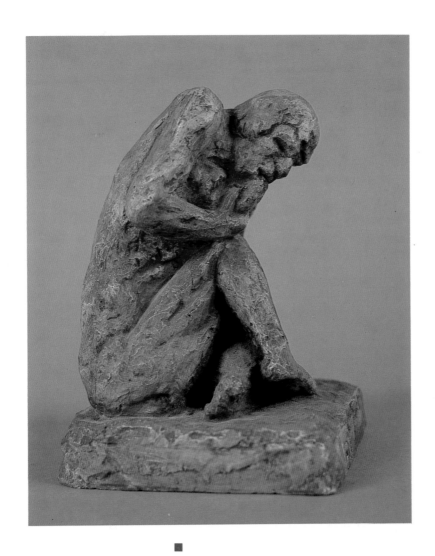

Plate 1.
Meta Warrick Fuller. MAN
EATING OUT HIS HEART.
*c. 1905–6. Painted
plaster, 7 × 3 × 2".
Collection Solomon Fuller,
Bourne, Massachusetts*

Plate 2.
Meta Warrick Fuller.
ETHIOPIA AWAKENING.
1914. Bronze, 67 × 16
× 20". The Schomburg
Center for Research in
Black Culture, The New
York Public Library

■

Plate 3.
Meta Warrick Fuller.
MARY TURNER (A SILENT
PROTEST AGAINST MOB
VIOLENCE). *1919.
Painted plaster, 15
× 5¼ × 4½". The
Museum of Afro-American
History, Boston*

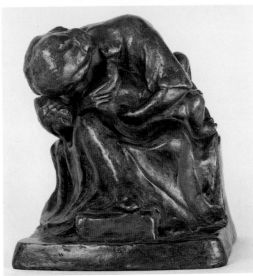

■

Plate 4.
Meta Warrick Fuller.
MOTHER AND CHILD.
*1914–20. Bronze, 5½
× 4¾ × 4¾". The
Danforth Museum of Art,
Framingham,
Massachusetts*

■

Plate 5.
Aaron Douglas. STUDY
FOR ASPECTS OF NEGRO
LIFE: FROM SLAVERY
THROUGH
RECONSTRUCTION.
1934. Tempera on paper,
11 × 26". Collection
Stephanie E. Pogue,
Hyattsville, Maryland

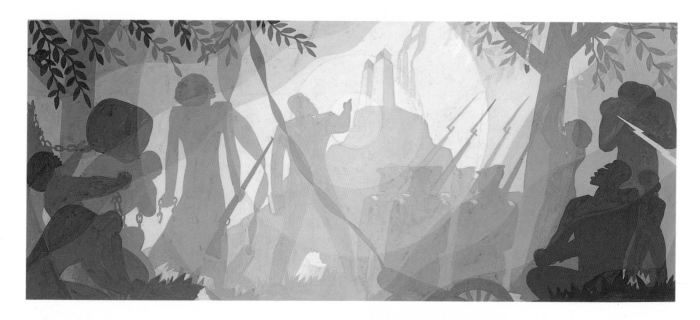

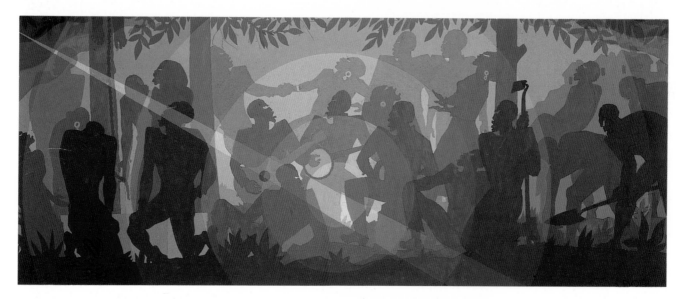

■

Plate 6.
Aaron Douglas. STUDY
FOR ASPECTS OF NEGRO
LIFE: AN IDYLL OF THE
DEEP SOUTH. *1934.*
Tempera on paper, 11
× 26". Collection
Professor and Mrs. David
Driskell, Hyattsville,
Maryland

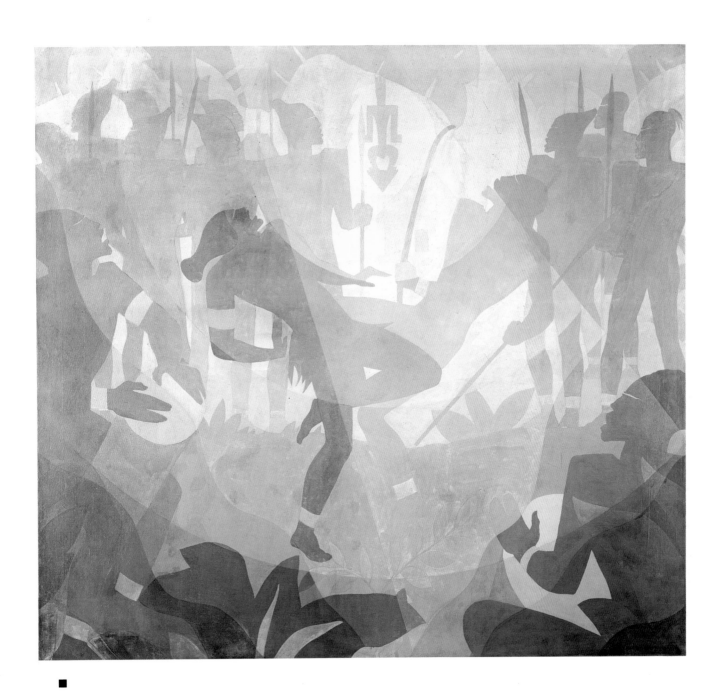

Plate 7.
Aaron Douglas. ASPECTS
OF NEGRO LIFE: THE
NEGRO IN AN AFRICAN
SETTING. 1934. Oil on
canvas, 6 × 6'. The
Schomburg Center for
Research in Black
Culture, The New York
Public Library

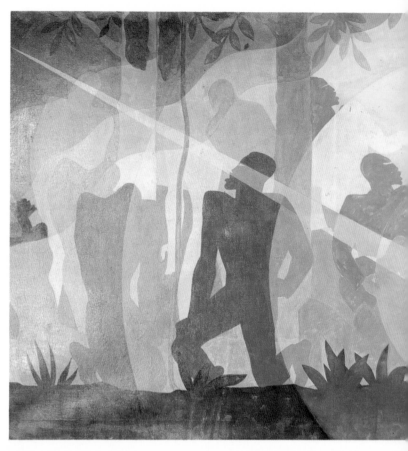

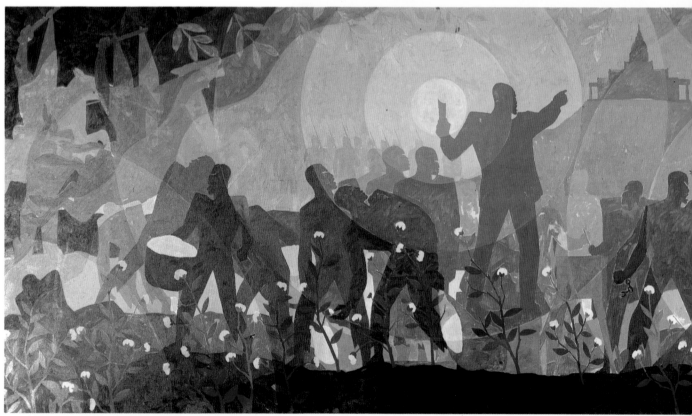

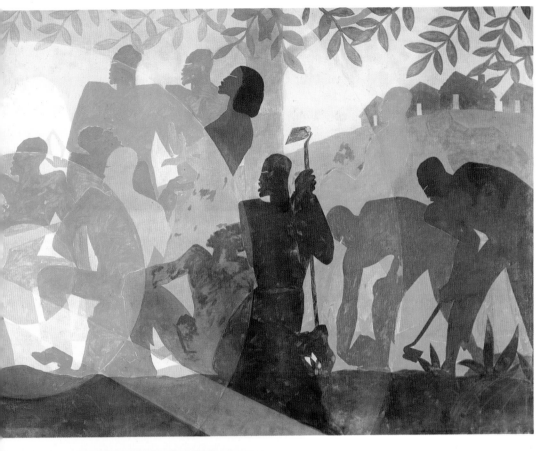

■

Plate 8.
Aaron Douglas. ASPECTS
OF NEGRO LIFE: AN
IDYLL OF THE DEEP
SOUTH. *1934. Oil on
canvas, 5' × 11'7". The
Schomburg Center for
Research in Black
Culture, The New York
Public Library*

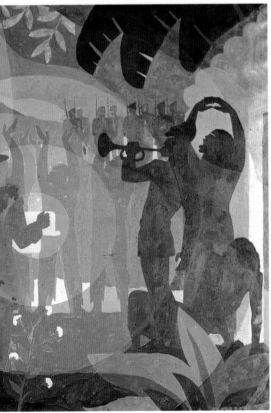

■

Plate 9.
Aaron Douglas. ASPECTS
OF NEGRO LIFE: FROM
SLAVERY THROUGH
RECONSTRUCTION.
*1934. Oil on canvas, 5'
× 11'7". The Schomburg
Center for Research in
Black Culture, The New
York Public Library*

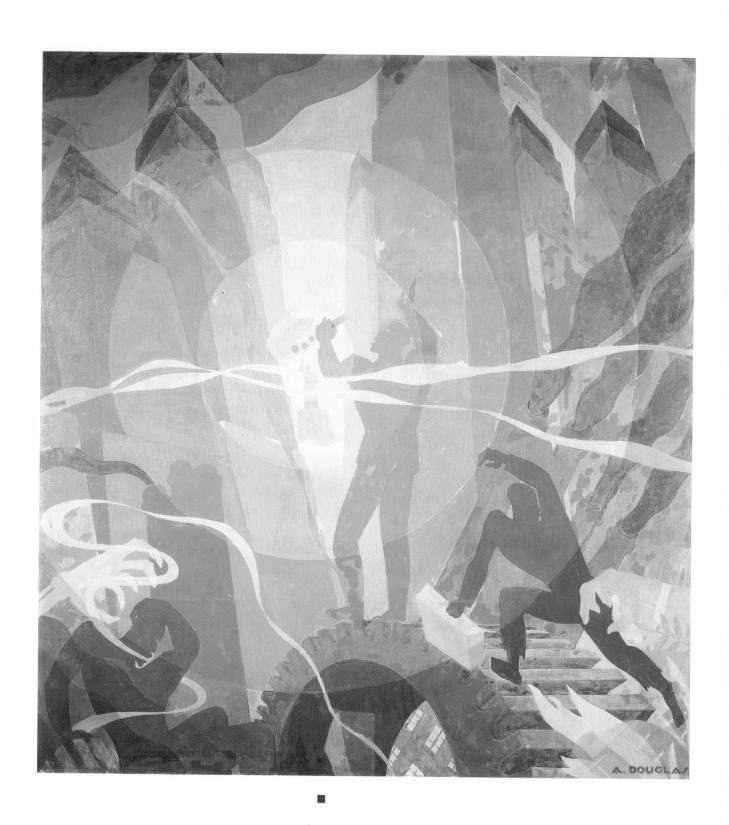

Plate 10.
Aaron Douglas. ASPECTS
OF NEGRO LIFE: SONG
OF THE TOWERS. *1934.*
Oil on canvas, 9 × 9'.
The Schomburg Center
for Research in Black
Culture, The New York
Public Library

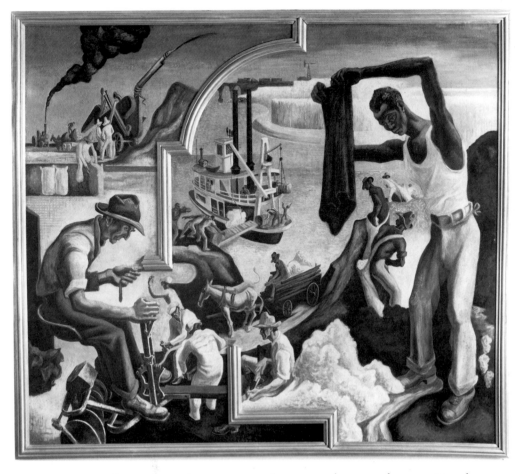

Fig. 3.
Thomas Hart Benton.
AMERICA TODAY. *1930.*
Mural. Collection The
Equitable Life Assurance
Society of the United
States

America in the 1920s, however, made reconciliation elusive. On the one hand, the very positive notion of a Black vision of American life that drew upon the cultural wealth of Black folklore and interpreted the African past along with the realities of Black American history and the day-to-day experience of Black life did in fact engender images and stylistic approaches that were fresh and new. On the other hand, the separatism of American life which required a separatist foundation to hold segregated exhibitions, the absence of repositories to collect and preserve the art, and the distortions of critics hostile to the very notion that Black people could make high art only served to widen rather than narrow the breach. Disappointingly, the legacy of the Harlem Renaissance has been a cultural separatism that to this day persistently lingers in the history of American art.

The principals in *Harlem Renaissance* represent the range of professional and creative options open to the Black artist in America during the 1920s. Meta Vaux Warrick Fuller (1877–1968), an elegantly Victorian, deeply spiritual sculptor, was one of the most important precursors of the Renaissance. She was trained at the Pennsylvania Museum and School for Industrial Arts and studied with Rodin in Paris at the turn of the century. When she returned to the United States, Meta Vaux Warrick married a Liberian physician, Dr. Solomon Fuller. Thereafter, she spent most of her career in Framingham,

Massachusetts, where she worked in a studio she built—against the wishes of her husband—with her own hands. Described by the historian Benjamin Brawley as one of the first to explore "the tragedy of the Negro race in the New World," Fuller became a powerful symbol of artistic determination for a generation of Black artists who came after her. Inspired by W.E.B. Du Bois's Pan-Africanist philosophy, which emphasized Black Americans' common African heritage, her finest works, *Ethiopia Awakening* (1914) and her 1919 *Mary Turner (A Silent Protest Against Mob Violence)*, are among the earliest examples of American art to reflect the formal exigencies of an aesthetic based on African sculpture. They are also important indictments of the prevailing political and social climate (plates 2 and 3).

■

Fig. 4.
META WARRICK FULLER.
n.d. Silver print.
Collection Solomon Fuller,
Bourne, Massachusetts

Relying more on an Egyptian rather than a West African sculptural concept, *Ethiopia Awakening,* with its condensed, simplified forms, looks like an ancient funerary statue. Fuller seemed to portray a woman awakening from the deep sleep of the past, but she tempered her romanticism with a very clear-eyed view of the contemporary condition of Black people in America. The years immediately following the war witnessed some of the worst violence toward Black citizens since the antebellum period. In July 1917, more than ten thousand Black citizens protested the obsessive violence, the mobs, the lynchings, and the sporadic, unpredictable outbursts against Blacks by marching down Fifth Avenue in New York City in a silent parade. The parade commemorated the lynching of Mary Turner, a Black woman from Valdosta, Georgia, who along with her husband and two other Black men had been accused of planning to murder a White man. Mary Turner's lynching, reported in the *New York Times* as well as in the Black press, had become a rallying point for the UNIA and had come to symbolize the lawlessness that threatened Black life. Impressed by the account she read of the parade in *The Crisis* magazine, Fuller memorialized the awakening defiance of her people in her sculpture of 1919. Considerably more classical than *Ethiopia Awakening, Mary Turner* is, nonetheless, a poignant portrayal of a woman struggling to define and free herself.

In 1984, Joy L. Gordon of The Danforth Museum of Art organized the first retrospective exhibition of Fuller's work. Much of the work for this show and for *Harlem Renaissance* was obtained from the Fuller family, from the Meta Warrick Fuller Legacy, incorporated by her son William T. Fuller and now managed by Harriet Fuller, and from a second son, Solomon Fuller. Some important pieces belong to institutions, including The Danforth Museum, the Museum of Afro American History in Boston, The Schomburg Center, and Radcliffe College. The Danforth Museum's catalogue of Fuller's art provides an important document on the life and work of this pioneering American artist.

Painter Aaron Douglas (1899–1979) was perhaps the most well known of Harlem's visual artists in the 1920s. He came to New York in 1924, shortly after graduating from the University of Nebraska. In Harlem, Douglas quickly developed a highly stylized aesthetic, characterized by spatially compressed com-

positions and chromatically subdued forms. Soon after the young painter came to New York, he had the good fortune to meet the Philadelphia collector Albert Barnes. Barnes, a contributor to Alain Locke's *The New Negro* and a White patron and supporter of Black artists, permitted Douglas to see his outstanding collection of West African sculpture as well as his superlative modern European paintings. Ironically, at a time when most of the American art establishment was experiencing ambivalence toward modernism and the influence of so-called primitivism, Douglas had access not only to the very best examples of African sculpture, but also to its influence in the paintings of such masters as Gauguin, Picasso, and Matisse. Strongly influenced by the modernists' shallow depth of field, the monochromism of Analytic Cubism, and the extreme simplifications and stylizations of African sculpture, Douglas developed a style for his paintings and illustrations that came to be regarded as the prototypical visual expression of the Harlem Renaissance.

■

Fig. 5.
AARON DOUGLAS. *n.d. Silver print. The Schomburg Center for Research in Black Culture, The New York Public Library*

Indeed, the illustrations gave the young artist wide visibility. His work appeared on the pages of *Opportunity* and *The Crisis*, the magazines of the Urban League and the NAACP, respectively; in such fashionable periodicals as *Harper's* and *Vanity Fair*; and in James Weldon Johnson's popular book of Black sermons, *God's Trombones: Seven Negro Sermons in Verse* (plates 30–33). The culmination of Douglas's art, however, came several years after the Harlem era. In 1934, during the Depression, he completed a monumental mural series entitled *Aspects of Negro Life* (plates 5–10). Four large panels document the emergence of a Black American identity. The series begins with a rather stereotypical portrait of life on the African continent, complete with tribal music and drums. The two middle panels depict slavery and emancipation in America, the rebuilding of the South, the birth of Jim Crow laws, and the flight of Blacks to the cities of the North. The final panel (plate 10) returns to the theme of music, as a jazz musician, saxophone in hand, stands atop the cog of a wheel. Although Douglas's mural has the lean contours of the Precisionists, unlike Demuth or Sheeler he does not celebrate the strength and efficiency of the industrial landscape; rather, his vision of an American machine age concentrates on the intrinsic tension between individual freedom and the grinding routine of the machine. The jazz musician, Douglas's emblem of that freedom, would also become a leitmotif in the work of Black American artists such as Romare Bearden and the photographer Roy DeCarava.

With emotional similarities to Thomas Hart Benton's 1930 mural, *America Today* (fig. 3), Aaron Douglas's mural represents origins, history, and the development of a people's identity; but it is distinctly more ethnically focused than Benton's newsreel-like celebration of American life. *Aspects of Negro Life*, originally mounted in the 135th Street branch of The New York Public Library (now The Schomburg Center), had a dramatic influence on the next generation of Black artists. The grand scale of the murals, the unique blend of history, religion, myth, politics, and social issues in a stylistically daring, epic framework made a lasting impression on young Harlem artists of the 1930s such as Jacob

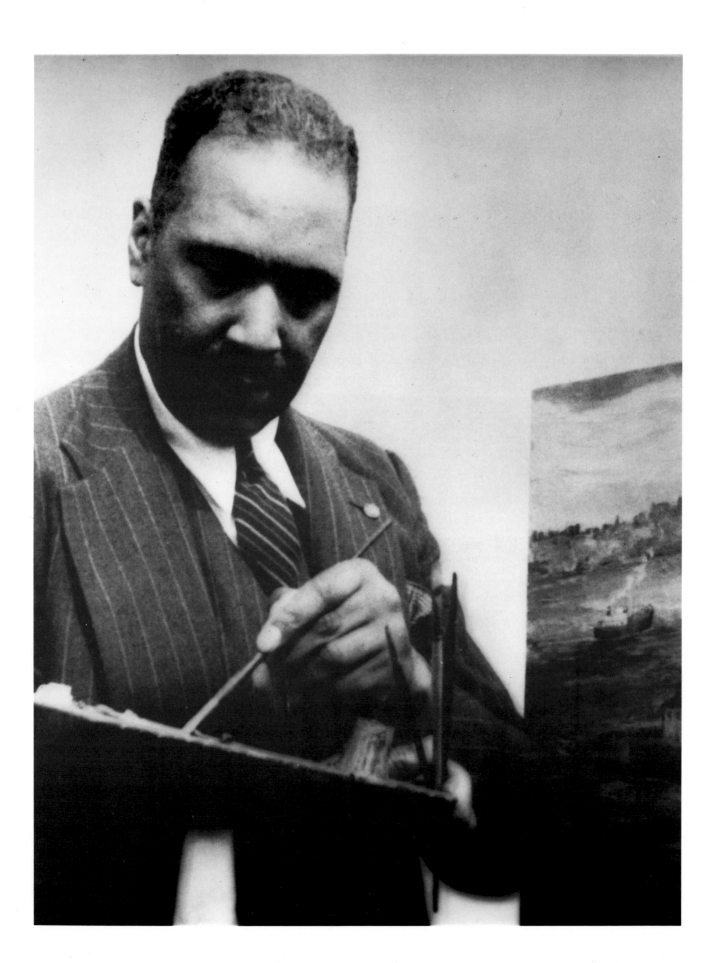

Lawrence and Romare Bearden. Yet Douglas, whose influential role increased when he eventually became the first president of Harlem's artists' guild, has not received the retrospective he so richly deserves. In addition to several smaller one-man shows, however, his work has appeared in major surveys of Black American art recently, including *Two Centuries of Black American Art* (1976), organized by David Driskell for the Los Angeles County Museum of Art; Bucknell University's *Since the Harlem Renaissance* (1984), curated by Joe Jacobs; and *Hidden Heritage* (1985), curated by David Driskell and circulated by the Art Museum Association of America. The Museum of Art of the Rhode Island School of Design has several key pieces. Otherwise most of Douglas's work is in the hands of private collectors or belongs to Black institutions, including Fisk University, where Douglas taught for several decades; The Gallery of Art at Howard University; the Hampton University Art Museum; and The Schomburg Center. A comprehensive study of Douglas's work is long overdue. Undoubtedly, it would yield valuable insights into the intellectual ideas of the Harlem Renaissance and could add an important dimension to our understanding of the influences of so-called primitivism in modern art. Douglas, a deeply philosophical artist, developed an aesthetic philosophy, style, and subject matter that embodied African metaphors and forms as the basis for his portrayal of American life.

The deep, almost spiritual kinship which both Meta Fuller and Aaron Douglas felt for their African heritage was but one hallmark of the Harlem Renaissance artist. An alternative approach was a newfound attentiveness to Black American life, legends, and folk heroes. Palmer Hayden (1890–1973), a World War I veteran who supported his painting career in the 1920s with menial jobs, was one of the first painters to offer a candid, if somewhat controversial, interpretation of Black life. Like Langston Hughes's poetry, his canvases often portrayed Harlem street life or recounted the customs and lore of the small-town folks from his native Virginia and from West Virginia, where he worked on the railroad before going to war. Hayden was eventually sponsored by a wealthy White patron who financed a trip to Paris in 1927. The following year, he showed at the Bernheim-Jeune Gallery, an important outpost of Paris's modern artists. (Since the nineteenth century, Europe had been a refuge for the talented Black American artist. Henry O. Tanner was probably the most well-known Black American artist to become an expatriate. During the Harlem Renaissance, many of The Harmon Foundation award winners, including Hale Woodruff, William H. Johnson, and Lois Mailou Jones, lived and worked in Europe. Not only did the artists find training available through a system of ateliers, but they found a public genuinely interested in their work.)

Hayden was often criticized for lapsing into a portrayal of Blacks that seemed to be rooted in cultural stereotypes. Late in his career, he became extremely sensitive to this kind of criticism of his work, and his paintings from the 1940s and 1950s depict Black people in a much more sympathetic manner. One particularly striking example of Hayden's sensitivity to his critics was his

Fig. 6.
PALMER HAYDEN. *n.d.*
Silver print. The Schomburg Center for Research in Black Culture, The New York Public Library

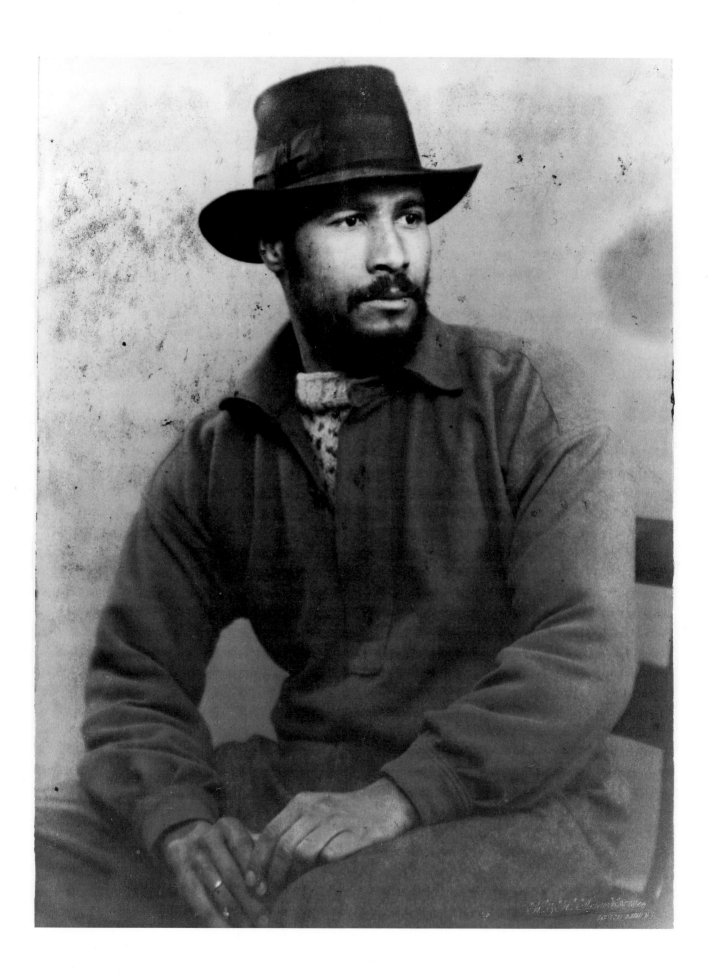

decision to repaint *The Janitor Who Paints*, a major work now in the collection of the National Museum of American Art (plate 13). Originally painted in 1939, the painting in its current state pictures a Black man wearing a beret with a brush and a palette in his hand, sitting in front of an easel. The subject of his painting within the painting is a beautiful young Black woman holding a child. Their apartment is modestly furnished, with a delightful little painting on the wall of a cat curled up in a ball. The painting is suffused with domesticity, the earnest efforts of the janitor, and a charming, almost sweet naiveté. An earlier version of this painting, however, which is clearly visible in a recent X-ray scanning of the painting performed by the National Museum of American Art, shows quite another point of view of the aspiring janitor. In the earlier version, the janitor looks like a caricature of a Black person, a grinning monkey with fleshy lips and a head that has been distorted into a bulletlike shape. In place of the beautiful Black woman and her lovely newborn are a minstrel-faced mammy and a grinnin' child. On the wall hangs a portrait of Abraham Lincoln, a reminder that Lincoln and the Republicans were still the great liberators in the South. (Emancipation Day was still celebrated in some Black communities.) Hayden's deliberately self-effacing interpretation of his efforts as an artist, his insistence on portraying Blacks with the masks of the minstrels—that is, as performers for a White audience—and his ingratiating reference to the benevolence of his liberators, are probably honest, if not particularly ennobling, portrayals of Hayden's very real feelings about his efforts at making art. As such, they are poles apart from Meta Fuller's aristocratic defiance and political sophistication or Aaron Douglas's epic perspective on the history and origins of the African American. It is to Hayden's credit that his later genre scenes are sensitive records of the small, day-to-day social rituals that prevailed in urban communities. Similarly, his scenes based on Black folklore are sensitive documents of the oral tradition that framed his past (plates 41 and 42).

Hayden also produced marine paintings and evocative landscapes that amply demonstrate his talents as a watercolorist (plates 43 and 44). His best work, the John Henry series, a story of a Black American folk hero, with its keenly observed scenes, earthy humor, and narrative skill aptly summarizes his career (plates 14–16). Completed in 1954, the series escaped whatever expectations Hayden's early patrons may have held for him and reflect the candor and honesty of a mature artist.

The Studio Museum in Harlem mounted a retrospective exhibition of Palmer Hayden's work in 1974. A significant number of his paintings have since entered into several private collections. The bulk of his work, maintained for years by his widow, Miriam Hayden, is now in the collection of the Museum of African American Art in Los Angeles, where Dr. Samella Lewis is currently preparing a retrospective exhibition.

William H. Johnson (1901–1970), a handsome adventurer from Florence, South Carolina, began his career as an academic painter. As his art matured, however, he shed his learned realism for a deliberate primitivism. Johnson

Fig. 7.
WILLIAM H. JOHNSON.
c. 1930–35. Silver print.
The National Museum of American Art,
Smithsonian Institution,
Washington, D.C.

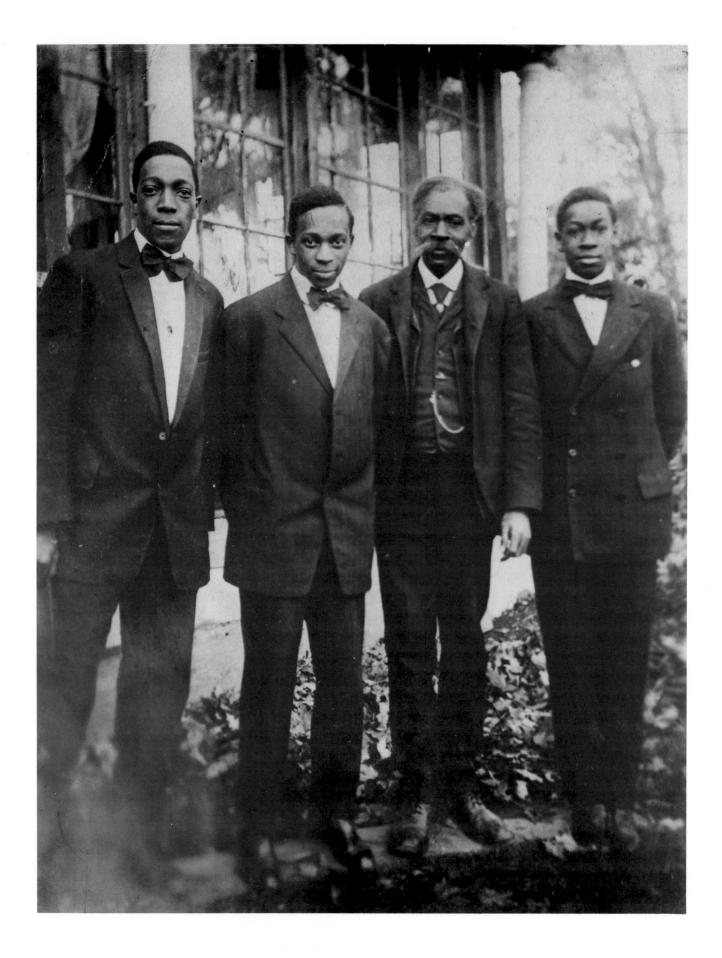

studied at the National Academy of Design in New York and was invited to assist the painter George Luks in Provincetown. Yet, like Hayden and so many other Black artists of the 1920s, Johnson left the United States in 1926 to seek his fortune in Europe. His travels brought him into contact with the art of Vincent van Gogh, Edvard Munch, and Chaim Soutine whose intensely expressive, angst-ridden paintings deeply moved the young artist. Johnson's early paintings, skillful, realistic tableaux, done in somber tones, were now followed by bright, dramatically simplified scenes of religious subjects and Black life (plates 17–20). Johnson's self-enforced primitivism puzzled many Harlem Renaissance observers: but it was a style that allowed him to express the deeply felt emotions inherent in the scenes he conveyed.

Johnson's primitivism has been the subject of much debate. Not only did he simplify his painting style, but he also deliberately created a naive, almost childlike style, awkward and crude as if he had not been trained at all. At the same time, his use of color and iconographic detail betrayed his sophistication. Johnson's choice of a childlike approach often left him open to charges that he, like Hayden, painted what he thought his patrons preferred. The charge is particularly insightful since Johnson, of all the artists in the show, has attracted the best documentation and has been the subject of a major retrospective, a catalogue, and two dissertations. The interest in Johnson and other Black folk artists is no doubt a part of a continuing set of expectations about the way Black people should make art; a set of expectations framed during the Harlem Renaissance years.

The National Museum of American Art (then the National Collection of Fine Arts), the major repository for the works of William H. Johnson, mounted a major retrospective exhibition of his works in 1971 and published a substantive catalogue that amply illustrates his oeuvre and includes a chronology of the artist's life. Johnson is also the subject of two doctoral theses: *The Life and Works of William H. Johnson, 1901–1970* by Dr. Leslie King Hammond at Johns Hopkins University (1975); and by Richard Powell at Yale University (currently in progress). Johnson's direct association with important twentieth-century modern artists, his controversial primitivism, and his documentation of Black life make him a fascinating figure in modern American art.

James Van Der Zee (1886–1983) was a popular Harlem photographer with a Lenox Avenue studio where New Negroes came to document the important rites and ceremonies of their lives. With his camera, Van Der Zee was able to bear witness to Harlem's weddings, funerals, and parades, as well as its bridge clubs, fraternities, school groups, and church organizations. He photographed Harlem's sights: famed patron A'Lelia Walker's Dark Tower, a chic salon for artists and socialites; the Reverend Adam Clayton Powell, Sr.'s Abyssinian Baptist Church; the elaborate, complex ceremonies of Marcus Garvey's UNIA; or the Theresa Hotel, which, in the days of segregated residences, was one of the country's finest Black hostelries (figs. 23, 37, 45, 49). Above all, he captured the extraordinary sense of self-esteem, style, and optimism that was Harlem in the

Fig. 8.
James Van Der Zee.
JAMES VAN DER ZEE
WITH HIS FATHER AND
TWO BROTHERS. *n.d.*
Silver print. The Schomburg Center for Research in Black Culture, The New York Public Library

James is at the left.

1920s. Van Der Zee's Harlem was the site where the modern Black identity was born, where the New Negro forged an urban personality.

The Black urban immigrants needed a means of legitimizing their newfound identity in the city. In New York, Van Der Zee's photographs served that purpose. All of his subjects bear a stylish resemblance. His studio portraits are identifiable by a few carefully composed sets, which were meant to represent an orderly bourgeois life. Mr. Van Der Zee arranged everything. He coaxed his subjects to sit with their legs crossed, their backs straight, a hat cocked to the side, a coat collar turned up, all to convey a studied, almost defiant confidence. Sartorially, his subjects are impeccable. All of them, men, women, and children, wear the most stylish clothes, made from the most luxurious fabrics and tailored with the most intricate detailing. And if, by chance, a sleeve was frayed or a button missing, Van Der Zee conveniently hand-painted and corrected the detail. In fact, he touched up imperfections, straightened teeth, sketched a few extra pieces of jewelry, smoothed out skin color—whatever was necessary to make his clients fit the New Negro mold. In scene after scene, a regimented, formalized image recurs, all cut from the same pattern. The image of the Harlem Renaissance, captured by Van Der Zee's photographs, was partially real pride and partially carefully constructed artifice.

Of all the artists in *Harlem Renaissance,* James Van Der Zee is the best known to critics, historians, and the American public. Introduced to a large audience through the Metropolitan Museum of Art's controversial exhibition *Harlem on My Mind* (1969), Van Der Zee's work has been widely represented in photography texts such as *A Century of Black Photographers: 1840–1960* and *Camera Lucida: Reflections on Photography.* The bulk of his estate, however, which is owned by his widow, Donna Van Der Zee, Van Der Zee Institute, and The Studio Museum in Harlem, has never been shown. Most of his photographs in *Harlem Renaissance* are images that are presented to the public for the first time. And for the first time, the photographs can now be seen within the context of the visual art of the period.

In addition to Van Der Zee's photographs, the exhibition includes a selection of photography by a patron of the Harlem Renaissance artists, Carl Van Vechten (1880–1964). Van Vechten, who shocked some Harlem intellectuals with his bawdy satire of Harlem night life, *Nigger Heaven,* photographed such noted Harlem literati as Langston Hughes, Zora Neale Hurston, W.E.B. Du Bois, and Paul Robeson (figs. 22–42). His portraits, poetic interpretations of the artists' personalities, provide some insight into the way in which a Harlem Renaissance patron quite literally saw the artists. With their formal poses and baroque, patterned backgrounds, Van Vechten's photographs present men and women who were dignified yet slightly exotic, mysterious, and vaguely sensual. It was a perception which, no doubt, clouded interpretations of their work.

The Studio Museum in Harlem's exhibition looks at each artist through the lens of his or her own work. Thus, the artists are represented by a selection of works created not only at the time of the Renaissance but throughout their

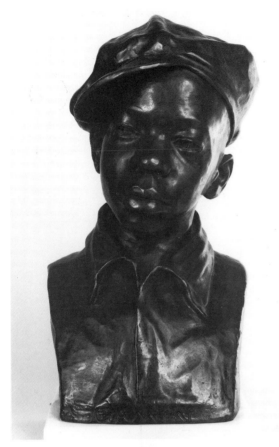

Fig. 9.
*Augusta Savage (1900–
1962).* GAMIN. *1930.
Plaster, height 6". The
Schomburg Center for
Research in Black Culture,
The New York Public
Library*

*Augusta Savage became
an important aesthetic
leader in the Harlem
community. Many young
artists became her
protégés, and she held
classes for aspiring artists
in a converted garage.
Much of her sculpture,
however, was lost or
destroyed and few
examples of her work have
been preserved. What
remains of her work clearly
indicates that her concern
was with the noble and
heroic within the ordinary.*

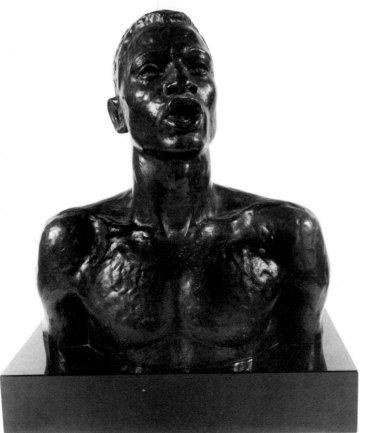

Fig. 10 ·
*Richmond Barthe
(b. 1901).* THE SINGING
SLAVE. *1940. Plaster,
height 11¾". The
Schomburg Center for
Research in Black Culture,
The New York Public
Library*

*Richmond Barthe's
sculpture was well known
in Harlem. His sculptural
concept, like that of Meta
Warrick Fuller's, used
African sculpture as a
stylistic point of departure
and a link with his
ancestral heritage.*

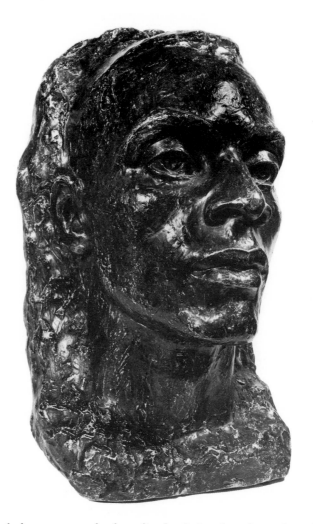

Fig. 11.
Richmond Barthe.
THE NEGRO LOOKS
AHEAD. 1940. Plaster,
height 17". The
Schomburg Center for
Research in Black
Culture, The New York
Public Library

careers. Each of these artists had a clearly defined style and each produced an aesthetically coherent body of work. Each also suffered from the peculiar circumstances of the Black artist in the early decades of the twentieth century: circumstances which frame any discussion of these artists and their subsequent treatment in American cultural history.

The principal spokesman for the Black artist during the 1920s was the scholar Alain Locke. Locke, an urbane, Harvard-educated philosopher and Howard University professor, articulated an innovative aesthetic theory which called for the Black artist to acknowledge his African heritage. In 1925, Locke wrote "The Legacy of the Ancestral Arts," a classic essay in which he maintained that if the Black American were to lay claim to the rich African sculptural tradition which, he noted, was already a potent force in the evolution of European modernism, he would have the power to create an art that would add a new dimension to Black America's cultural identity. Locke's arguments appeared in his 1925 anthology of Harlem Renaissance writers, *The New Negro,* a collection of short stories, essays, and poems of the era with illustrations by the German artist Winold Reiss, as well as woodcuts by Aaron Douglas. Douglas's stylized tableaux, patterned after African designs, suggested the possibilities for Locke's ideas of an authentic African American aesthetic. Locke, the author

of what would become a hotly debated theory of Black art, was also one of the chief architects of a controversial system of patronage, a system designed to make Harlem the center of Black art in America.

To give substance to his philosophical goals, the resourceful philosopher persuaded a wealthy White real-estate magnate and philanthropist, William Harmon, to sponsor an annual national competition, exhibition, and award program for Black artists under the auspices of The Harmon Foundation. The foundation, originally organized in 1922 to "assist in the development of a greater economic security for the [Black] race," inaugurated in 1926 the first achievement awards for Black Americans in literature and in the visual arts. When the call for entries went out nationally in the Black press, however, only nineteen visual artists responded, including the janitor at The Harmon Foundation, Palmer Hayden. Hayden promptly became the first gold-medal winner. His award immediately left the foundation open to charges of amateurism, but did not dampen the spirits of other aspiring Black artists. By 1933, the last year of the competition, over four hundred entries were exhibited at the International House on Riverside Drive in New York, where the annual show was held.

Indeed, entries came from all over the world—Chicago, San Francisco, Topeka, Washington, D.C., Framingham, Paris, Copenhagen, and Havana. The award-winning artists included sculptors Augusta Savage, Richmond Barthe, Sargent Johnson, Selma Burke, and Meta Fuller, along with painters William H. Johnson, Laura Wheeler Waring, Archibald Motley, Malvin Gray Johnson, Lois Mailou Jones, Edward Scott, and Hale Woodruff, in addition to Palmer Hayden and Locke's protégé Aaron Douglas. Under the auspices of The Harmon Foundation, the Black artist emerged for the first time in great numbers. Indeed, Harlem, spiritual home to the New Negro, became home to the Black artist as well. In the strictest sense of the word, however, these artists by no means constituted a movement. They never organized formally as a group, in contrast to both the next generation of Black artists supported by the Works Project Administration (WPA) and the artists of the civil rights movement, who were compelled to unite by the urgency of political and social events. Although some of the artists were cognizant of Locke's aesthetic and as a group did in fact celebrate their ancestral connections with Africa, they did not openly subscribe to one theory of Black art or, for that matter, to any one aesthetic point of view. Nonetheless, the annual competition, the accompanying exhibition in Harlem which was circulated to major cities, and the ancillary shows of individual artists in local civic organizations did create a loose amalgam of Black artists which previously did not exist.

Yet even as Black artists made their debut on the American cultural stage, critics—Black and White—excoriated their efforts. Supporters like W.E.B. Du Bois and Alain Locke expressed reservations about the conservatism and conventionalism of most Black artists. Misguided White critics such as Albert Barnes, a strong supporter of young Black artists, wrote in Locke's *The New Negro*: "That there should have developed a distinctively Negro art in America

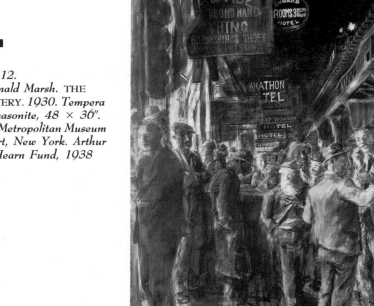

Fig. 12.
Reginald Marsh. THE
BOWERY. *1930. Tempera*
on masonite, 48 × 36".
The Metropolitan Museum
of Art, New York. Arthur
H. Hearn Fund, 1938

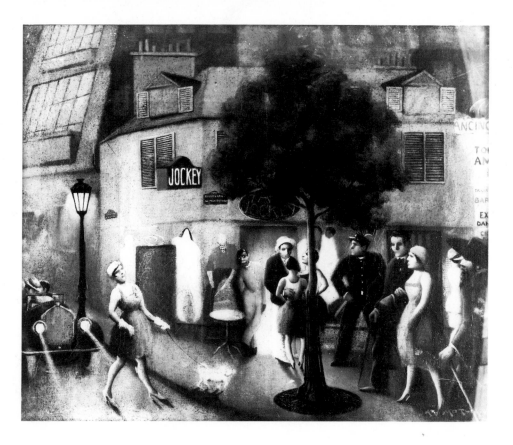

Fig. 13.
Archibald Motley. (1891–
1980). JOCKEY CLUB.
1929. Oil on canvas,
24³/₄ × 32". The Schomburg
Center for Research in Black
Culture, The New York
Public Library

Archibald Motley, like
William H. Johnson, was
able to shift from academic
realism to a more earthy
folk idiom in his scenes of
Harlem or Parisian
nightlife.

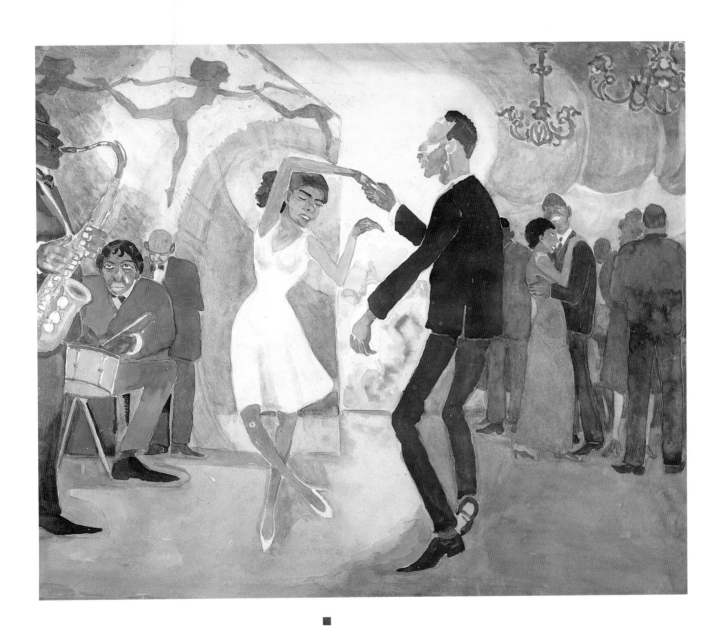

Plate 11.
Palmer Hayden. BAL
JEUNESSE. c. 1927.
Watercolor on paper, 14
× 17". Collection Dr.
Meredith F. Sirmans,
New York

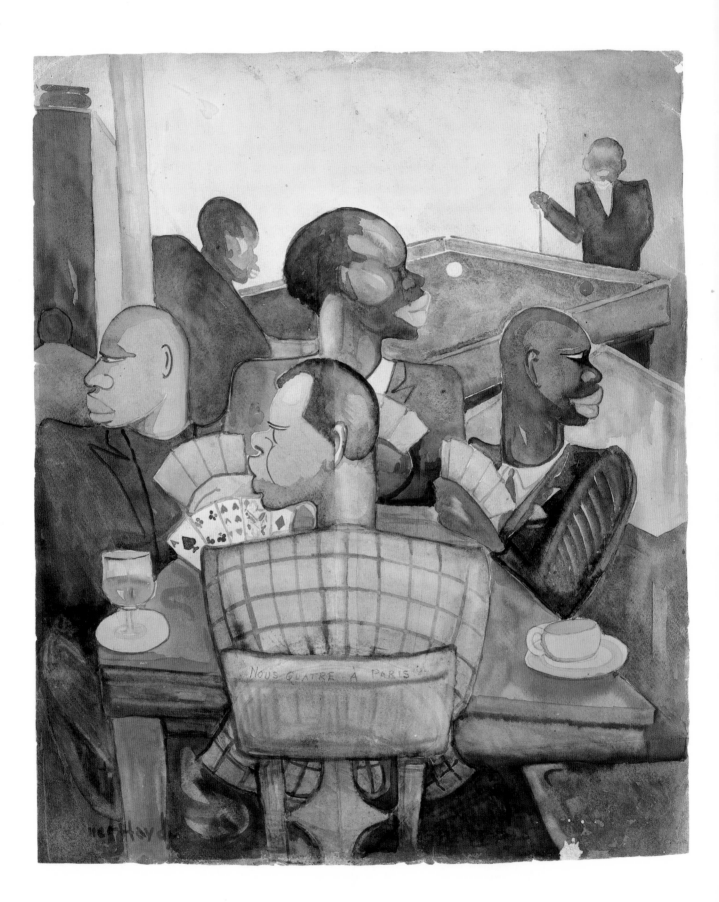

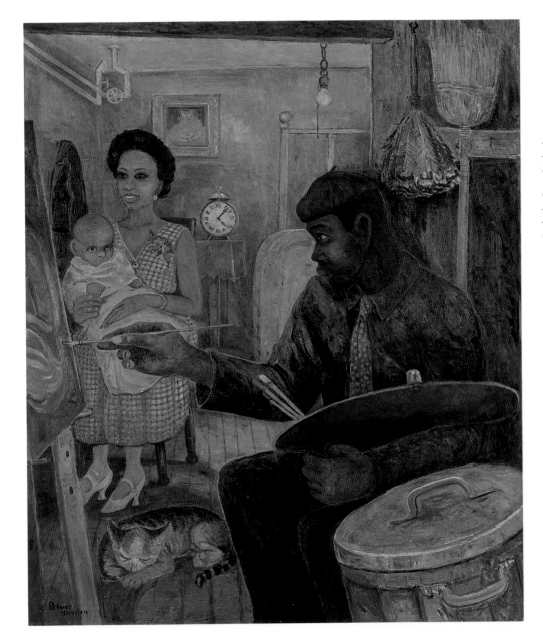

Plate 13.
Palmer Hayden. THE
JANITOR WHO PAINTS.
1939–40. Oil on canvas,
39⅛ × 33″. The
National Museum of
American Art,
Smithsonian Institution,
Washington, D.C.

Plate 12.
Palmer Hayden. NOUS
QUATRE À PARIS.
c. 1930. Watercolor on
paper, 21⅞ × 18″. The
Metropolitan Museum of
Art, New York. Joseph H.
Hazen Foundation, Inc.,
Gift Fund (1975.125)

Plate 14.
Palmer Hayden. HIS
HAMMER IN HIS HAND,
from the John Henry
series. 1944–54. Oil on
canvas, 27 × 33". The
Museum of African
American Art, Los
Angeles. Palmer C.
Hayden Collection, gift of
Miriam A. Hayden

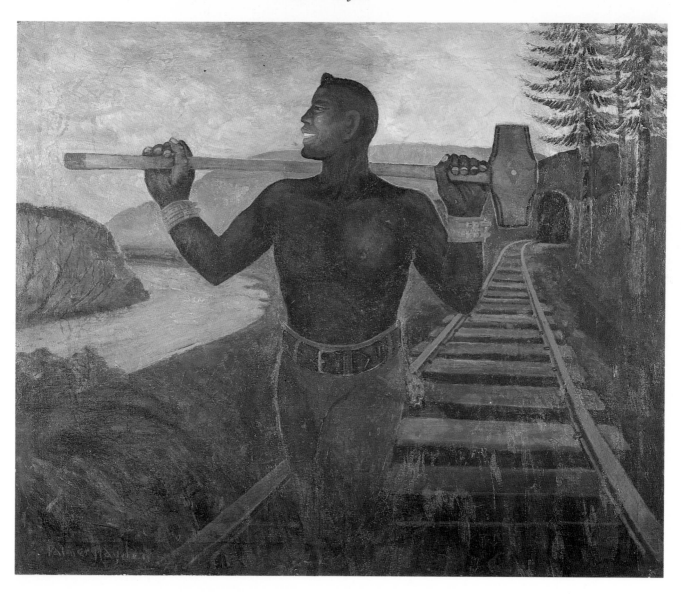

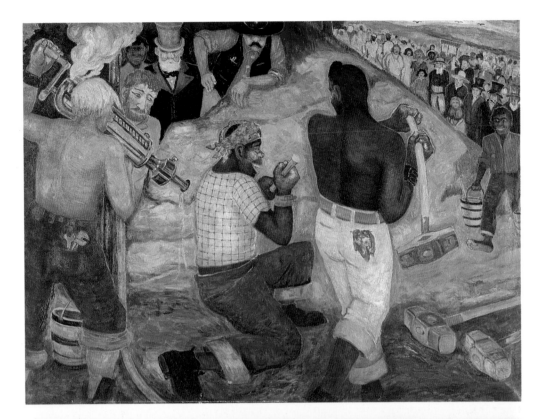

■

Plate 15.
Palmer Hayden. JOHN
HENRY ON THE RIGHT,
STEAM DRILL ON THE
LEFT, *from the John
Henry series. 1944–54.
Oil on canvas, 30 × 40".
The Museum of African
American Art, Los
Angeles. Palmer C.
Hayden Collection, gift of
Miriam A. Hayden*

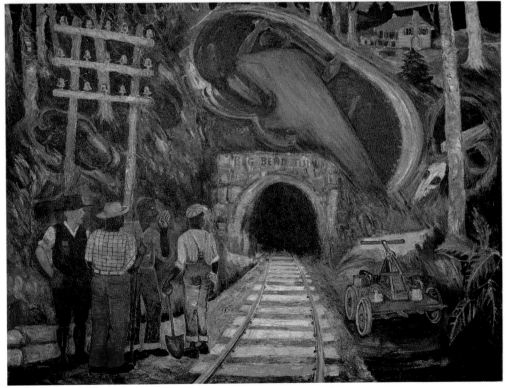

■

Plate 16.
Palmer Hayden. THE BIG
BEND TUNNEL, *from the
John Henry series. 1944–
54. Oil on canvas, 30
× 40". The Museum of
African American Art,
Los Angeles. Palmer C.
Hayden Collection, gift of
Miriam A. Hayden*

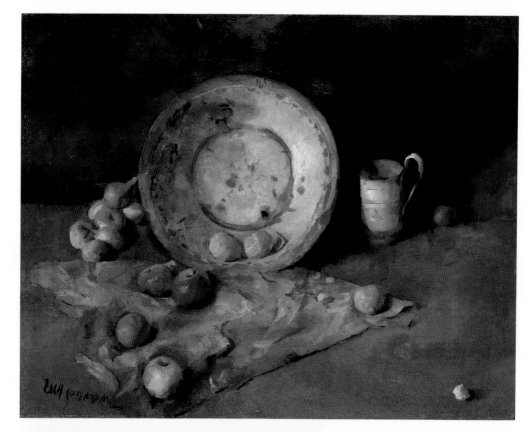

■

Plate 17.
William H. Johnson.
STILL LIFE. *1921–26.*
Oil on canvas, 25
× 31⅝". *The National*
Museum of American Art,
Smithsonian Institution,
Washington, D.C. Gift of
The Harmon Foundation

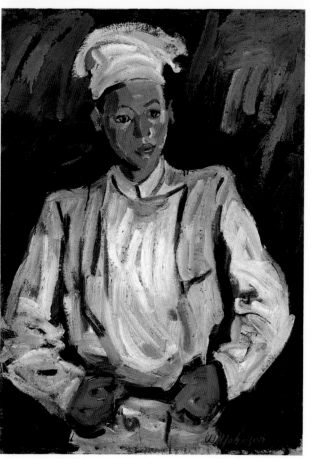

■

Plate 18.
William H. Johnson.
YOUNG PASTRY COOK.
c. 1927–28. Oil on
canvas, 31⅛ × 22⅛".
The National Museum of
American Art,
Smithsonian Institution,
Washington, D.C. Gift of
The Harmon Foundation

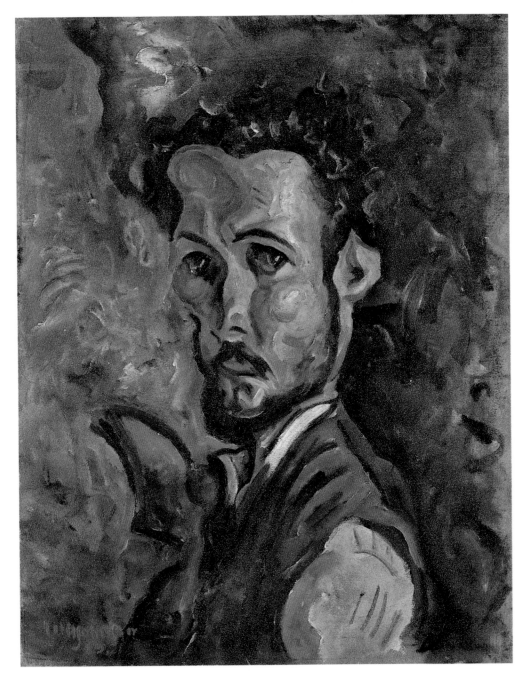

■

Plate 19.
William H. Johnson.
SELF-PORTRAIT. 1929.
Oil on canvas, 23
× 18½". The National
Museum of American Art,
Smithsonian Institution,
Washington, D.C. Gift of
The Harmon Foundation

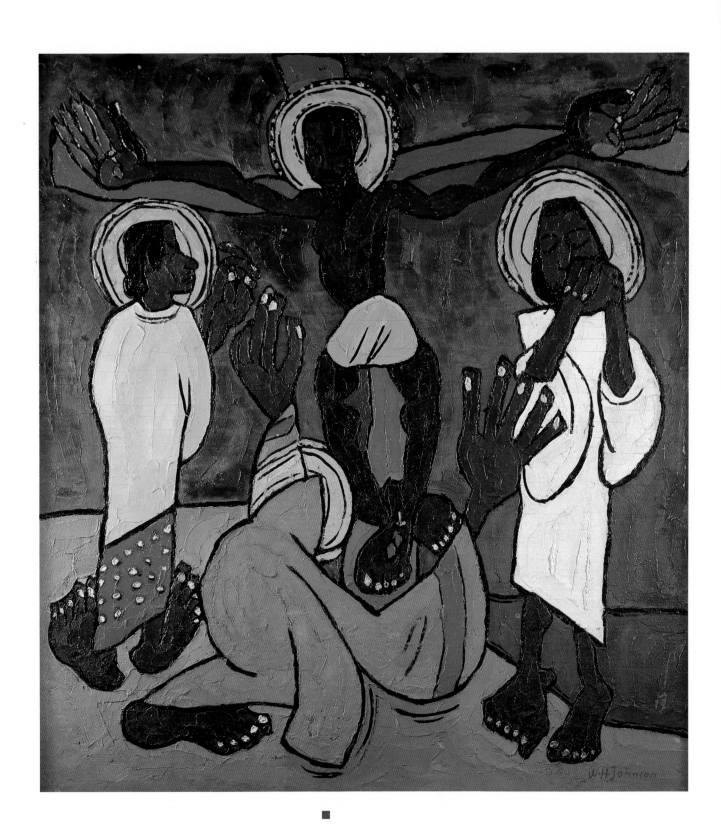

Plate 20.
William H. Johnson.
JESUS AND THE THREE
MARYS. *1935. Oil on
board, 37¼ × 34¼".
The Gallery of Art,
Howard University,
Washington, D.C.*

was natural and inevitable. A primitive race, transported into an Anglo-Saxon environment and held in subjection to that fundamentally alien influence, was bound to undergo the soul-stirring experiences which always find their expression in great art." Such well-meaning comments only contributed to a patronizing misinterpretation of the Harlem Renaissance. Other White critics were deliberately harsh. On the occasion of one of The Harmon Foundation's traveling exhibitions, a reviewer for the *New York American* referred to the artists as so "peculiarly backward, indeed so inept as to suggest that painting and sculpture are to them alien channels of expression."

The Harmon Foundation itself promoted a set of questionable attitudes. In organizing its segregated exhibitions, the foundation published catalogues in which it was argued that there were "inherent Negro traits"—a point of view that was condescending at the very least. The repertoire of Negro characteristics included "natural rhythm," "optimism," "humor," and "simplicity." And in linking the Black artist to Africa, the foundation was less concerned with the nobility of the African heritage than with the African personality as evidence of a natural primitivism that has "deeply rooted capacities and instincts capable of being translated into vital art forms." Perhaps the most telling evidence against The Harmon Foundation was the fact that the most daring and innovative works of many Harlem artists were completed outside the domain of Harmon patronage: Meta Fuller's *Ethiopia Awakening, Mary Turner,* and her 1939 *Talking Skull* (plate 27); Aaron Douglas's *Aspects of Negro Life,* completed as a project of the WPA; Palmer Hayden's John Henry series of the 1950s; and William H. Johnson's paintings from the 1940s.

The most scathing criticism, however, came from fellow Black writers and artists. The novelist Wallace Thurman referred to all of the principals of the Renaissance—visual artists and literary artists alike—as a "motley ensemble without cultural bonds." In his 1932 roman à clef, *Infants of the Spring,* a bitter satire of the Harlem Renaissance, he pictured the one Black visual artist as a self-destructive effete. Even more stinging chastisement came from the young Romare Bearden. About to embark on a career as a painter, Bearden wrote a commentary on the Harlem Renaissance artists in a 1934 essay entitled "The Negro Artist and Modern Art," which appeared in *Opportunity* magazine: "Their work is at best hackneyed and uninspired and is only a rehashing of the work of any artist who may have influenced them. They have looked at nothing with their own eyes—seemingly content to use borrowed forms. They have evolved nothing original or mature like the spiritual or jazz music." He counted among the reasons for these shortcomings the absence of a critical standard, the intervention of philanthropic societies like The Harmon Foundation, and the absence of ideology or social philosophy in their work. By the mid-1930s, the reputations of the Harlem Renaissance artists had plummeted.

Thurman's point of view was echoed by many during the Renaissance who saw Black American culture as essentially no different from American culture in general. The famous exchange between the poet Langston Hughes and the

■

Fig. 14.
*Malvin Gray Johnson
(1896–1934).*
POSTMAN. *1934. Oil on
canvas, 37½ × 30". The
Schomburg Center for
Research in Black
Culture, The New York
Public Library*

*Malvin Gray Johnson was
an early Harmon
Foundation award winner
whose scenes of Black life,
like those of Palmer
Hayden, presented a
glimpse of the day-to-day
rituals that organized
urban communities.*

*He clearly had looked
carefully at twentieth-
century modernism and
incorporated the flattened
space and surface design
elements into his
paintings. His early death
in 1934 was a real loss to
the Harlem Renaissance.*

editor George Schuyler in the pages of *The Nation* magazine in 1926 exemplified the debate. In his essay "The Negro Art Hokum" of June 1926, Schuyler argued that it was a farce to pretend that Black people were any different from other Americans and that all talk of a cultural Renaissance based on a separate culture was a hoax. Hughes responded the following week with "The Negro Artist and the Racial Mountain," in which he argued that there was a Negro soul, separate and distinct, molded by the special experience and heritage of Black people. The debate continues in more recent studies of the period. Nathan Huggins, in his outstanding and controversial study of the era, *Harlem Renaissance* (1971), built a substantive case against the Renaissance, calling it a "historical fiction."

History has been no kinder to the Harlem Renaissance artists. James A. Porter, a Howard University professor and prominent art historian, found little value in those artists who were inclined toward what he called Alain Locke's theory of "racial heritage." In his book *Modern Negro Art* (1943), whenever Porter found evidence of the expression of this heritage, he was quick to condemn the artists. Aaron Douglas, for example, came under attack for his "flat and arid angularities" and fanciful "exoticism." Although Palmer Hayden earned praise for his marine paintings and landscapes, Porter chastised him for his genre scenes of Black life. Calling them "tasteless" and akin to "ludicrous billboards that once were plastered in public buildings to advertise the Black race minstrels," he dismissed their folk-art style and content. And, of William H. Johnson, Porter expressed bewilderment at what he declared was Johnson's deliberate effort to be unintelligible. In part, he blamed The Harmon Foundation, whose juries encouraged artists to exploit racial concepts, and in part, he held Alain Locke responsible for what he considered aesthetic aberrations, since it was Locke who encouraged racial art with an emphasis on the African legacy. By the 1970s, Elsa Honig Fine, in *The Afro-American Artist*, a survey of Black art, dismissed the period almost completely, noting that Aaron Douglas "was the only Black artist of significance to emerge from the Harlem Renaissance." Thus, fifty years after the Harlem Renaissance the artists, falsely saddled with an aesthetic now considered obsolete, isolated by a segregated patronage system, and critically dismissed, had virtually disappeared from American cultural history.

Many of the judgments passed on the Harlem Renaissance artists were based on an unfortunate lack of evidence. The Harmon Foundation exhibitions, for example, were filled with a diverse range of material from amateur and professional artists alike. Even the award-winning artists were represented by only one or two examples of their work. At any given time, then, critics who reviewed the Harmon shows were looking at a largely indiscriminate mix of the best and the worst by Black artists. What is perhaps most perturbing about all of these critical assessments, however, is the fact that the Harlem Renaissance artists are rarely, if ever, discussed within the context of the crucible of ideas that was Harlem in the 1920s and 1930s. The interest in Black folklore on

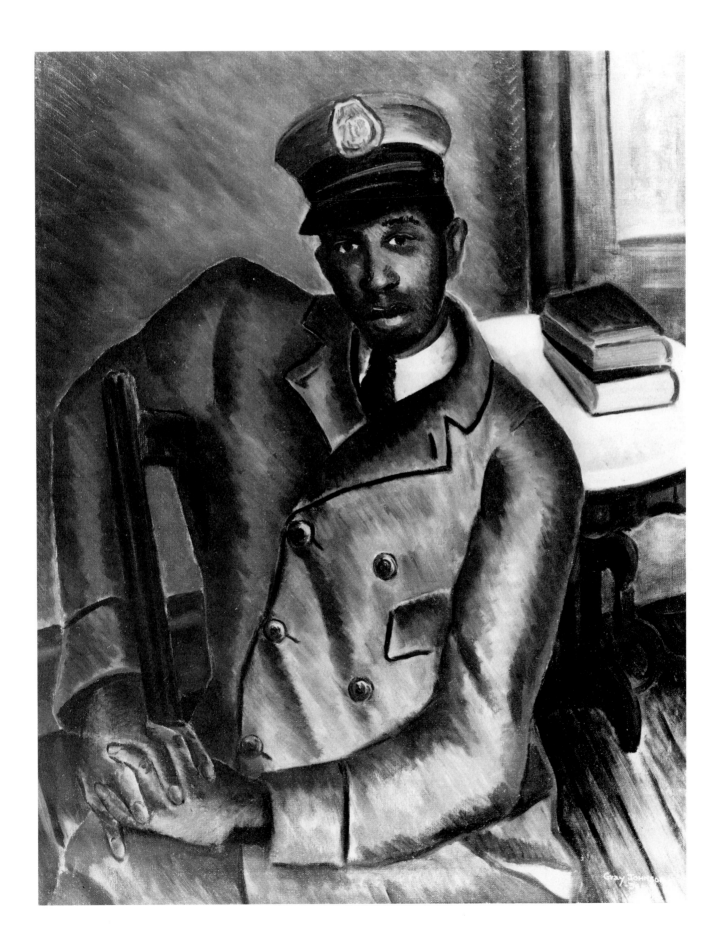

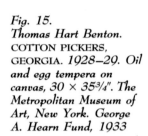

Fig. 15.
Thomas Hart Benton.
COTTON PICKERS,
GEORGIA. *1928–29. Oil
and egg tempera on
canvas, 30 × 35³⁄₄". The
Metropolitan Museum of
Art, New York. George
A. Hearn Fund, 1933*

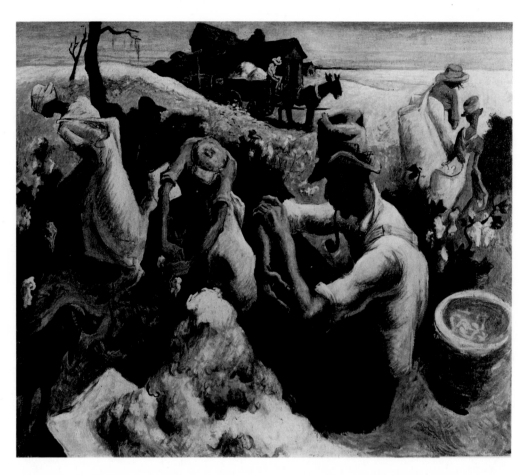

the part of writers like Hughes or Hurston, the messianic zeal of men like Arthur Schomburg, who sought to document the authentic Black American past, the political activism that inspired thousands of men and women to respond to a Marcus Garvey, the Pan-Africanist ideas of W.E.B. Du Bois, and, of course, the emergence of the first truly avant-garde American art form, jazz, were a vital part of the Black artists' consciousness. Images like Fuller's *Ethiopia Awakening,* Douglas's *Aspects of Negro Life,* Hayden's *The Janitor Who Paints,* or William H. Johnson's *Self-Portrait* (plate 19) all reflect the overwhelming, urgent search for identity so prevalent in the Harlem Renaissance.

Furthermore, the images are not discussed within the context of American art of the 1920s and 1930s, which was emphatically conventional. Even after the Armory Show attempted to introduce modern European artists to America in 1913, a strong nationalistic flavor was laced throughout American imagery of the 1920s. Although there was no mainstream, no dominant style or approach to art to speak of, as there would be after World War II, portrayal of the American character was a primary concern throughout the artistic community. Whether it was the boosterism of regionalists like Thomas Hart Benton, Grant Wood, or John Steuart Curry, the more somber critiques of the American life-style in the paintings of Edward Hopper (fig. 17) or Charles Burchfield, or the appreciation of industrial landscapes in the paintings of Charles Demuth or Charles Sheeler, the identity and expression of the American character was

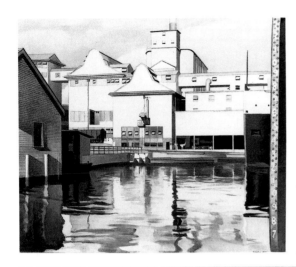

■

Fig. 16.
Charles Sheeler. RIVER
ROUGE PLANT. *1932.
Oil on canvas, 20 × 24".
The Whitney Museum of
American Art, New York*

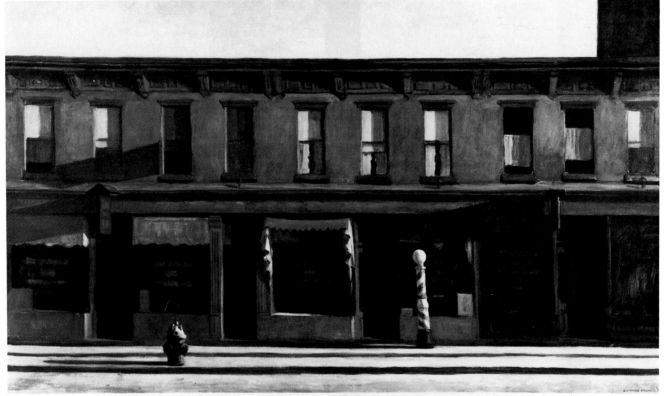

the leitmotif. A fruitful line of critical inquiry would compare Aaron Douglas's
and Thomas Hart Benton's solutions for epic historical narrative paintings
(plate 10 and fig. 3). Or ask how the images of urban life by Palmer Hayden
or Archibald Motley differ from those of Reginald Marsh or John Sloan (figs.
13, 20, 12, 19). And what, in fact, did William H. Johnson contribute to
the influence of primitivism in modern American expression?

The search for visual images—hewn from memory, experience, and history—
that convey a Black American identity is the achievement of the Harlem
Renaissance artists. In many ways the images of these artists created a watershed:
before the 1920s Black painters such as Henry O. Tanner and Edward Bannister
and the sculptor Edmonia Lewis rarely portrayed the day-to-day realities of

■

Fig. 17.
Edward Hopper. EARLY
SUNDAY MORNING.
*1930. Oil on canvas,
35 × 60". The Whitney
Museum of American Art,
New York*

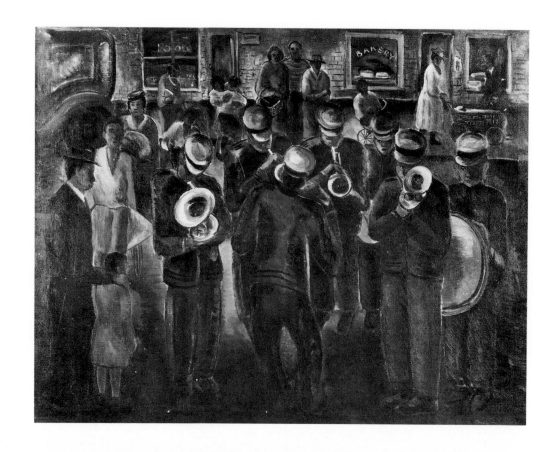

Fig. 18.
Malvin Gray Johnson.
ORPHAN BAND. 1934.
Oil on canvas, 30 × 38'
The Schomburg Center
for Research in Black
Culture, The New York
Public Library

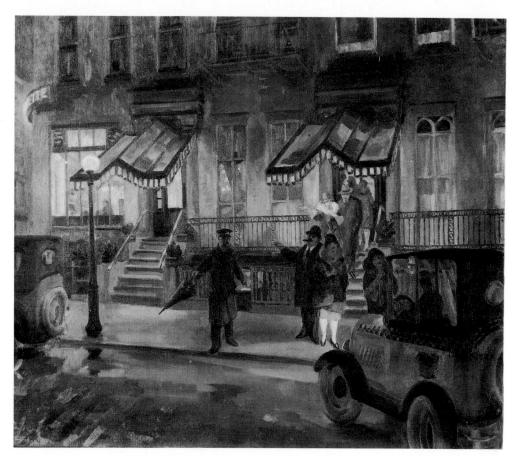

Fig. 19.
John Sloan. THE
LAFAYETTE. n.d. Oil on
canvas, 30½ × 36⅛".
The Metropolitan Museum
of Art, New York. Gift of
Friends of John Sloan,
1928

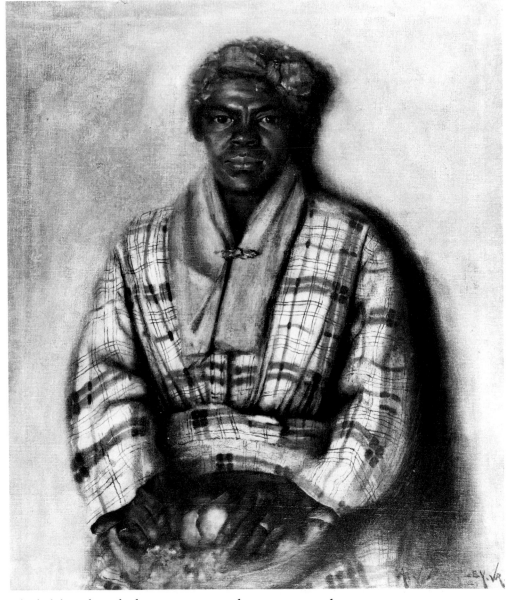

■

Fig. 20.
Archibald Motley.
WOMAN PEELING
APPLES. *1924. Oil on*
canvas, 32½ × 28". The
Schomburg Center for
Research in Black
Culture, The New York
Public Library

Black life. The Black community, when it appeared in American art, was most often represented in the works of White American artists. Winslow Homer, Eastman Johnson, and Thomas Eakins made use of aspects of Black life for their own aesthetic and iconographic purposes. Eastman Johnson's *My Old Kentucky Home* (1859), for example, is part of a pictorial tradition that defines slavery as a bucolic existence. The enlightened noblesse oblige of the former slave owner and the dignified humility of the former slaves in Homer's *A Visit from the Old Mistress* (1876) are not images which Black American artists had any part in creating. Often iconographically complex narratives, these images contrast sharply with the simplicity and directness of the images of Harlem Renaissance artists. Their work has the look of something new, something raw and deliberate, a tradition freshly crafted and conceived. If they contributed anything, they contributed the sense that for the first time the Black artist could take control of the images of Black America.

Harlem My Home

Almost everything seemed possible above 125th Street in the early 1920s. You could be Black and proud, politically assertive and economically independent, anarchic or disciplined—or so it seemed. The poet and novelist Arna Bontemps and his literary comrades made a wonderful discovery. They found that it was "fun to be a Negro" under certain conditions. "In some places the autumn of 1924 may have been an unremarkable season," Bontemps said. "In Harlem, it was like a foretaste of paradise. A blue haze descended at night and with it strings of fairy lights on the broad avenues." The Campus (as the intersection of 135th Street and Seventh Avenue was called) was the spot where English major Arthur Davis was more often found than on the campus of Columbia University. "One of the pleasures," wrote Davis many years later, "was seeing celebrities. Just around the corner, at 185 West 135th Street, lived James Weldon Johnson. Next door to him lived Fats Waller" (fig. 22). A stroll to the Lafayette Theater at 132nd Street led past the Tree of Hope, under which Davis often saw "such artists as Ethel Waters, [Noble] Sissle and [Eubie] Blake, Fletcher Henderson, and [Flournoy] Miller and [Aubrey] Lyles. It was truly bliss to be alive then."

The variety of things to do and see seemed enormous. There were the exhilarating Garveyite rallies at Liberty Hall, where the self-proclaimed Provisional President of Africa held forth before an audience of disciplined, uniformed thousands, defiantly proclaiming the demise of European imperialism and the imminent unity of African peoples. At the 135th Street YMCA, Columbia's John Dewey or the NAACP's William Edward Burghardt Du Bois might be speaking; or even Hubert H. Harrison, the learned West Indian who, as one Yale visitor to Harlem opined, "If he were White, he might be one of the most prominent professors at Columbia University." Tenured holder of a 135th Street soapbox, Hubert Harrison's enormous learning was eventually recognized by New York University, which granted him special lecturer status, and by the city's Board of Education, which made him a staff lecturer in 1926. Meanwhile, Harrison's book *When Africa Awakes* (1921) had an influence well beyond the audience of Marcus Garvey's UNIA (figs. 23, 51–54).

Dramatic productions at the "Y" were major happenings. Du Bois's Krigwa Players staged plays by Angelina Grimké, Willis Richardson, Georgia Douglas Johnson, Eulalie Spence, and other Black American talents, as well as Eugene O'Neill's controversial dramas. People flocked to these productions, for Harlem remembered how, in 1920, a reluctant Paul Robeson had taken part in the first revival of Ridgely Torrence's *Simon the Cyrenian* at the "Y." Torrence and

(opposite) *Fig. 21. James Van Der Zee.* PORTRAIT OF A WELL-DRESSED MAN WEARING WRISTWATCH. *1932. Silver print. Collection of The Schomburg Center for Research in Black Culture, The New York Public Library*

Fig. 22. Carl Van Vechten. JAMES WELDON JOHNSON (1871–1938). *1932. Hand gravure print. The Studio Museum in Harlem*

A founding father of twentieth-century Black American literature, Johnson was an author, poet, diplomat, songwriter, and self-educated lawyer. He wrote the lyrics to "Lift Every Voice and Sing" and established the first Black North American daily newspaper. Yale University's Afro-American archives were named in his honor by Carl Van Vechten, his close friend.

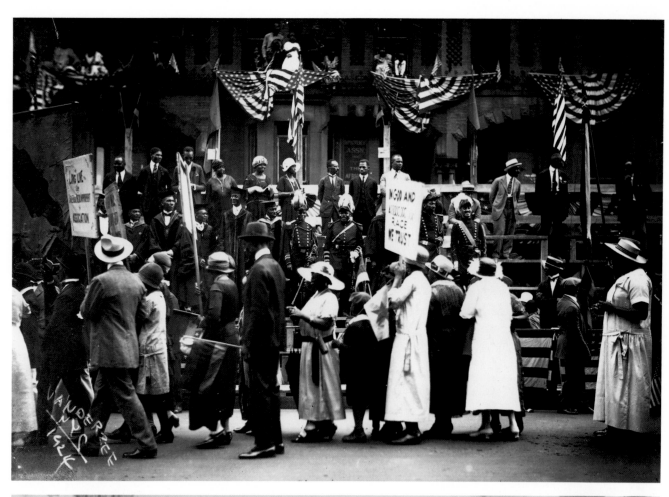

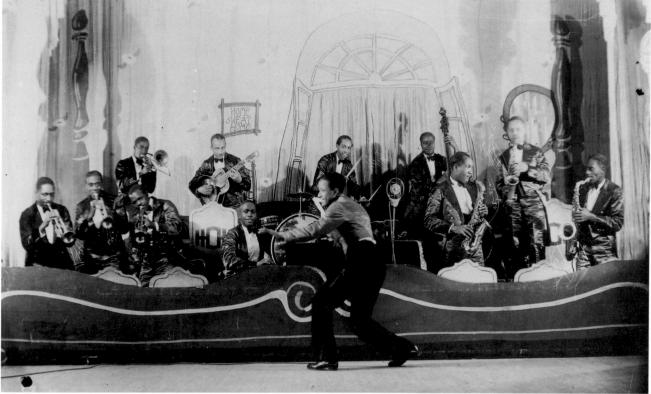

two other founders of an experimental theater, the Provincetown Playhouse, had rushed backstage after the show to offer Robeson the lead in O'Neill's new play, *The Emperor Jones.* "I went home and forgot about the theater," Robeson remembered, "and went back next morning to the law school as if nothing had happened." But the young and hungry actors of Harlem had not forgotten the story (fig. 28).

The intellectual pulse of Harlem was most accurately taken at the 135th Street branch of The New York Public Library (today's Schomburg Center), for there at evening readings of poetry, novels, and plays, the community's novices often received their first and most revealing assessments. Librarian Ernestine Rose, assisted by volunteers Jessie Fauset, Ethel Ray Nance, and Gwendolyn Bennett, organized and presided over these occasions, doing a great deal to make Harlem cultural life as intellectually discriminating as it was vital. Du Bois's Krigwa Players had their home at the library for a while, and Countee Cullen regularly declaimed verse there (fig. 36).

Just off Lenox Avenue, eight blocks above the library, was Arthur "Happy" Rhone's club. Happy Rhone was the first Black club owner to hire waitresses and the first to present floor shows in his plush upstairs establishment, fittingly outfitted with black-and-white decor. Noble Sissle himself often presided as master of ceremonies before an audience which might include John and Ethel Barrymore, Charlie Chaplin, W. C. Handy, Ted Lewis, and Ethel Waters. Happy Rhone practically invented the American nightclub—at least, he deserves to share the glory with Texas Guinan, the downtown entrepreneur to whom that honor is usually accorded. In any case, Harlem did for the nightclub what Detroit did for the automobile. In The Jungle (that is, 133rd Street) there was Pod's and Jerry's (The Catagonia Club), along with Banks's, Basement Brownie's, The Bucket of Blood, and comedian Bert Williams's favorite, Leroy's—places beyond the pale for "respectable" Harlemites. Barron's was the club for Whites and the small, but celebrated, Black sporting crowd. Connie's Inn and the new Cotton Club barred Blacks and were too expensive for most of them, anyway. To Harlem's aficionados the best clubs were the ones few downtown Whites knew about. Hayne's Oriental was a favorite of physician-writer Rudolph Fisher and Paul Robeson. There was also the fading Libya, of which it was said, "People you saw at church in the morning you met at the Libya at night." Above all, there was Smalls', which had a racially balanced clientele, roller-skating waiters, and probably the greatest atmosphere in Harlem.

Saturday nights were terrific in Harlem, but rent parties every night were the passion of the community. Yet these were also times, Willie "the Lion" Smith remembered, when "the average Negro family did not allow the blues, or raggedy music, played in their homes." In fact, though, after a sedate parlor gathering and after the cabarets closed, poets and writers (and even the occasional NAACP official) often would follow musicians to one of the nightly rent-paying rites. "If sweet mama is running wild, and you are looking for a Do-right child, just come around and linger," crooned an invitation to one such affair. Another,

Fig. 25.
Carl Van Vechten. W.E.B. DU BOIS (1869–1963). *1936. Hand gravure print. The Studio Museum in Harlem*

Pioneering organizer, educator, author, scholar, Du Bois is revered for his powerful leadership of the fight to obtain equal justice for Black Americans. Throughout this century, his manifold activities and published writings had a major impact in the United States, Africa, and Europe.

(opposite: above) *Fig. 23. James Van Der Zee.* UNIA PARADE WITH MARCUS GARVEY AND MEMBERS ON BANDSTAND. *1924. Silver print. The James Van Der Zee Collection*

(opposite: below) *Fig. 24. James Van Der Zee.* MUSICIANS ONSTAGE. *n.d. Silver print. The James Van Der Zee Collection*

Van Der Zee has drawn in a portion of the background and musical notes.

Fig. 26.
Carl Van Vechten.
LANGSTON HUGHES
(1902–1967). *1939. Hand gravure print. The Studio Museum in Harlem*

Hughes was perhaps the most widely published Black writer of his era. An important American poet and humorist, he wrote original works of all kinds—short stories, novels, essays, plays, children's books, and autobiography, as well as anthologies, translations, criticism, and journalism.

to Cora Jones's at 187 West 148th Street, urged, "Let your papa drink the whiskey / Let your mama drink the wine / But you come to Cora's and do the Georgia grind." Rent parties began anytime after midnight. Willie the Lion called them "jumps," "shouts," or "struts," where, for a quarter, "you would see all kinds of people making the party scene: formally dressed downtown society folks, policemen, painters, gamblers, lesbians, and high-styled entertainers of all kinds." At the hottest of these struts, along about 3 A.M., the tempo would quicken when Willie the Lion, James P. Johnson, Claude Hopkins, Fats Waller, or Corky Williams—even Edward Kennedy "Duke" Ellington—arrived palm-slapping and tuning up. Some musicians had to hire booking agents to handle this after-hours volume.

At a good rent party, everybody was a star. Soon, it almost seemed that to be a Harlemite was to be a star. The time was approaching when almost everybody above Central Park seemed to be writing for *The Crisis, Opportunity,* or *American Mercury* magazines, to be under contract to Boni and Liveright, Harper and Brothers, or Alfred A. Knopf, to be singing spirituals and lieder

at Aeolian Hall or Carnegie Hall, performing in sizzling Broadway revues or in significant dramatic roles, or heading for Paris to paint and sculpt. In his famous recollection, *The Big Sea*, Langston Hughes (fig. 26) captured this Harlem:

> It was a period when, at almost every Harlem upper-crust dance or party, one would be introduced to various distinguished White celebrities there as guests. It was a period when almost any Harlem Negro of any social importance at all would be likely to say casually: "As I was remarking the other day to Heywood"—meaning Heywood Broun. Or: "As I said to George"—referring to George Gershwin. It was a period when local and visiting royalty were not at all uncommon in Harlem.

To contemporary observers, Harlem arts and letters seemed to be the natural consequences of the great Black migration to the cities that began during World War I. The artistic ventures were widely considered to be little more than the latest creative bubble in the American melting pot: just as early twentieth-century New York City had had its Little Renaissance, and just as the previous century had had its literary flowerings of New England, Knickerbocker, Hoosier, and Yiddish traditions.

But artistic and literary Harlem was decidedly not the natural phenomenon it appeared to be. It was artifice imitating likelihood. Other sectional and ethnic literatures were robust when compared with the African American's. Slavery and segregation had made literacy a much pursued but far from realized Black American goal. Yale and Princeton dropouts heading for writing seminars in Paris cafés were invariably White. Although Claude McKay (fig. 27) or Jean Toomer or Hughes would have written poetry even if Harlem had remained indifferent to them, for others—the scores of unknown painters, sculptors, and writers who poured into Harlem in the 1920s—there would have been no moral and material support without the patient assemblage and management of substantial White patronage by a handful of Black American notables. Indeed, the artistic migration to Harlem would have been modest to negligible without the efforts of a half dozen or so prominent figures. Otherwise the Harlem cultural scene would have become little more than a larger version of Washington, D.C., or Philadelphia, places where arts and letters meant Saturday night adventures in tidy parlors, among mostly tidy-minded literati.

Principal among these Harlem notables were five men and one woman: Jessie Redmon Fauset at the NAACP's publication, *The Crisis*; Charles Spurgeon Johnson, sociologist and editor of the Urban League's *Opportunity*; Alain Locke, professor at Howard University (fig. 33); James Weldon Johnson and Walter Francis White, secretary and assistant secretary, respectively, of the NAACP; and the literate, self-effacing Caspar Holstein, Virgin Islands-born, numbers-racket king of Harlem, whose generous purse helped make possible the prestigious *Opportunity* prizes. Without these impresarios, the Harlem roster of

Fig. 27.
Carl Van Vechten.
CLAUDE McKAY (1891–
1948). *1941. Hand
gravure print. The Studio
Museum in Harlem*

McKay was a Jamaican who moved to Harlem. His lyrical poetry provided a model that helped encourage a new generation of Black poets. He was also a radical journalist who assailed exploitation and racism, and a novelist whose narratives celebrate working-class life.

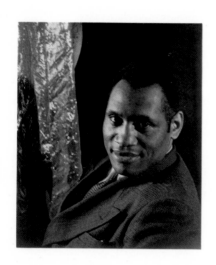

Fig. 28.
Carl Van Vechten. PAUL
ROBESON (1898–1976).
*1933. Hand gravure
print. The Studio Museum
in Harlem*

*At Rutgers and Columbia
Law School, Robeson's
extraordinary gifts—
athletic, intellectual,
musical, theatrical—gave
him an aura of heroism.
His accomplishments
brought him world fame,
but because of his
principled stands on
political and social issues,
he was forced to end his
career in the United
States against his wishes.*

twenty-six novels, ten volumes of poetry, five Broadway plays, innumerable essays and short stories, two or three performed ballets and concerts, and a large output of paintings, sculpture, and photography would have been considerably reduced.

In March 1924, Charles S. Johnson sent out invitations to almost a dozen young and mostly unknown poets and writers to dine at Manhattan's Civic Club on the evening of the twenty-first. The original notion had been an informal assembly to honor publication of Jessie Fauset's novel *There Is Confusion,* but Johnson had transformed the event into a major, well-advertised literary gala. "A group of the younger writers, which includes Eric Walrond, Jessie Fauset, Gwendolyn Bennett, Countee Cullen, Langston Hughes, Alain Locke, and some others," would gather at the Civic Club, Johnson wrote to Jean Toomer. About fifty other persons would attend: "Eugene O'Neill, H. L. Mencken, Oswald Garrison Villard, Mary Johnston, Zona Gale, Robert Morse Lovett, Carl Van Doren, Ridgely Torrence, and about twenty more of this type. I think you might find this group interesting, at least enough to draw you away for a few hours from your work on your next book." In all, 110 guests attended.

To most Black Americans nothing could have seemed more impractical as a means of advancing racial standing than the promotion of Black poetry, novels, and painting. Yet, Charles Johnson, along with Fauset, White, Holstein, James Weldon Johnson, and Locke, was keenly aware that some White writers had already found the Black American a marketable commodity. The signs were positive. From the older writers Lincoln Steffens and Van Wyck Brooks to the younger generation of Waldo Frank and Matthew Josephson, there existed a common belief that Western civilization had been badly wounded by runaway industrialism. "In literature alone," Brooks proclaimed, could the regeneration of America "have a substantial beginning." White rediscovery of Black Americans followed logically and naturally, for if the factory was dehumanizing, the university and the office stultifying, and the great corporation predatory, the Black American, excluded from factory, university, office, and corporation, was the ideal symbol of innocence and revitalization. "One heard it said," the writer Malcolm Cowley recalled, "that the Negroes had retained a direct virility that the Whites had lost through being overeducated."

This new White fascination with Black America had most notably announced itself in 1917, when Emily Hapgood produced her husband, Ridgely Torrence's dramatic trilogy, *The Rider of Dreams, Simon the Cyrenian,* and *Granny Maumee,* with Black actors at the old Garden Theater. When Eugene O'Neill's *The Emperor Jones* followed three years later, the public was keener than ever to see the fashionable Black themes developed. In the summer of 1921, Flournoy Miller and Aubrey Lyles presented *Shuffle Along,* the first postwar musical with music, lyrics, dance, cast, and production entirely by Blacks. Mary Hoyt Wiborg's *Taboo* followed, with Paul Robeson in the starring role. And at the very moment Charles Johnson's Civic Club invitations were being received,

New Yorkers, White and Black, were caught up in controversy over O'Neill's play about miscegenation, *All God's Chillun Got Wings,* again starring Paul Robeson (by now a law school graduate).

Despite understandable misgivings about the new White curiosity, Harlem intellectuals and leaders generally applauded the developments. As literary critic Benjamin Brawley remarked to James Weldon Johnson, "We have a tremendous opportunity to boost the NAACP, letters, and art, and anything else that calls attention to our development along the higher lines." Charles Johnson fully understood this. He intended to use the unique situation for a Black American breakthrough, a display of artistic talent and discipline that would win for his people at least some of the rights denied them. The moment seemed near during the memorable evening of March 21, at the Civic Club. The master of ceremonies was Rhodes Scholar Alain Locke, and the principal speaker was W.E.B. Du Bois. His generation, Du Bois told this new generation of writers, had been denied its true voice. But, he challenged, the time for the end of the literature of apology had finally come. James Weldon Johnson rose to respond to the audience's praise for him as a precursor who had given "invaluable encouragement to the work of this younger group." Carl Van Doren, the White editor of the influential literary magazine *Century,* eloquently professed "a genuine faith in the future of imaginative writing among Negroes in the United States." He concluded: "What American literature decidedly needs at this moment is color, music, gusto, the free expression of gay or desperate moods. . . . If the Negroes are not in a position to contribute these items, I do not know what Americans are."

When the historic dinner was over, Paul Kellogg, the White editor of *Survey Graphic,* a mainstream cultural magazine, approached Charles Johnson with an unprecedented offer. He wanted to devote an entire issue of his magazine to these artists. Johnson eagerly accepted. Locke was made editor for the enterprise. Johnson also decided that these newly arrived artists and writers needed an established forum with its own rules, standards, and rewards, and his September *Opportunity* editorial announced the new *Opportunity* prizes for outstanding achievement, to be presented for the first time the following May. Shortly thereafter, *The Crisis* announced it was establishing comparable literary prizes, to be sponsored by the NAACP. Meanwhile, the special issue of *Survey Graphic* appeared, entitled "Harlem: Mecca of the New Negro." Locke's opening essay, "Harlem," predicted the community would have "the same role to play for the New Negro as Dublin has had for the New Ireland or Prague for the New Czechoslovakia."

In May 1925, 316 people attended the elegant *Opportunity* prize dinner at the Fifth Avenue Restaurant. Prizewinners included Hughes, Cullen, Sterling Brown, E. Franklin Frazier, Zora Neale Hurston (fig. 29), Eric Walrond, Frank Horne, and John Matheus. Hughes's acclaimed "The Weary Blues," read by James Weldon Johnson, transfixed the gathering and brought Carl Van Vechten, the former music critic for the *New York Times,* trotting to the poet's

Fig. 29.
Carl Van Vechten. ZORA NEALE HURSTON (1903–1960). *1935. Hand gravure print. The Studio Museum in Harlem*

A novelist, folklorist, and anthropologist prominent during the Harlem Renaissance, Hurston wrote Mules and Men, Their Eyes Were Watching God, *and other important works. After writing a number of books that celebrated Blacks, her life of fame, travel, and adventure ended in poverty.*

Fig. 30.
James Van Der Zee.
DINNER PARTY WITH
BOXER HARRY WILLS.
1926. Silver print. The
James Van Der Zee
Collection

Harry Wills was called
"The Black Panther"
during the 1920s. He
was active in the ring for
twenty-two years. Wills
retired from boxing in
1932 to enter the real-
estate business in Harlem.

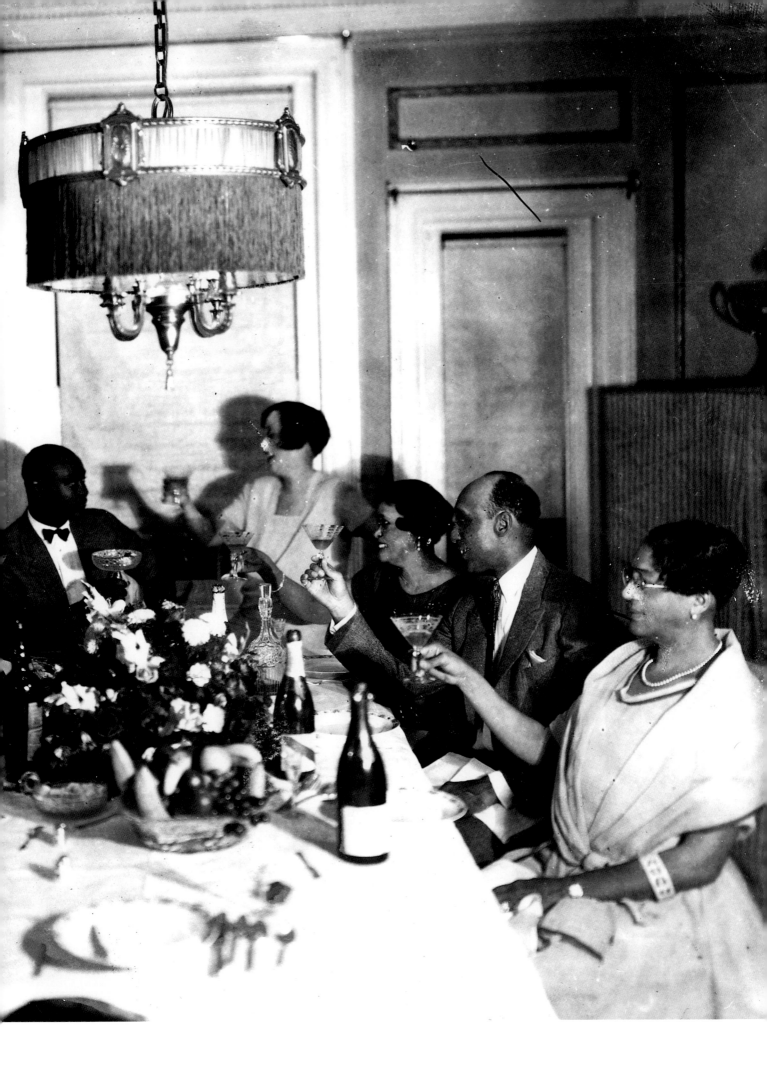

side to offer him a contract with Knopf (fig. 32). A week later, the *Herald Tribune* gave the literary ferment its name. In a reference to the Fifth Avenue Restaurant evening, it predicted that America was "on the edge, if not already in the midst of, what might not improperly be called a Negro renaissance." The year ended with publishers Albert and Charles Boni's release of Locke's *The New Negro,* an expanded and much polished offering of poetry and prose generated by the *Opportunity* contest and the special *Survey Graphic* edition.

The New Negro contained distinctive Egyptian-style silhouettes and geometric shapes by Aaron Douglas. No other artist would express the Renaissance themes of racial talent and confidence more faithfully—even didactically—than he. With the notable exceptions of Asa Randolph, editor of the iconoclastic and somewhat socialistic *Messenger* magazine, George Schuyler, and Wallace Thurman, Locke's thirty-four Black (and four White) contributors included almost all the future Harlem Renaissance regulars. They constituted an astonishingly tiny band of artists, poets, essayists, and novelists upon which to base, as Locke did, the assertion that the race's "more immediate hope rests in the revaluation by White and Black alike of the Negro in terms of his artistic endowments and cultural contributions, past and prospective." It was heady stuff, but the times were intoxicated with optimism. Harlem was beginning to turn its back on Garvey's grandiose but electrifying movement in order to admire Phi Beta Kappa poets, university-trained painters, concertizing musicians, and novel-writing civil rights officials. "No sane observer, however sympathetic to the new trend, would contend that the great masses are articulate as yet," Locke's *Survey Graphic* preface had conceded. "But they stir, they move, they are more than physically restless. The challenge of the new intellectuals among them is clear enough." Fittingly, Locke quoted lines from Langston Hughes:

> We have tomorrow
> Bright before us
> Like a flame
> Yesterday, a night-gone thing
> A sun-down name
> And dawn today
> Broad arch above the road we came
> We march!

And march they continued to do. By summer 1926, Harlem writings already included Toomer's *Cane* (1923), Fauset's *There Is Confusion* (1924), White's *Fire in the Flint* (1924) and *Flight* (1926), volumes of poetry by Hughes, *The Weary Blues* (1926), and Cullen, *Color* (1925), as well as Claude McKay's path-breaking novel, *Harlem Shadows* (1922). The mysterious and lovely Virgin Islander Nella Larsen was hard at work on *Quicksand,* her fine, existential novel. Du Bois was busy with *Dark Princess,* his hefty, didactic novel about

■

(opposite) *Fig. 31. James Van Der Zee.* TWO MEN READING. *1922. Silver print. The James Van Der Zee Collection*

■

Fig. 32. CARL VAN VECHTEN. *n.d. Silver print. The Schomburg Center for Research in Black Culture, The New York Public Library*

global race solidarity, as was the young physician Rudolph Fisher with his sprightly *The Walls of Jericho,* a superb social satire. *Tropic Death,* Eric Walrond's scintillating collection of short stories was already at his publishers, Boni and Liveright. Indeed, the third year of the *Opportunity* awards, 1927, was a vintage one for Black American poetry, with the panel of distinguished judges hard-pressed to rank entries by Arna Bontemps, Sterling Brown, Helene Johnson, Hughes, and the now forgotten Jonathan H. Brooks. The White literary critic Robert T. Kerlin marveled in *The Southern Workman* that he had "just finished reading the poems submitted to *Opportunity.* . . . Acquainted as I am with Negro literature, I was not prepared for this abundance of excellence." Kerlin was not only ecstatic for literary motives, but for the singularly libertarian motive that, as he concluded, "It [Black American verse] is hostile to lynching and to jim-crowing."

Most Black leaders, despite occasional doubts increasingly voiced by Du Bois, in particular, were equally confident of the power of the muses to heal social wrongs. Locke's attempt to invest the arts with great civil rights potency had already been eloquently expressed in *The New Negro.* In every issue of *Opportunity,* or even in the *Messenger,* as well as in the gossipy *Inter-State Tattler, Amsterdam News,* and *Chicago Defender,* the refrain of racial salvation through artistic excellence was sounded, at least until the early 1930s. That some of what the picaresque, Utah-born, and California-educated Wallace Thurman called the "Niggerati" were painfully naive in supposing the dramatic triumphs of Paul Robeson, the literary artistry of Jean Toomer and Countee Cullen, the musical magnetism of Hall Johnson, or the elegant, interracial soirees at A'Lelia Walker's Dark Tower and Carl Van Vechten's Downtown could be catalysts for voting rights, jobs, and housing now seems beyond dispute. But long before academic and activist critics in the 1960s diminished the social value of the Harlem Renaissance as an exercise in Black bourgeois egocentrism and meliorism, some of the Niggerati themselves had already expressed serious doubts about what they were accomplishing.

There were considerable risks for those who openly criticized the arts-cum-civil rights creed of the NAACP and Urban League—jeopardizing concert performances, publishing contracts, and foundation grants. At first, the critics nibbled rather than bit the organizational hands that fed them, but increasingly these mostly younger artists became dissatisfied with their fealty. Art, they began to say, was not primarily about politics and race relations, but about truth—authenticity. Moreover, the faithful portrayals in song, prose, and canvas of Black people might, as Langston Hughes suggested in his eloquent 1926 essay for *The Nation,* "The Negro Artist and the Racial Mountain," do more in the long run to bring about a less racially benighted world than all the energies of the Black cultural establishment.

Fire!!, a quarterly "Devoted to the Younger Negro Artists," caught Black America by surprise in November 1926. Professor Brawley found it so offensive as to predict that if "Uncle Sam ever finds out about it, it will be debarred

Fig. 33.
Carl Van Vechten. ALAIN LOCKE (1886–1954). *1941. Hand gravure print. The Studio Museum in Harlem*

A philosopher who educated his students and the public about African and Black American aesthetic achievements, Locke championed the young artists and writers of the Harlem Renaissance, whose aims he set forth in The New Negro *in 1925. A Harvard graduate and Rhodes Scholar, he taught at Howard University.*

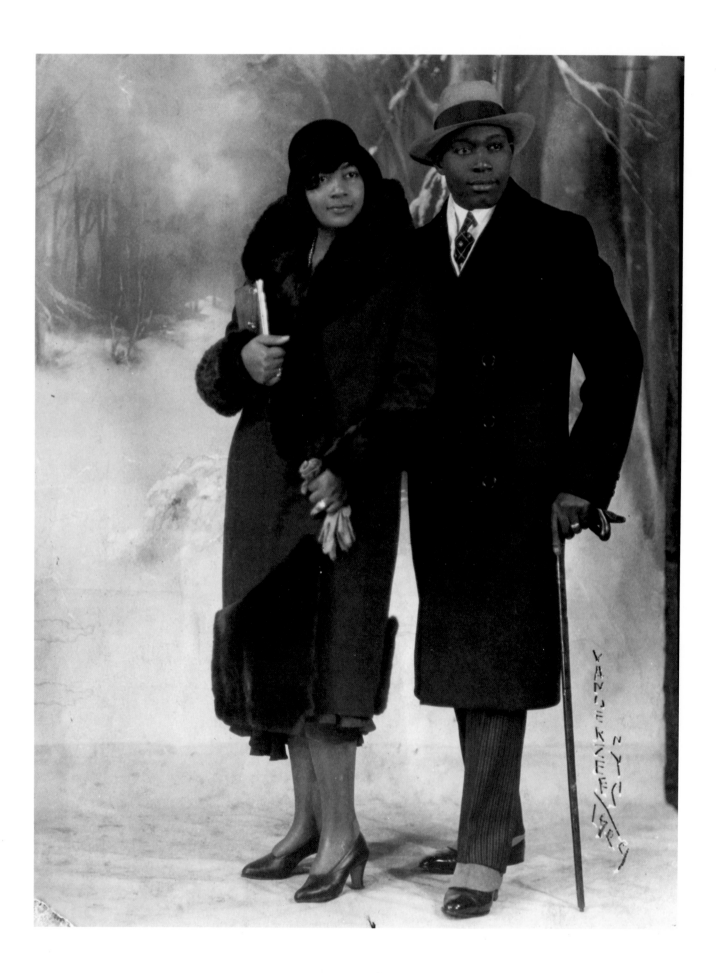

from the mails." A friend wrote Cullen that mere mention of *Fire!!* to Du Bois hurt *The Crisis* editor's "feelings so much that he would hardly talk to me." At Craig's, the restaurant hangout of literary Harlem, the magazine's contributors were given the silent treatment by all, including the visiting Paul Robesons. "I have just tossed the first issue of *Fire!!* into the fire," sniffed the literary editor for the Baltimore *Afro-American. Fire!!*'s publisher, Wallace Thurman, had devoted every spare hour and dollar to the publication, editing manuscripts with his friend the caricaturist and literary dilettante Richard Bruce Nugent, planning layouts at Aaron Douglas's, holding meetings in Zora Neale Hurston's quarters at her famous novelist-employer's, Fannie Hurst, and going deeply into personal debt. From his rent-free lodgings on 136th Street—the soon infamous 267 House—the revolt of the young artists was launched against the established cultural canons of the Urban League and the NAACP. Langston Hughes's extraordinary declaration of artistic independence in "The Negro Artist and the Racial Mountain," had been a terrific catalyst for the revolt, as had Van Vechten's explosive novel of Harlem high and low life, *Nigger Heaven.* "Let the blare of Negro jazz bands and the bellowing voice of Bessie Smith singing the Blues penetrate the closed ears of the colored near-intellectuals until they listen and perhaps understand," Hughes challenged. "We younger Negro artists who create now intend to express our dark-skinned selves without fear or shame" (fig. 42).

Wallace Thurman's 267 House artists—Hurston, Arthur Huff Fauset, Gwendolyn Bennett, Waring Cuney, Nugent, Douglas, and Hughes himself—were fully in tune with what Hughes described as "those elements within the race which are still too potent for easy assimilation" and which the elites want "hidden until they no longer exist." Now was the time, the *Fire!!* artists proclaimed, to feature honestly those supposedly unassimilable elements. "The way I look at it," Hurston confided, *"The Crisis* is the house organ at the NAACP and *Opportunity* is the same to the Urban League. They are in literature on the side." Thurman meant to shock. Aaron Douglas's illustrations placed an uncomfortable emphasis on things African, while Nugent's drawings of Nordic-featured figures with Negroid hair mocked the assimilationist obsessions of many middle-class Black Americans, as did Arthur Fauset's sociological essay, which analyzed Black middle-class pretensions. Hughes's poem "Elevator Boy" and the short stories by Thurman and Hurston, "Cordelia the Crude" and "Sweat," respectively, were bluntly realistic, slice-of-life depictions. But Nugent's impressionistic piece "Smoke, Lillies, and Jade" was like nothing published before by a Black American writer, a hymn to androgyny, drugs, and creative decadence. "Beauty rather than propaganda," Du Bois warned the artists, could, if taken too far, "turn the Negro renaissance into decadence."

Respectable Harlem ignored *Fire!!* It died after one issue. But respectable Harlem could not ignore McKay's *Home to Harlem,* released by Harper and Brothers in the spring of 1928. Within two weeks it became the first novel by a Harlem writer to reach the best-seller list. Du Bois, after reading it,

Fig. 34.
James Van Der Zee.
PORTRAIT OF COUPLE, MAN WITH WALKING STICK. *1929. Silver print.*
The James Van Der Zee Collection

This studio portrait is enhanced by the use of a backdrop painted to resemble the English countryside.

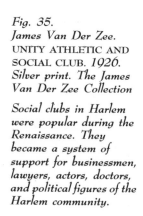

Fig. 35.
James Van Der Zee.
UNITY ATHLETIC AND
SOCIAL CLUB. 1926.
Silver print. The James
Van Der Zee Collection

Social clubs in Harlem
were popular during the
Renaissance. They
became a system of
support for businessmen,
lawyers, actors, doctors,
and political figures of the
Harlem community.

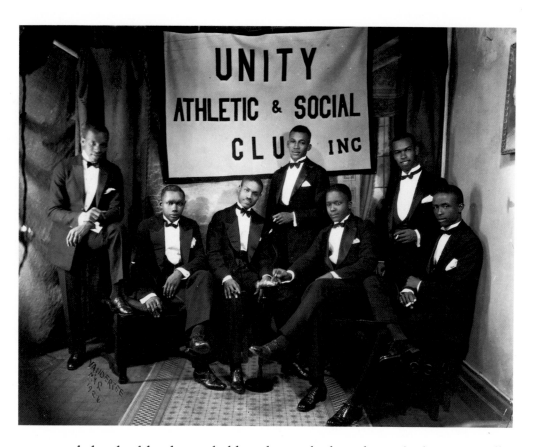

announced that he felt "distinctly like taking a bath." The *Defender* was equally aggrieved, but *Home to Harlem* finally shattered the enforced literary code of the civil rights establishment. In McKay's novel, primitivism triumphs. No graduates of Howard and Harvard discourse on literature at A'Lelia Walker's or Jessie Fauset's; there are no readily recognizable imitations of Du Bois, James Weldon Johnson, or Locke—and no Whites at all. Du Bois said that instead of portraying Black America's talented tenth, the novel was about the "debauched tenth." *Home to Harlem* was ostentatiously plebeian. In Jake, the protagonist, McKay created a Lenox Avenue noble savage in order to demonstrate the superiority of the Negro mind uncorrupted by Western learning.

The assertive energy of the New Negro Movement was now evident throughout the land. In just about every good-sized city, earnest little bands of culture nurturers drew up bylaws, politely heard each other's book reports, and, if truly ambitious, tithed themselves to underwrite a literary publication. In Boston, the Quill Club launched the *Saturday Evening Quill;* in Philadelphia, the literati published *Black Opals,* one of the most promising of the little reviews of the early 1920s; in Cleveland, the literary club benefited from the presence of the premier Black novelist, Charles Chesnutt, and his daughter Helen; and in Washington, Georgia Douglas Johnson's Saturday Nighters were almost as lively as the earlier salon occasions Mabel Dodge presented in New York at the turn of the century. But, incontestably, Harlem was Black America's Paris.

The mid-1920s solidified the Harlem Renaissance. Most of the signs of the times were enormously encouraging. Where arts and letters had been mainly

supported by the Urban League and the NAACP, there now sprang up a number of prizes and fellowships officially sponsored by White benefactors, businesses, and foundations. Rosenwald and Guggenheim fellowships became available. Where, before, Harlem had conducted its interracial activities with judiciousness, under the patronage of the James Weldon Johnsons and the Walter Whites, the community now began to reciprocate the generosity of the downtowners, party for wicked party. When only a few years back Harlem's popular music had been held in low esteem by many Black bandleaders, its clubs were now rapidly becoming laboratories of a new type of jazz, even attracting the great masters of New Orleans and Chicago, as well as hordes of excited, uninitiated Whites. And there was now an explosion of books, plays, and musicals about Black Americans by Whites.

When Sir Osbert Sitwell arrived in New York in late 1926, he observed that no one was sober, and everybody seemed to be as rich as Croesus. "Never have so many rich people been crowded together in so minute a space," he believed. "The torrent of prosperity swept on. Colored people offered hospitality as much as White," and to Sitwell's astonishment the conspicuous consumption of Park Avenue extended to Harlem. After merriment at Mrs. Cornelius Vanderbilt's Fifth Avenue chateau, Sir Osbert found himself at A'Lelia Walker's town house on West 136th Street. Her twin brownstones flaunted their mistress's wealth with their marble entrance hall, French gold-and-buff rooms, and Aubusson carpets beneath Louis XVI furniture. But A'Lelia Walker's imposing home was only one of Harlem's grand addresses. Stanford White's turn-of-the-century Italianate houses under the trees on 138th and 139th Street—Striver's Row—were architectural masterpieces and addresses of distinction. Not as rich as A'Lelia, the bandleaders, dentists, prizefighters, and surgeons who had almost entirely displaced the original White residents were nonetheless persons of considerable affluence and reputation.

A'Lelia—A'Lelia Walker Robinson Wilson, for she had already taken unto herself and rapidly shed two husbands—had been left the controlling interest in a hair-straightening empire, along with a palace on the Hudson, rental properties in and outside New York City, the 136th Street brownstones (with the Walker beauty culture salon at ground level), and nearly a million dollars in cash. A'Lelia was not beautiful (certainly not by the color-dominated standards of her day), but she managed, by carriage and dress (erect, tall, jewel-turbaned, and riding crop often in hand), always to appear striking. She was, testimony reveals, somewhat blunt (though never vulgar). She received the Harlem artists and sent them congratulatory notes, but spent most of the Renaissance playing bridge. Her parties were attended by English Rothschilds, French princesses, Russian grand dukes, members of New York's social register and the stock exchange, Harlem luminaries, prohibition and gambling nobility, and a fair number of stylishly attired employees of the U.S. Post Office and the Pullman Corporation. Her party at which Whites were seated apart and served chitterlings and bathtub gin and the Blacks caviar and champagne was

■

Fig. 36.
Carl Van Vechten.
COUNTEE CULLEN
(1903–1946). *1941. Hand gravure print. The Studio Museum in Harlem*

Educated at New York University and at Harvard, Cullen was considered by many to be the major poet of the Harlem Renaissance. In addition to his elegant poetry, he wrote novels and plays. For many years he taught French at Frederick Douglass Junior High School in Harlem.

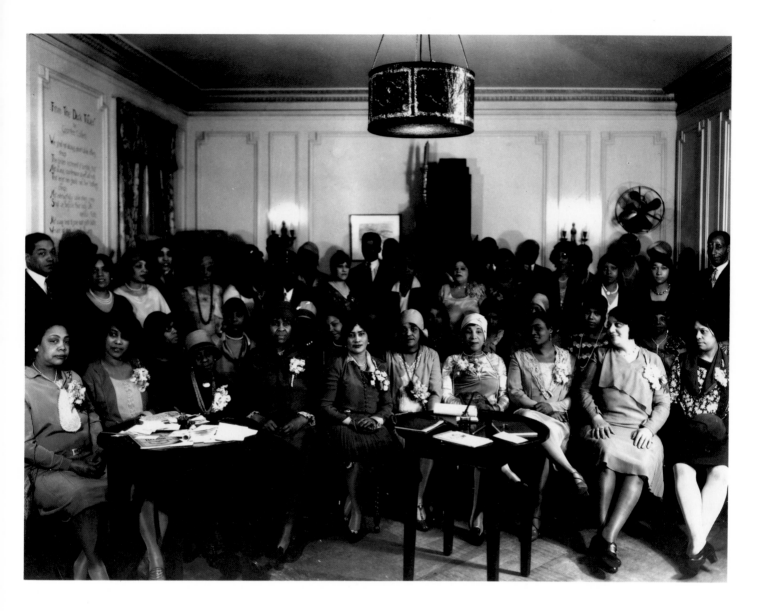

■

Fig. 37.
James Van Der Zee.
GROUP PORTRAIT IN
THE DARK TOWER. *n.d.*
Silver print. The James
Van Der Zee Collection

The Dark Tower, a salon
in heiress A'Lelia
Walker's town house on
West 136th Street,
became an extravagant
social forum for the
fashionable Black elite.
Poems by Langston
Hughes and Countee
Cullen were painted on
the walls of The Dark
Tower by a local sign
painter.

famous in New York society lore. The evening Sir Osbert visited, he shook hands with a distinguished gentleman who very likely may have been Du Bois, admired the luxury of the grand salon—"a tent room, carried out in the Parisian style of the Second Empire"—and was whisked upstairs to meet a tired A'Lelia, complaining of new shoes and new husbands over a beaker of champagne.

A'Lelia decided to go in for culture in a big way in the fall of 1927. Gathering several of the artists and writers at her hideaway Edgecombe Avenue apartment, she offered to convert part of her 136th Street town house into a setting for cultural intercourse. Nugent and Douglas were to decorate the new space. Nugent suggested calling it "The Dark Tower," after Cullen's famous poem of the same name. The name stuck, but plans and schedules were muddled by too much bonded gin and adverse temperaments whenever the artists met at A'Lelia's. Finally, the heiress had the room done by a noted Manhattan decorator. The gold French wallpaper contrasted strikingly, but not discordantly,

with the huge, modern bookcase and the red chairs and tables. On one wall hung the framed text of "The Dark Tower," on the opposite, Hughes's "The Weary Blues" (fig. 37). But when the room finally opened in 1928, A'Lelia had modified her original idea. Instead of the squabbling, freeloading artists and writers, there were the rich, the prominent, and the striving. "Those engraved invitations should have warned them," Nugent recalled of the opening night surprise in store for the artists:

> *The large house was lighted brilliantly. There was an air of formality which almost intimidated them as singly and in pairs they arrived. . . . The great room and hall was a seething picture of well-dressed people. Everyone had worn evening clothes. One of the artists was nearly refused admission because he had come with open collar and worn no cravat, but someone already inside fortunately recognized him and he was rescued. . . . Colored faces were at a premium, the place was filled to overflowing with Whites from downtown who had come up expecting that this was a new and hot night club.*

Fig. 38.
Carl Van Vechten. ROSE McCLENDON (1884–1936). *1932. Hand gravure print. The Studio Museum in Harlem*

"First Lady of the Negro Theater," a playwright and founder of the Negro People's Theatre in Harlem, McClendon created roles in important plays of the 1920s and 1930s and was the principal crusader for the advancement and appreciation of Black talent in the legitimate theater.

However much it may have resembled opening night at the new Savoy Ballroom on Lenox Avenue, between 140th and 141st streets, The Dark Tower was not a hot, new night spot. Yet, in a meaningful sense, The Dark Tower and the Savoy were also versions of the same phenomenon: the upsurge of Black American self-confidence and creativity. Often quarreling bitterly among themselves, Garveyites, neo-Bookerites, socialists, utopians, and all manner of integrationists fully shared what might be called Harlem nationalism—the proud certainty that the dynamism of the "World's Greatest Negro Metropolis" was somehow a guarantee of ultimate racial ascendancy. Nowhere in America were ordinary people more aware of the doings of artists and actors, composers and musicians, painters and poets, sculptors and singers, and of their literary and academic writers than in the Harlem of the middle and late 1920s. Newspapers, periodicals, and civil rights monthlies shared with readers every possible item of cultural gossip and success, much of it as overblown as it was unanalyzed. Street-corner orators inserted into their political harangues news of McKay's European wanderings, Zora Hurston's anthropological junkets, or Walter White's Guggenheim fellowship.

The Dark Tower was the social forum for the elite. The Savoy was everybody's forum; there, class lines were as blurred as the sheer energy was intense. The Savoy opened on March 12, 1926. It had a dazzling spacious lobby framing a huge, cut-glass chandelier and marble staircase, an orange-and-blue dance hall with a soda fountain, tables, and heavy carpeting covering half its area; the remainder a burnished dance floor, 250 feet by 50 feet, with two bandstands and a disappearing stage at the end. Four thousand people could be entertained at one showing; two thousand fewer than the Rockland Palace (the old Manhattan Casino), but many more than the half-dozen other competitors. Neither

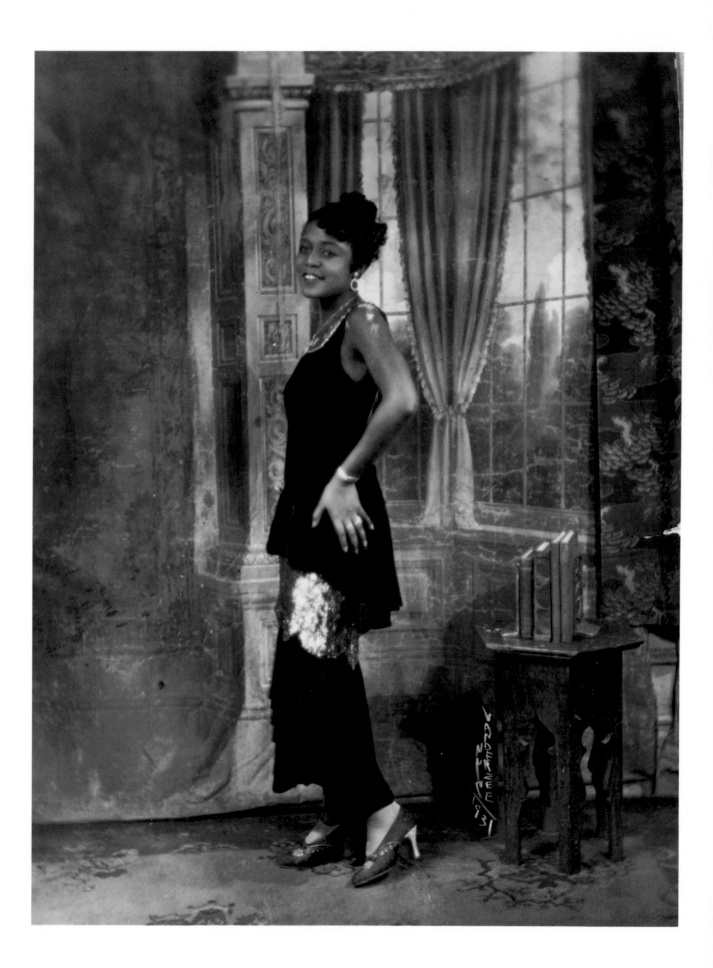

the Alhambra nor the Renaissance regularly evoked as much pure joy from Harlem as when there was "stompin' at the Savoy." The memorable opening night was pandemonium. "You will be bombarded with a barrage of the most electrifying spasms of entertainment ever assembled under one roof," the publicity bragged. The hour of delirium came after the crowd had been revved up by Fess Williams's Royal Flushers, the Charleston Bearcats, and Eddie Rector's band. At 1:30 A.M., Fletcher Henderson's Rainbow Orchestra arrived to an ovation (its gig at the Manhattan Casino had just ended), and when its wiry little conductor finally led the men through the last number, the brand-new building seemed to shift on its foundations.

Fletcher Henderson was New York jazz in the flesh, and New York jazz was soon to be the dominant school as far as the record-buying public was concerned. New York jazz was big-band music, with its roots in the showy, fast-paced one-hundred- and even two-hundred-piece orchestras of the late James Reese Europe's prewar Clef Club. Scores of Jim Europe's musicians were now the leavening of many major musical efforts in Black America. In the late 1920s, when Fletcher Henderson's bands were among the most sought-after in the country and he was too successful (or too unhinged from an automobile accident) to care much, his musical arrangements became jumpier and stickier. The line between Henderson's music and Paul Whiteman's (to whom he lost some of his best players) grew thinner. Yet Fletcher Henderson was a pioneer of both "hot" and "sweet" jazz. At his best, he was just shy of being truly innovative, as he showed with his brilliant reworking of King Oliver's "Dippermouth Blues" into "Sugar Foot Stomp," first recorded in May 1925, and the classic model for the New York style. The swing that would become the trademark of Artie Shaw and Benny Goodman was there all along in Henderson's arrangements.

There had been no jazz in Henderson's background before he came to New York. His father was principal of a small-town Georgia high school; his mother, a pianist of local distinction. Cautious, aloof, a bachelor of science in chemistry from Atlanta University, Henderson arrived in New York in 1920 at twenty-two and went to work for the Pace and Handy Music Company as a music demonstrator. When the then unknown Ethel Waters met him in early 1921, "sitting behind a desk and looking very prissy and important," Henderson had never even heard of the great pianist-composer James P. Johnson. But until the end of the 1920s, the national jazz sound was to be the swinging syncopation of Henderson's orchestra—with the Cotton Club orchestra of Duke Ellington placing a close second.

In his culture and character, Fletcher Henderson himself also represented another significant development: the sufferance, if not the approval, of jazz by some of the talented tenth leadership. Black American music had always been a source of embarrassment to the elite, who continued to be more than a little annoyed by spirituals long after James Weldon Johnson and Alain Locke had pronounced them America's most precious, original musical expression. Its feelings about urban spirituals—the blues—and about jazz sometimes verged

Fig. 40.
Carl Van Vechten.
BILL "BOJANGLES"
ROBINSON. (1878–1949).
1941. Hand gravure
print. The Studio Museum
in Harlem

Born in Virginia, this
unique percussive dancer
adopted Harlem as his
home and was in turn
christened "Bojangles" by
its admiring residents. A
national celebrity who
performed for generations
onstage and in films,
Robinson invented the
"stair tap dance." He
coined the word
"copacetic" to express his
philosophy of life.

∎

(opposite) Fig. 39.
James Van Der Zee.
PORTRAIT OF WOMAN
STANDING NEAR
WINDOW. *1931. Silver*
print. The James Van Der
Zee Collection

Van Der Zee's concern for
naturalism in his studio
portraits is clear in this
portrait. The backdrop,
the carpet, and the books
are displayed as if in a
home setting.

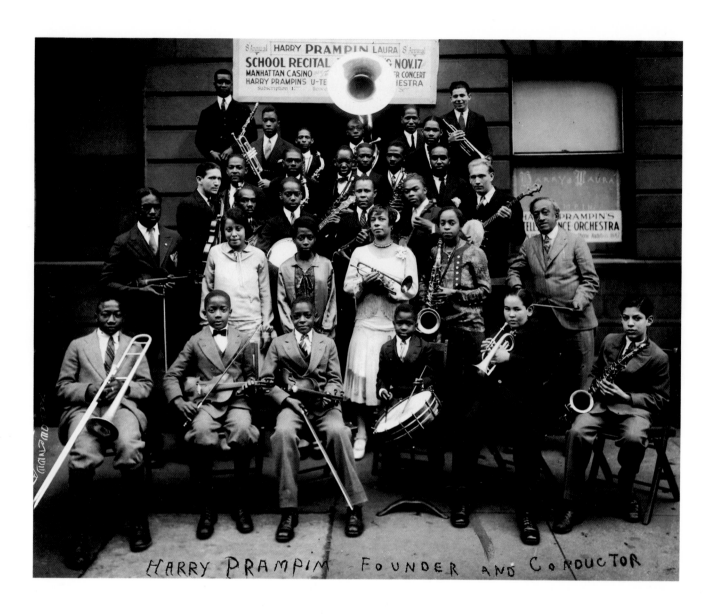

Fig. 41.
James Van Der Zee.
HARRY PRAMPIN'S
ORCHESTRA. *1927.*
Silver print. The James
Van Der Zee Collection

A popular Harlem band
in the 1920s.

on the unprintable. Ernest Ansermet might marvel over Sidney Bechet's clarinet and Maurice Ravel sit for hours in Chicago's Apex Club listening to Jimmy Noone's band, but upper-crust Blacks mostly recoiled from music that was as explosive as the outlaw cathouses and speakeasies that spawned it. Somehow, though, under Henderson's baton, the funkiness and raucousness of jazz dissipated—not altogether, certainly, but enough so that an Afro-Saxon, college-trained professional man might leave The Dark Tower and thoroughly enjoy himself at the Savoy without being downright savage about it.

Looking back across the decades through the findings of census tracts, medical data, and socioeconomic studies, it is clear that Harlem was becoming a slum even as Charles Johnson and Alain Locke arranged the coming-out party of arts and letters, and even as Duke Ellington and Fletcher Henderson enchanted thousands. Those exciting rent parties were a function first of economics, whatever their overlay of sex and music. The Urban League's 1927 report on

2,326 Harlem apartments disclosed that 48 percent of the renters spent twice as much of their income on rent as comparable White New Yorkers. For a four-room apartment, the average monthly rent was $55.70; average family income was about $1,300 annually. White New Yorkers spent $32.43 in rent and family income averaged $1,570. A fourth of Harlem's families had at least one paying lodger (twice the White rate), and an unknown number of house-holders practiced a "hot bed" policy: the same mattress for two or more lodgers working different shifts. Many Harlemites lived deplorably, in tenements so "unspeakable" and "incredible," the chairman of the 1927 housing commission reported, that "the State would not allow cows to live in some of these apart-ments." In Harlem, the syphilis rate was nine times higher than in White Manhattan; the tuberculosis rate was five times higher; pneumonia and typhoid rates were twice as high; two Black mothers and two Black babies died for every White mother and infant. The 1931 *Report to the Committee on Negro Housing,* presented to President Hoover, identified a generalized and unique Black residential dilemma: "One notable difference appears between the immig-rant and Negro populations," the investigators concluded. "In the case of the former, there is the possibility of escape, with improvement in economic status in the second generation." Not so for Black Americans.

Harlem's statistics were dire. But what the numbers obscured was the mood of the world north of Central Park, for the one certainty almost all who lived there shared was that Harlem was no slum. Ghetto, maybe; slum, never. Publications overflowed with Horatio Alger triumphs. Not only newspapers like the *Amsterdam News* and New York *Age,* but critical organs like *The Crisis* and *Opportunity* proudly catalogued every known triumph over adversity as manifestations of ubiquitous Black progress. The supposedly socialist *Messenger* sometimes read more like *Vanity Fair* than a protest periodical. Harlem ballyhoo even obscured the findings of the Urban League's own researchers. "It has been estimated that 75 percent of the real estate in the community is under colored control," the League's 1927 report on "Living Conditions of Small Wage Earners" stated. If it was true for the 2,326 units in the report, the Urban League neglected to add that 75 percent Black "control" certainly did not mean ownership. Harlem was a colony where absentee White landlords and commercial barons hid behind Black managers, where the largest department store, Blum-stein's, even refused to hire Black elevator operators until forced to do so, and where H.C.F. Koch's, another large department store, eventually chose liquida-tion over integration.

Yet if jobs and rent money were not easy to come by, and Whites owned more than 80 percent of the wealth, the ordinary people of Harlem—not just civil rights grandees and excited talents from the provinces—exuded a proud self-confidence. It was the unlikely story of Pig Foot Mary's success, rather than the fictional but more typical misfortunes of Rudolph Fisher's Solomon Gillis character in "City of Refuge," that gripped Harlemites' imaginations. Appropriating a bit of 60th Street sidewalk in 1901, over which she reigned

■

Fig. 42.
Carl Van Vechten. BESSIE SMITH *(1895–1937) 1936. Hand gravure print. The Studio Museum in Harlem*

Appearing in tent shows throughout the South as a young woman, Smith spent much of her life on the road performing for mostly Black audiences. Universally recognized as the "Empress of the Blues," her influence on American music has been profound and lasting.

with a baby carriage filled with chitterlings, corn, hogmaw, and pigs' feet, Pig Foot Mary plied a brisk trade. Moving to 135th Street and Lenox Avenue in 1917, she brought along a "specially constructed portable steam table" which she had designed herself. Soon she acquired both a husband and a thriving newsstand and, as Mrs. John Dean, invested in Harlem real estate. By 1925, her holdings were conservatively valued at $375,000. When renters fell behind in payments, she was famous for notifying them by post, "Send it, and send it damn quick."

But Pig Foot Mary was by no means Harlem's greatest success story. That distinction went to Madame C. J. Walker, A'Lelia's mother. For five hard years after she had been deserted by husband Charles Walker, she and her daughter Sarah Breedlove wandered from their native Mississippi to St. Louis, Denver, Pittsburgh, and Indianapolis, winning markets for her product, a secret formula for straightening hair. She eventually settled in New York. Now fabulously rich and the first woman in America to earn a million dollars by her own hand, she built the 136th Street town houses. Within hailing distance of Jay Gould's Irvington-on-Hudson estate, she built her $250,000 Italianate palace, designed by Harlem's outstanding architect, Vertner Tandy. She gave lavish parties and dabbled in politics. Proud of her African roots, Madame Walker planned to represent Bostonian William Monroe Trotter's anticolonial National Peace Congress at the Versailles Peace Conference, when death overtook her in May 1919.

Harlem had so many successful bootleggers and racketeers, and so many political and religious and other characters, that it took most of them for granted: the barefoot seer, Prophet Martin; the mysterious herbalist-publisher, Black Herman; and the Senegalese world boxing champion, Battling Siki; the community of Black Jews; and on and on. It could never take Marcus Garvey for granted, but his Harlem days ended in federal indictment and conviction for mail fraud. But only after he bowed out with a last-ditch, spectacular international convention in 1924. With or without Garvey, Harlemites had good reason to believe that their ghetto was truly a vibrant microcosm of America, and that successes—even shady ones—were the rule rather than the exception. They even had their own intercontinental aviator before America discovered Lindbergh. Lieutenant (sometimes Colonel) Hubert Fauntleroy Julian, M.D. (for mechanical designer), was a feisty Trinidadian who had enlisted and trained with the Royal Canadian Air Corps during World War I. In Harlem, he became an officer in Garvey's UNIA and a community celebrity. In late October 1923, Julian parachuted from a plane over Harlem, blowing a gold-plated saxophone on the way down. The New York *Telegram* christened him "The Black Eagle." The next year, Julian announced his intention to fly from New York by way of Florida, the West Indies, Central America, Brazil, Saint Paul's Rock in the mid-Atlantic, to Monrovia; and to return via Senegal, North Africa, Paris, London, Iceland, Greenland, and Canada. Unfortunately, his hydroplane crashed in Flushing Bay soon after its takeoff on July 4, 1923.

Fig. 43. James Van Der Zee. PORTRAIT OF MAN SMOKING. 1929. Silver print. The James Van Der Zee Collection

(overleaf) Fig. 44. James Van Der Zee. PARADE ON SEVENTH AVENUE IN HARLEM. n.d. Silver print. The James Van Der Zee Collection

Seventh Avenue was Harlem's showcase in the 1920s, frequently used for large parades. It was on Seventh Avenue that Harlem boasted a renewed and vital culture with well-dressed families parading up the avenue on a Sunday afternoon.

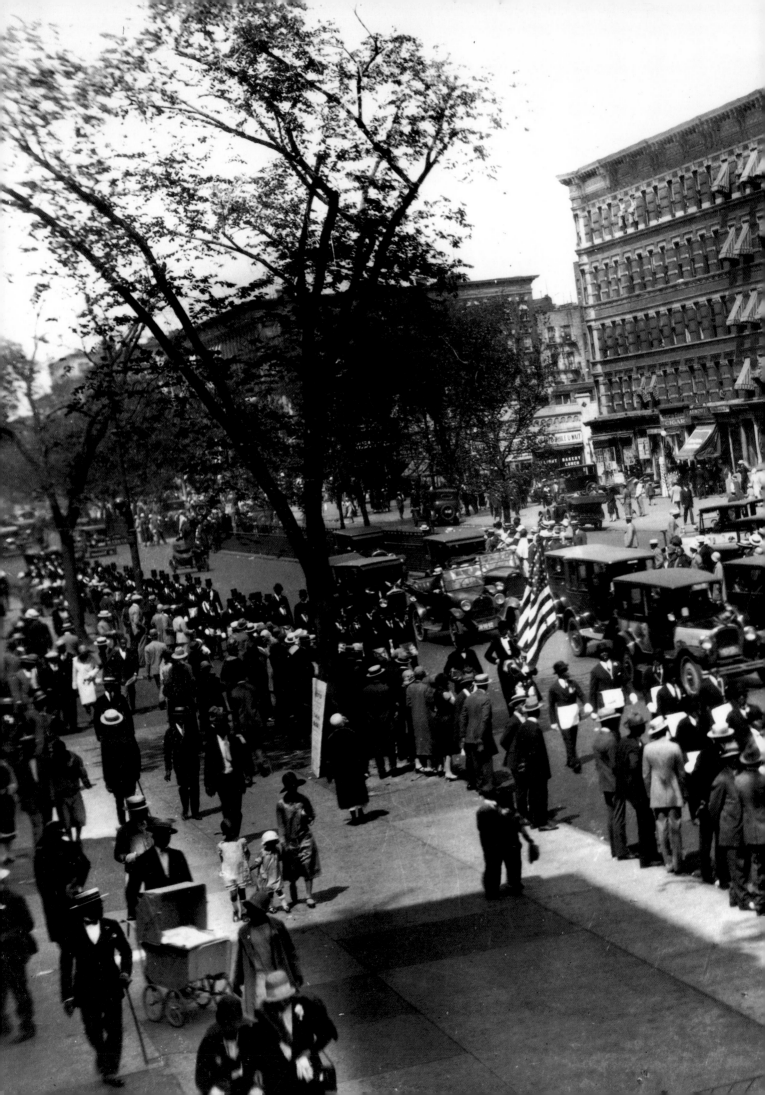

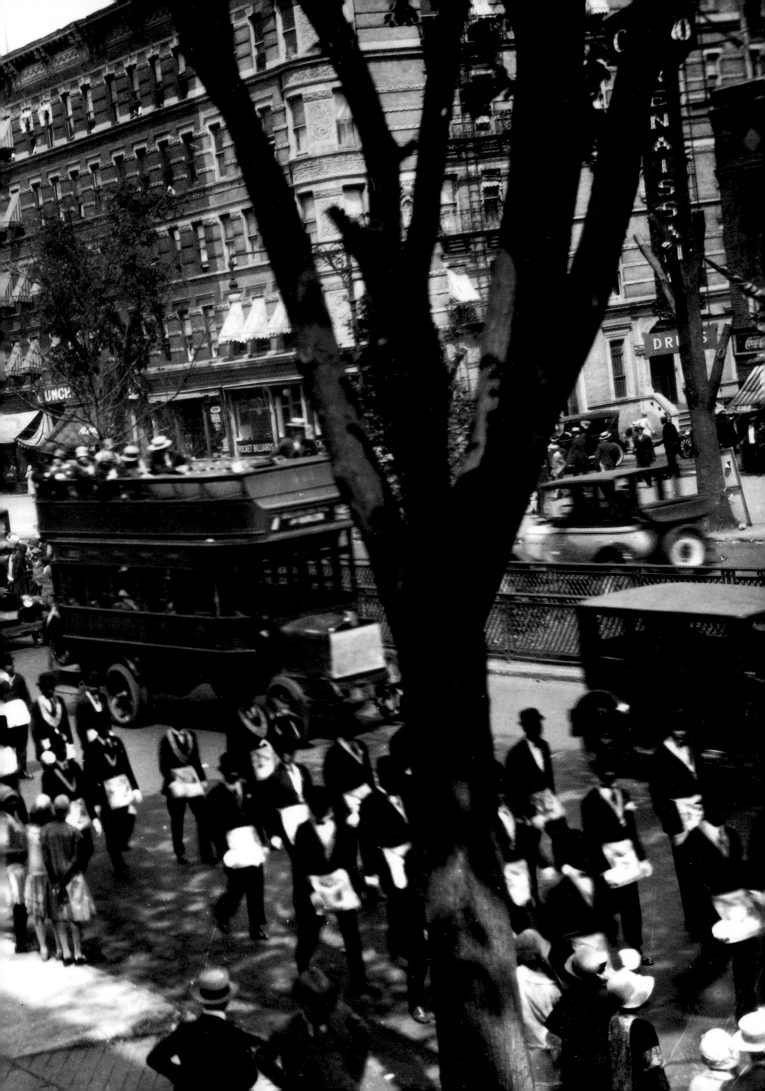

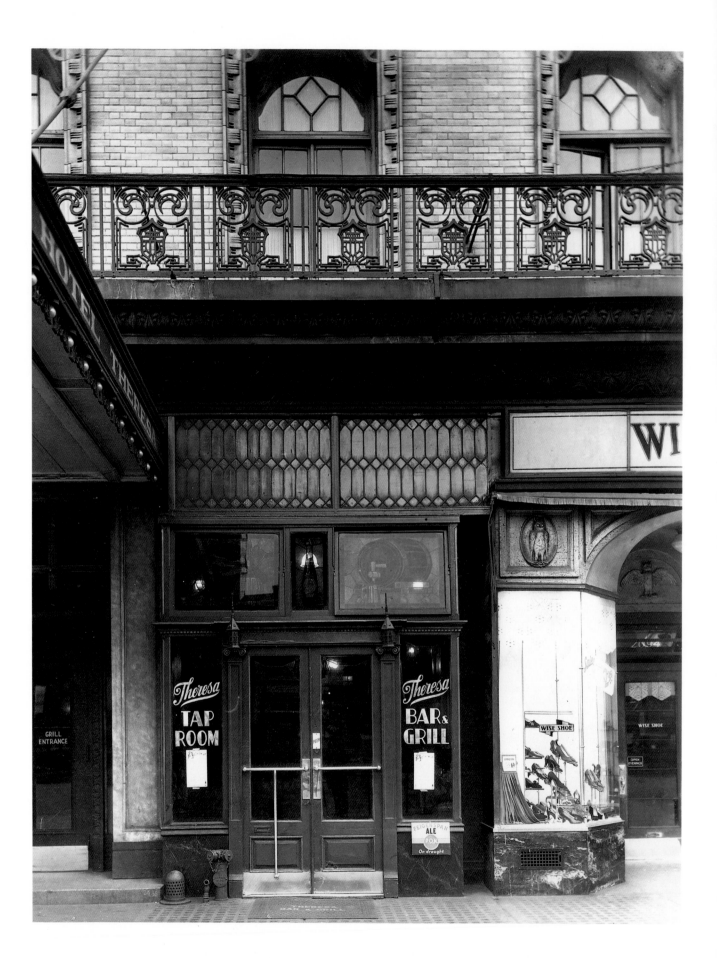

With the Black Eagle soaring (momentarily) above, and Bill "Bojangles" Robinson (fig. 40) tapping down Lenox Avenue, and every Black actor and musician worth knowing holding court at one time or another in the shadow of the Tree of Hope at 142nd and Lenox Avenue, Harlemites looked upon their world as "one of the most beautiful and healthful sections of the city." And there were compelling reasons why it would remain so, James Weldon Johnson (as an official of the NAACP) maintained in 1925:

> First, the language of Harlem is not alien; it is not Italian or Yiddish; it is English. Harlem talks American, reads American, thinks American. Second, Harlem is not physically a "quarter." It is not a section cut off.... Third, the fact that there is little or no gang labor gives Harlem Negroes the opportunity for individual contacts with the life and spirit of New York.

White anthropologist Melville Herskovits agreed, after a few investigative visits. "It occurred to me that I was seeing a community just like any other American community. The same pattern, only a different shade." Even in the trough of the Depression, sociologist Myrtle Pollard would find the people generally well dressed and well disposed.

In Harlem, progress continued to seem as regular as the running of the subway. At the top of the island of Manhattan now stood the largest National Guard Armory in the state, home of the much-decorated Fifteenth Regiment (the valorous 369th). At Harlem General Hospital, the monopoly held by White physicians and nurses had been effectively challenged by the NAACP and the brilliant young surgeon Louis T. Wright, future president of the NAACP. Although the average Harlemite was unlikely ever to use their services, there were two well-equipped private sanatoria by the end of the 1920s: the Vincent, financed by Caspar Holstein and opened by a former Harlem General Hospital physician; and the Wiley Wilson, built with divorce settlement funds by one of A'Lelia Walker's ex-husbands. In addition, there was Rudolph Fisher's X-ray laboratory, probably the most photographed Harlem medical facility. Although for most Harlem families who were poor, decent housing was increasingly difficult to find, for middle-class Harlemites decent housing was available. There were several Black-run hotels too, namely the Dumas and the Olga. By the end of 1929, Blacks were living in the five-hundred block of Edgecombe Avenue where Sugar Hill, a citadel of stately apartment buildings and liveried doormen on a rock, soared above the Polo Grounds like an Inca city. There, in the famous 409, resided at one time or another the Walter Whites, the Du Boises, and the Rudolph Fishers.

In the valley below Sugar Hill there was the five-acre, Rockefeller-financed Dunbar Apartments complex, begun in 1927 with its 511 units ready for occupancy in mid-1928. From Seventh and Eighth avenues, or under archways along 149th and 150th streets, Dunbar residents entered apartments overlook-

■

Fig. 45.
James Van Der Zee.
THERESA BAR AND GRILL. 1933. Silver print. The James Van Der Zee Collection

In the 1930s, the Theresa was the largest hotel in the United States that catered to Black Americans. The Bar and Grill was a noted meeting place for Harlem celebrities.

ing a grass-carpeted, flower-bordered courtyard. Living units were smallish, but well-lighted and well-equipped. There was a supervised basement nursery and a laundry room. A bank, Dunbar National, offered its depositors the peace of mind of a Rockefeller-backed and -regulated institution.

The Dunbar eventually became home for Du Bois, E. Simms Campbell (illustrator and cartoonist), Fletcher Henderson, Leigh Whipper (stage and screen actor), Clarence Cameron White (violinist-composer), George Edmund Haynes (economist), and, briefly, Paul and Essie Robeson. None other than the imperious Harvard man Roscoe Conkling Bruce, son of the Black senator from Mississippi, was appointed resident manager. "We let it be widely known," Bruce advised, "that the sporting fraternity, daughters of joy, the criminal elements are not wanted, and in fact will not be tolerated." The Dunbar was home for prospering families like the Enrique Cachemailles and the Lewis H. Faircloughs and such stylish singles as Sadella Ten Eyck and Ollie Capdeville, their apartment soirees and country weekends scrupulously reported in *Dunbar News* bulletins. John D. Rockefeller, Sr., had intended the complex to serve working-class families. Instead, the Dunbar became the preserve of the well-heeled. "Dinner guests of Mr. and Mrs. Lester A. Walton (5A) were Dr. Robert Russa Moton of Tuskegee and Alderman Frank R. Moore," a typical *Dunbar News* bulletin read.

Real political power eluded Harlem. Harlem's Republican congressional candidates made strong but unsuccessful runs in 1924 and 1928, and would try again. The ethnic algebra of the Twenty-first Congressional District (factored by Jewish, Irish, and Italian votes) would defeat Black Harlem until the boundaries were redrawn after World War II. Harlem did better on the state and city level. There had been Black aldermen since 1919 and state assemblymen since 1917. Starting out in the Republican Party, Black Harlemites had become Democrats when the rest of the city went Democrat. Charles W. "Charlie" Anderson, a legendary figure whose career had been given the nod by Booker T. Washington, was the "recognized colored Republican leader of New York." A man of considerable culture and kindness, the portly, aging collector of Internal Revenue for the Third District was less frequently seen on Lenox Avenue as the 1920s waned, but the memory of his considerable patronage and formidable political skills was still bright. Democratic party patronage was handled by Harvard-educated patrician Ferdinand Q. Morton, chairman of the Municipal Civil Service Commission and iron-willed boss of Harlem's United Colored Democracy—"Black Tammany." Morton preached and practiced politics as a "cold-blooded business proposition." In 1933, he cold-bloodedly left the Democrats to help elect mayor Fusion party candidate Fiorello La Guardia.

As is often the case with expiring movements, the beginnings of the end of the Harlem Renaissance were either mistaken for more success or only belatedly recognized for what they truly were. The publication of *Black Manhattan* toward the end of 1930 was one such ambiguous event. James Weldon Johnson had

Fig. 46.
James Van Der Zee.
PORTRAIT OF LESTER WALTON. *1932. Silver print. The James Van Der Zee Collection*

Walton, onetime manager of Harlem's Lafayette Theater, was U.S. ambassador to Liberia in the 1930s.

conceived his history of Harlem as both a chronicle of past achievements and a monument to future glory. "Harlem," the author wrote, "is still in the process of making." But Johnson's Harlem was fading even as Knopf issued the book. "The most outstanding phase of the development of the Negro during the past decade," Johnson was still certain, "has been the recent literary and artistic emergence of the individual creative artist; and New York has been, almost exclusively, the place where that emergence has taken place."

Racial progress through the arts still seemed to some arguably plausible, even after the Great Crash of 1929. In February 1930, there was much Broadway excitement over the opening of *The Green Pastures,* Marc Connelly's dramatization of Roark Bradford's book of short stories. The singing of the Hall Johnson Choir, the simple dignity of Wesley Hill acting the part of the Angel Gabriel, and the believable gravity of Richard B. Harrison as "De Lawd" brought capacity audiences to the Mansfield Theatre for 557 performances. Sterling Brown, who was in the process of becoming one of Black America's strongest literary critics, pronounced the play "a miracle." If not "accurate truth about the religion of the folk-Negro," Brown wrote, it was "movingly true of folk life." *Lulu Belle, Abraham's Bosom, Porgy, Harlem,* and King Vidor's controversial talking film *Hallelujah!* had prepared the way, but Connelly's fable was seen as a breakthrough more portentous than *Shuffle Along,* almost a decade past. There soon followed Hall Johnson's folk play, *Run Little Chillun* (written, directed, and acted by Blacks), and Paul Green's much praised *House of Connelly.*

Still, the Depression was there, ravaging Harlem—but not totally, and not all at once. Destructive, but capricious, it ran its course with a breadth and ferocity that varied according to class and luck and perspective. For most of the Niggerati (the expression was now commonplace), the good times rolled onward. Lincoln University met Hampton Institute at the Polo Grounds in early November 1929, the first time Black football teams had played there. Downtown, Van Vechten's parties were still the best. Now that the *Nigger Heaven* furor had subsided, Van Vechten seemed to be in competition with the Savoy for mounting sensational evenings. More than ever, the wages of alcohol and amusements paid in Harlem. The rich ignored or forgot the troubles of Wall Street in the old places like the Cotton Club and Connie's. "Smalls' is quite swank now," the bachelor boulevardier Harold Jackman wrote to his soul mate Countee Cullen as the club made its final transition from a Harlem club to a club in Harlem: "The place has been newly decorated and it looks spiffy." But there were more Whites now than ever, and many of them lacked the money for Connie's and Smalls'. Instead, they settled for small, dark places. "The night life in Harlem these days is in the speakeasies," Jackman reported. Many of these places were owned by the Irish, but a good number—Coal Bed, Air Raid Shelter, Glory Hole—were Black American. The vast dance halls never shut their doors now, but Jackman found their clientele distinctly disagreeable, half-seriously writing to Cullen of a Rockland Palace dance, "you talk about ugly niggers—they almost frightened me away!" Jackman preferred

some of the speakeasies. Above all, he loved the Clam House on 133rd Street, where Gladys Benley, "a Black cherub of some mean proportions stomps a piano and sings the blues in a deep contralto voice that is just out of this cosmos." Jackman sighed, "When Gladys sings 'Saint James Infirmary,' it makes you weep your heart out." Less than two years were left for weeping in speakeasies, though. The end of Prohibition was approaching.

Reviewing the literary year in the January 1930 issue of *Opportunity*, Locke was delighted that more books had been "published about Negro life by both White and Negro authors than was the normal output of more than a decade past." Du Bose Heyward's second novel, *Mamba's Daughters,* was an astonishing work; it was *Porgy* and *Nigger Heaven* combined, but with more genius and generosity. No other White novelist of the period dealt with the rural and the urban, the primitive and the assimilated, quite as successfully and empathetically. Two Harlem writers had produced unusual novels, as well. Jessie Fauset's *Plum Bun* fully deserved the positive reviews it received—not because it was a great work of fiction, but because in both its achievements and its flaws it spoke fluently for the rarefied, upper-crust, color-conscious Black American world from which Fauset drew her inspiration. Wallace Thurman knew far better than most of his fellow artists how prevalent were the hierarchical values extolled in *Plum Bun*. Very dark and very homely, he had too often been their victim. Into *The Blacker the Berry,* his first novel, which appeared in March 1929, Thurman put his bitterness and saving intellect. His heroine, Emma Lou, is obviously Thurman himself. But she also stands for those Black Americans in whom the obsession with respectability snuffs out personality and self-respect. The aesthetics of *Fire!!,* which found the real resource of Black America residing in honest, noisy, common folk and in its unconventional artists, inspired Thurman's novel on every page. When Emma Lou is invited to a rent party to meet the lights of the Renaissance (Douglas, Hughes, Hurston, Nugent, Thurman, and Van Vechten, all thinly disguised), her first thought is to swallow arsenic wafers to bleach her skin. It is the one occasion in Thurman's novel where complete acceptance is Emma Lou's for the asking, when all the racial and social taboos and ideals are held up for honest, if boozy, scrutiny. But Emma Lou is aghast: "Such extraordinary people—saying 'nigger' in front of a White man! Didn't they have any race pride or proper bringing up?"

When 1930 ended, the vital signs of the Renaissance still appeared remarkably healthy. Walter White was sure the Renaissance would go on forever. Locke shared White's optimism, entitling his yearly *Opportunity* retrospective "The Year of Grace." A year that opened with Marc Connelly's *The Green Pastures* and closed with Langston Hughes's *Not Without Laughter* and George Schuyler's *Black No More* surely did not herald the beginning of a decline, Locke thought. Returning from France that summer, after the restrained reception of his poetry volume *The Black Christ,* Countee Cullen began writing *One Way to Heaven,* a novel about high and low Harlem life. Arna Bontemps's *God Sends Sunday* was under contract. Nella Larsen, after writing her second novel, *Passing,* was

traveling in Europe on a Guggenheim fellowship. On the Broadway stage, there was no slackening yet of interest in "Negro" subjects. "Amos 'n' Andy" was still a national radio pastime. More remarkably than in the early Renaissance years, there was notice being taken of painters and sculptors. By 1931, they could be counted by the scores, with some hundred-odd entering their works in The Harmon Foundation's annual competition and exhibition. There were paintings by Aaron Douglas, Palmer Hayden, William H. Johnson, Archibald Motley, James A. Porter, Laura Wheeler Waring, and Hale Woodruff; sculpture by Meta Fuller, Sargent Johnson, Elizabeth Prophet, and Augusta Savage.

For the moment, Harlem gossip was so spiced by news of Harlemites in Europe that the Depression still seemed tolerably remote. In Edward Perry's "Impressions" column, *Tattler* readers were given details of baritone Jules Bledsoe's Paris concert debut at the Salle Gaveau, under the high patronage of Princess Violette Murat, Princes Michel Soumbatov and Touvalou Houenou, Madame Eva Gauthier, and Lady Cook. In the *Defender*, they read of singer Nora Holt (model for the femme fatale in *Nigger Heaven*) triumphing as the hostess of London's most exclusive café, the Coventry Street Restaurant. The *Amsterdam News, Defender*, Pittsburgh *Courier*, and *Tattler* gave front-page coverage to Ethel Waters's appearance at the London Palladium and her show at the Café de Paris, which the Prince of Wales was reported to have seen three times in one week. The private lives of the Robesons, subjects of endless Harlem fascination, were of extreme interest that season because of Essie Robeson's biography, *Paul Robeson, Negro*. Paul's performance of *Othello* in London had won great critical acclaim the previous summer.

On Monday, August 17, the Harlem Renaissance had a sudden prefiguration of its mortality. The *New York Times* announced that A'Lelia Walker "died suddenly early today at the home of friends in Lippincott Avenue, Long Branch. Her age was 46 years." The Reverend Adam Clayton Powell, Sr., of the mighty Abyssinian Baptist Church, eulogized her at the funeral parlor on Seventh Avenue (fig. 49). Carl Van Vechten was too distraught to come. Langston Hughes left a vivid impression of the last rites:

> A night club quartette that had often performed at A'Lelia's parties arose and sang for her. They sang Noel Coward's "I'll See You Again," and they swung it slightly, as she might have liked it. It was a grand funeral and very much like a party. Mrs. Mary McLeod Bethune spoke in that great deep voice of hers, as only she can speak. She recalled the poor mother of A'Lelia Walker in old clothes, who had labored to bring the gift of beauty to Negro womanhood, and had brought them the care of their skin and their hair, and had built up a great business and a great fortune to the pride and glory of the Negro race—and then had given it all to her daughter, A'Lelia.
>
> Then a poem of mine was read by Edward Perry, "To A'Lelia." And after that the girls from various Walker beauty shops throughout America brought their flowers and laid them on the bier.

Fig. 47.
James Van Der Zee.
PORTRAIT OF WOMAN
SEATED AT PIANO.
1931. Silver print. The
James Van Der Zee
Collection

Van Der Zee was noted
for posing his clientele
with musical instruments
as props.

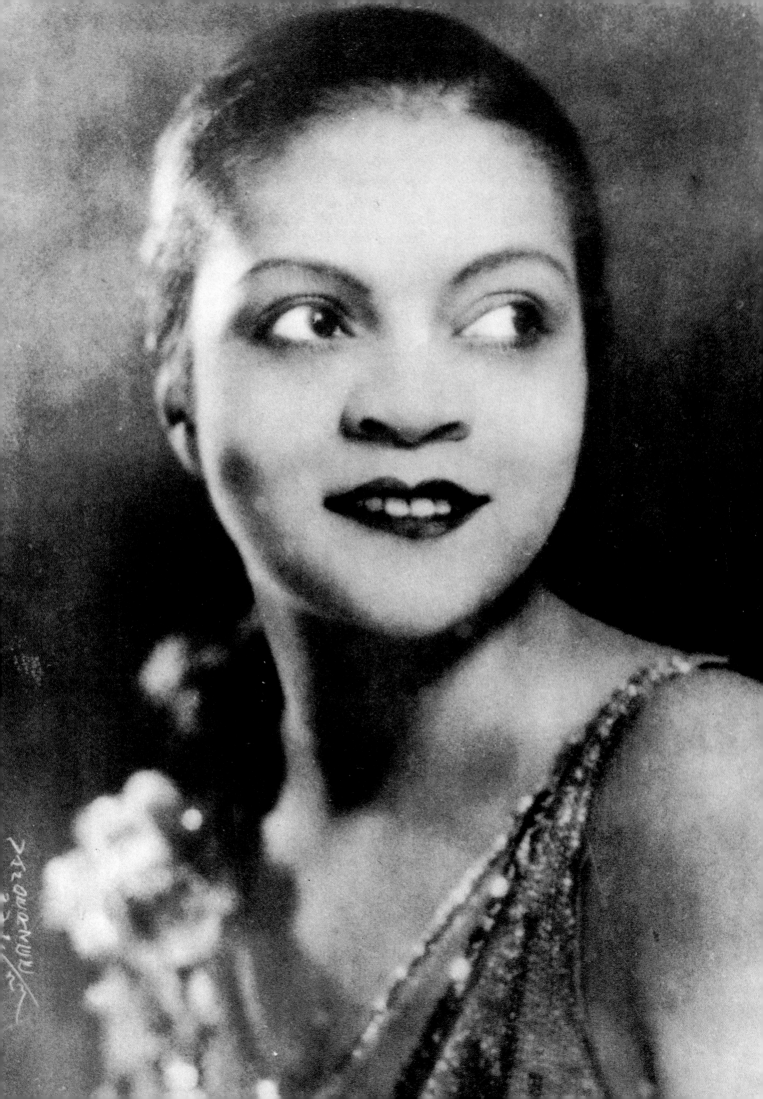

Villa Lewaro soon fell under the auctioneer's gavel; the town house was leased to the city eventually to make way for a branch of The New York Public Library.

The hostess was gone. But along with Walter White, most of the Harlem leadership continued to believe in the efficacy of lobbying for civil rights in places like the Civic Club and the Algonquin Hotel. At the end of 1931, Jessie Fauset wrote yet another novel about upper-crust mulatto life, *The Chinaberry Tree*. It was mercifully counterbalanced by a work of outstanding vigor and sensibility, Sterling Brown's collection of poetry, *Southern Road*, which Locke described as "true in both letter and spirit to the idiom of the folk's own way of feeling and thinking." Countee Cullen presented his badly flawed first novel, *One Way to Heaven*, the following year. The publication that same year of Wallace Thurman's *Infants of the Spring* was the last novel about—though not of—the Harlem Renaissance. It was the mediocre novel of a writer who no longer believed in himself as a man, a Black American, or an artist. Yet, it was a document of surpassing social importance. Most of the novel is situated in "Niggerati Manor," a residence very like 267 House. The place is usually packed with the cream of the Renaissance, whose disguises invite the reader's easy discovery.

The action of *Infants of the Spring* is in the ideas of the characters. They talk incessantly about themselves, Booker T. Washington, Du Bois, racism, and Black American destiny. The novel's ending is conceptually poignant, with some of Thurman's best, but elsewhere clumsy, prose. Paul Arbian (the likeness of Richard Bruce Nugent) commits suicide in a full tub of water. Every page but one of Arbian's unfinished manuscript lying on the bathroom floor is blotted by the overflow. On the remaining legible page:

> He had drawn a distorted, inky black skyscraper, modeled after Niggerati Manor, and on which were focused an array of blindingly white beams of light. The foundation of this building was composed of crumbling stone. At first glance it could be ascertained that the skyscraper would soon crumple and fall, leaving the dominating white lights in full possession of the sky.

Meanwhile, ordinary Harlemites watched with surprise and increasing disillusionment as their self-proclaimed leaders lost their grip. The young painter Romare Bearden reproached The Harmon Foundation for its attitude that "from the beginning has been of a coddling, patronizing nature." Arthur Fauset warned in *Opportunity* that the "Negro masses must suffer a socio-political-economic setback from which it may take decades to recover," unless bold political strategies were embraced. One thing was certain, he concluded, it was unrealistic "to believe that social and economic recognition will be inevitable when once the race has produced a sufficiently large number of persons who have properly qualified themselves in the arts." For Langston Hughes and his friend Loren Miller, the only solution to economic and racial injustice was as plain as day—communism.

■

Fig. 48.
James Van Der Zee.
FLORENCE MILLS,
SINGER AND
COMEDIENNE. *1923.*
Silver print. The James
Van Der Zee Collection

■

(overleaf) *Fig. 49.*
James Van Der Zee. THE
ABYSSINIAN BAPTIST
CHURCH. *1927. Silver*
print. The James Van Der
Zee Collection

The corner of West 138th
Street and Seventh
Avenue, with the facade
of the Abyssinian Baptist
Church and the
Renaissance Casino.

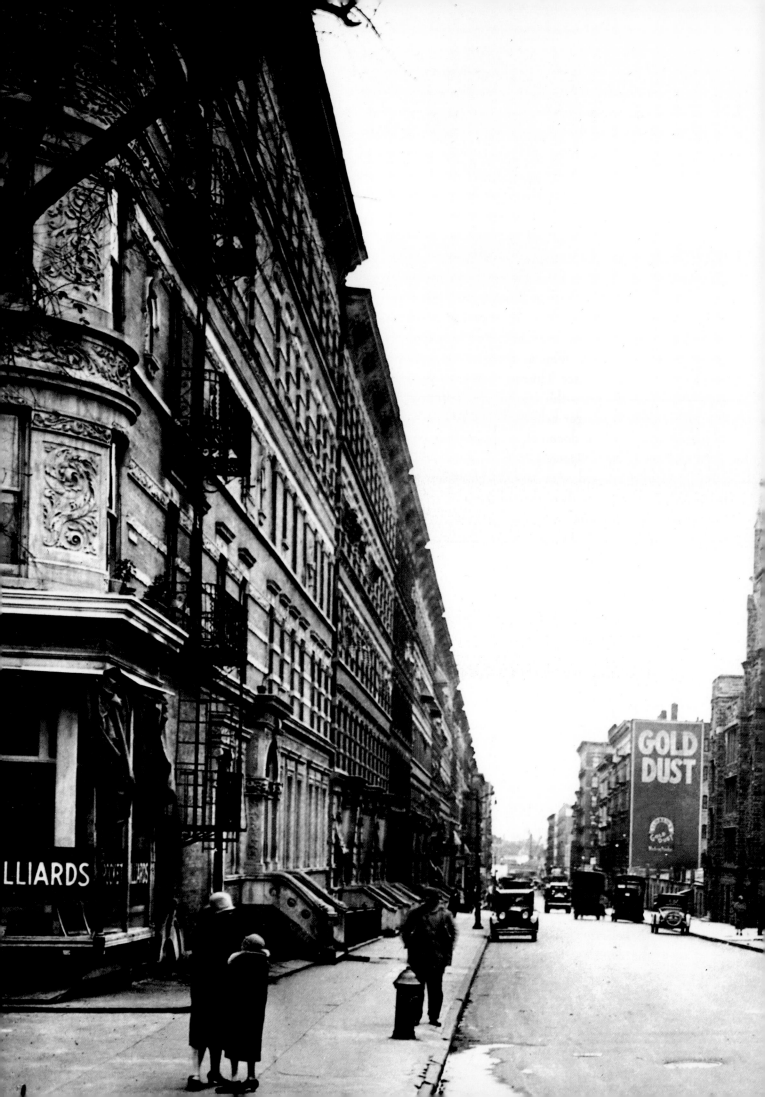

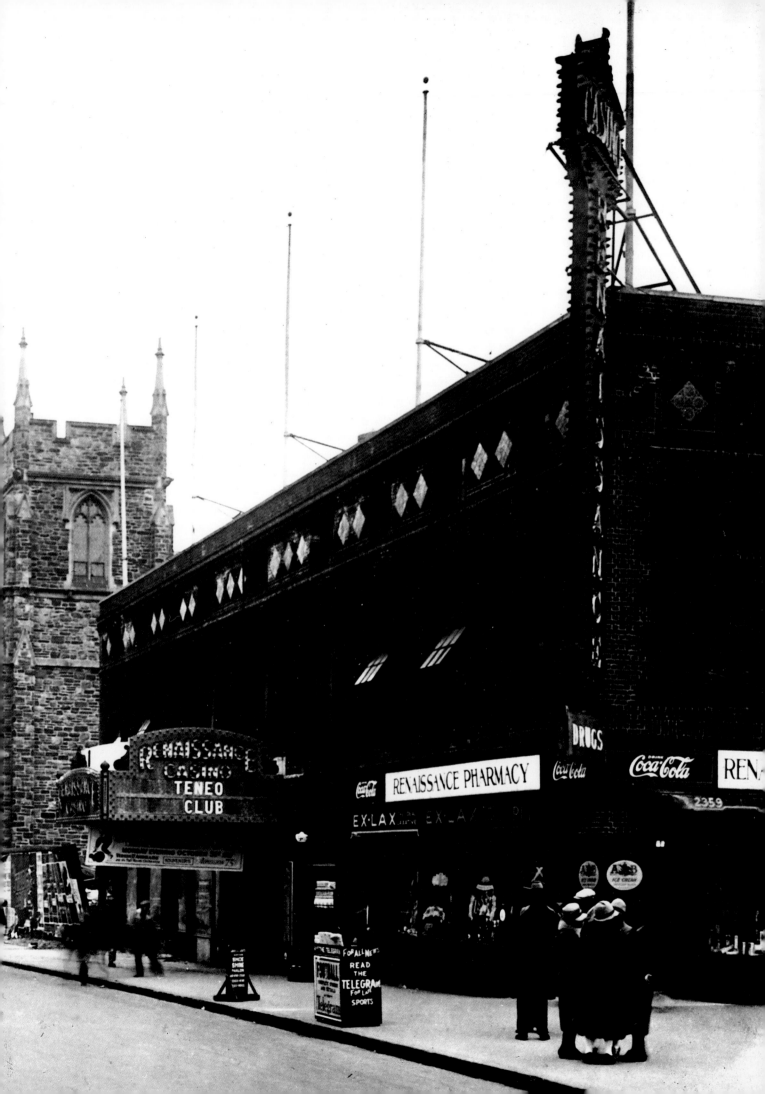

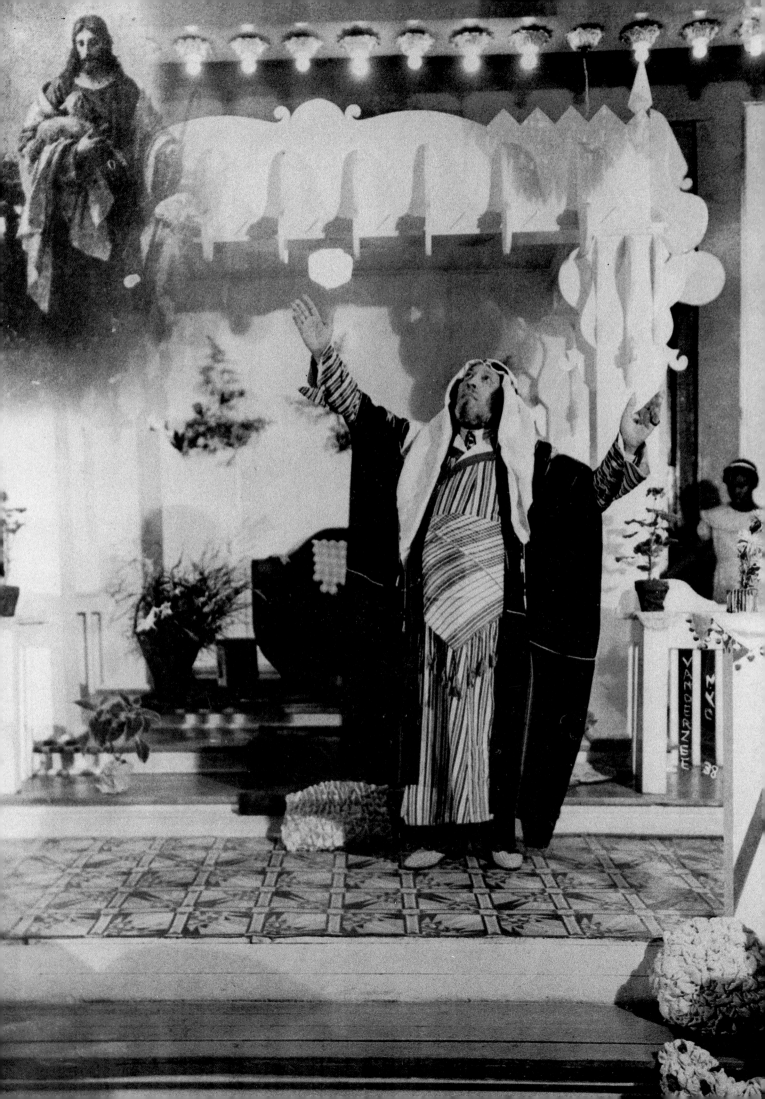

The Communist journal *The New Masses* and the myriad fronts of the Communist party operating in Harlem were beginning to interest ordinary folk in revolutionary doctrine. Certainly, Countee Cullen's public embrace of the Socialist party in the early 1930s was a measure of the new spirit abroad in Harlem. Under Walter White, the NAACP recoiled in horror from the Communists, even hesitating to fight for vindication of the Scottsboro Boys because the International Labor Defense (ILD) had got to the victims first. But Du Bois, long since disgusted with the arts-and-letters strategy, and even more disgusted with White's leadership, called for a revolt of the newer talented tenth generation at the 1933 Amenia Conference. Cooperatives, organized Black labor, more emphasis on economics and less on federal antilynch legislation, were what was needed, said Du Bois, now forcibly separated from the association he had helped to found.

By 1934, the Negro Industrial and Clerical Alliance, headed by the rambunctious Sufi Abdul Hamid, and the Citizens' League, manned by upper-crust Harlemites, began aggressive boycotting of White businesses guilty of hiring discrimination. Sufi was too aggressive for the Clerical Alliance leaders, who were appalled by the ex-Chicagoan's scathing verbal abuse of Jewish merchants and his questionable collection and handling of funds to support the campaign. The Citizens' League soon denounced the "Führer of Harlem" and began negotiations with the merchants. But radicalism was in the air. For one moment in early November 1934, establishment Harlem (Black and White) held its breath as the forces of Father Divine and Sufi joined in a monster rally at Rockland Palace to end discrimination in hiring and housing.

George Baker, alias Father Divine or "God at 20 West 115th Street," had alighted in Harlem in 1932 from a noisy ministry in Sayville, Long Island. Soon, Divine "heavens," with their hotels and soup kitchens and colorful sermons and rites, had replaced Garveyism as the populist force of the times. Mayor La Guardia paid homage to Father Divine, and, if neither Pope Pius XI nor President Roosevelt answered the command to appear at Rockland Palace for his Righteous Government Convention, national and religious leaders were not unmindful of the little man's pronouncements. He condemned fascism, anti-Semitism, the Scottsboro injustice, and also the tepid social policies of the New Deal. The moment of solidarity with Sufi Abdul Hamid passed, however, but the latter's boycott campaign paved the way for similar campaigns and launched the political career of Adam Clayton Powell, Jr., Harlem's first Black congressman.

Religion was always the bedrock of the people's energies, even if the secular leadership (Du Bois, both Johnsons, White) was curiously agnostic or indifferent to its power to galvanize and mold. Locke's "migrating peasant" had brought his religious fundamentalism and evangelical fervor to Harlem. The parishioners of St. Philip's Gothic-style Episcopal Church might conduct themselves with notable restraint on Sundays, thereby smugly emphasizing the psychic space separating them from the excited flocks bursting a hundred storefront churches

Fig. 50.
James Van Der Zee.
DADDY GRACE. *1938.*
Silver print. The James
Van Der Zee Collection

Grace was a popular
Harlem evangelist.

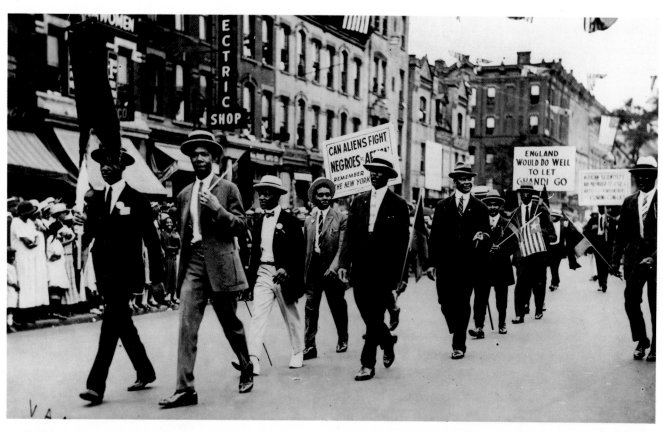

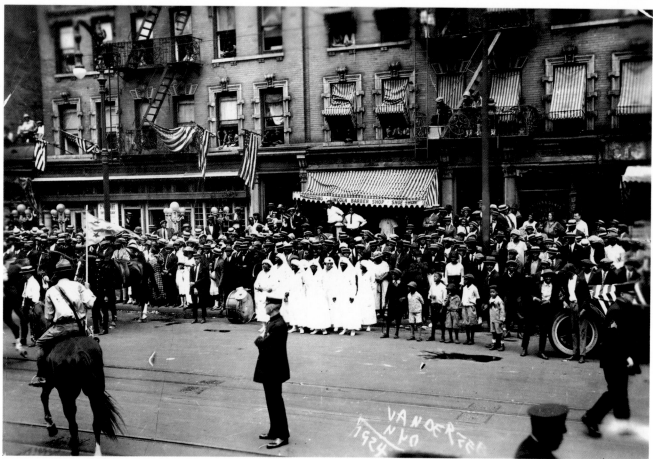

at the seams, but passion and pageantry tended to transcend class. There was the case of Countee Cullen's own father's church, Salem Methodist. When Reverend Cullen relinquished his pulpit to Reverend George Wilson Becton because of poor health, the new preacher took the community by storm. Until his mysterious kidnapping and murder in May 1932, Becton was one of the Lord's most graceful, mellow-voiced, and colorful instruments. His church became known as the "World's Gospel Feast," where gorgeously caparisoned pages enforced quiet on cue, a mighty choir and orchestra thrilled the worshipers, and Becton, radiating animal magnetism and divine revelation, led his flock in a great outpouring of "consecrated dimes."

But when the transplanted revivalism of the South went far beyond its traditional boundaries, it created cults that were frequently weird, sometimes unsavory, or both. The Black Jews were certainly unusual. No one knew where they came from, nor exactly when they arrived. "Funny thing," butcher M. Shapiro was quoted as saying in a 1929 edition of the New York *Sun*, "some colored people came in the other morning and wanted some kosher meat. Real Negro people from up in Harlem. They say they are Jews." Perhaps, as myth claimed, a few wayfaring Ethiopian Jews—Falashas—had settled in Harlem after World War I. Strange, shadowy holy men like Rabbi Ishi Kaufman and Elder Warren Robinson (later convicted for violation of the Mann Act) kept kosher, conducted services in Yiddish, and substituted the saxophone, guitar, and tambourine for the kynor, nevel, and tupim. In 1924, ex-Garveyite Arnold Ford and ex-boxer Wentworth Arthur Matthew established the Beth B'nai Abraham congregation at 29 West 131st Street and brought the Black Jews to Harlem's attention. Beth B'nai Abraham thrived until it was wrecked by financial scandal in 1930. Rabbi Ford fled to Ethiopia. Rabbi Matthew founded a new congregation, remaining in Harlem for years thereafter.

However unusual it may have seemed to mainstream America, Harlem's vitality gave few signs of abating during the early 1930s. Indeed, it was becoming politically more vibrant than ever before. But the progress report on the literary Renaissance contained deeply troubling information mixed with signs of continuing health. The last novel of the Renaissance, Zora Hurston's beautifully written *Jonah's Gourd Vine*, went on sale in May 1934. The two Johnsons and Locke greatly admired this allegorical book about Hurston's immediate family (especially her father) and the life of an autonomous Black community in Florida called Eatonville. Two writers from whom much more should have come, Rudolph Fisher and Wallace Thurman, died avoidable deaths within days of each other. Fisher fell victim on the day after Christmas 1934 to intestinal cancer caused by careless exposure to his own X-ray equipment. Thurman died four days earlier, soon after returning from a Hollywood film project. He hemorrhaged after too much drink in his apartment. A devastated Locke wrote: "It is hard to see the collapse of things you have labored to raise on a sound base."

On the evening of March 19, 1935, a riot swept down Lenox Avenue. Ten

■

(opposite: above) *Fig. 51. James Van Der Zee.* UNIA PARADE. *1924. Silver print. The James Van Der Zee Collection*

■

(opposite: below) *Fig. 52. James Van Der Zee.* BLACK CROSS NURSES WATCHING A UNIA PARADE. *1924. Silver print. The James Van Der Zee Collection*

The Black Cross was an auxiliary of the UNIA movement, its purpose was to care for sick members. They were appointed to instruct the membership on health and safety.

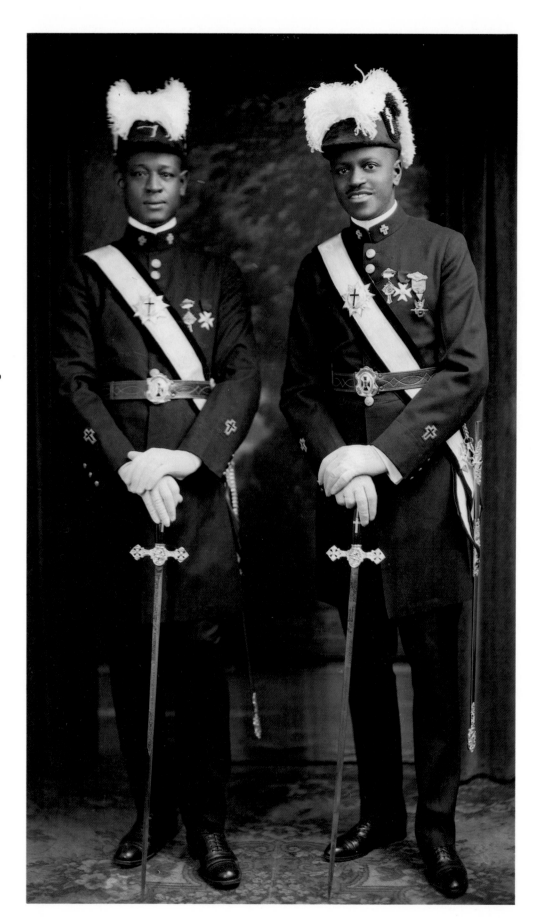

Fig. 53.
James Van Der Zee. TWO
UNIA MEMBERS. *n.d.*
*Silver print. The James
Van Der Zee Collection*

*UNIA officers wore
distinguished uniforms
complete with feather
plumes and white gloves.*

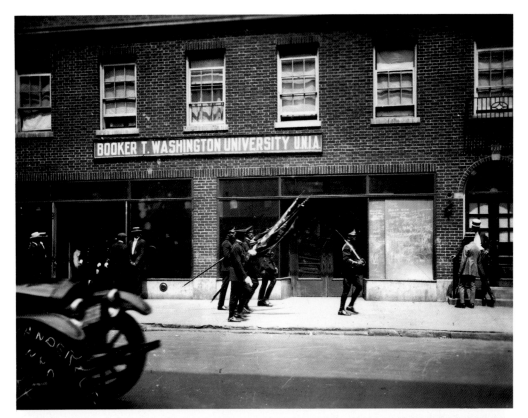

■

Fig. 54.
James Van Der Zee.
BOOKER T.
WASHINGTON
UNIVERSITY, UNIA.
1924. Silver print. The
James Van Der Zee
Collection

The school for Marcus
Garvey's recruits.

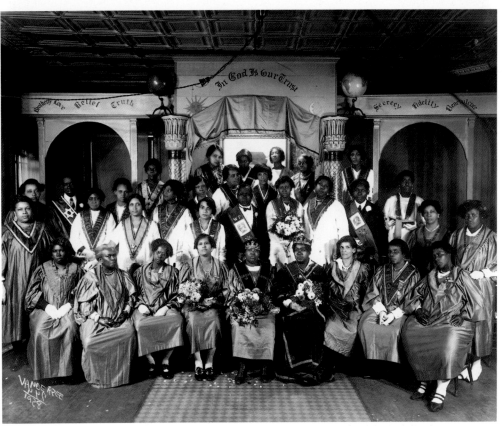

■

Fig. 55.
James Van Der Zee.
RELIGIOUS CLUB, IN
GOD IS OUR TRUST.
1928. Silver print. The
James Van Der Zee
Collection

In almost every church in
Harlem, there were at
least twenty organized
clubs. Many of these clubs
were organized not only
for worship but also for
companionship among the
church members.

■

Fig. 56.
James Van Der Zee.
PORTRAIT OF COUPLE
WITH RACCOON COATS
AND STYLISH CAR. *1932.*
Silver print. The James
Van Der Zee Collection

This portrait typifies the
sense of pride and style
during the Renaissance.

thousand Harlemites destroyed two million dollars in mostly White-owned, commercial property. Lino Rivera, a sixteen-year-old Puerto Rican, had been roughly handled by White store clerks who caught him shoplifting in the West 135th Street five-and-dime. It was rumored that the teenager had been beaten to death. The Young Communist League incited people against the police. When the riot was over the following morning, three Blacks were dead, thirty people were hospitalized, and more than a hundred were in jail. By the following year, most of the New Negroes realized that the Depression had finally destroyed their work. Langston Hughes went to Spain to fight fascism and write more Marxist poetry; Paul Robeson found the promised land in Russia; and even

Countee Cullen called on Blacks to vote for the Communist party. But many would find their new political hopes poisoned by exploitation and intellectual tyranny often far surpassing that of their former capitalist patrons.

Others—the great majority—mastered their disenchantment and tried to find a place in the new order of things. For artists and writers, this often meant a place with a patron better endowed than Caspar Holstein, Alfred Knopf, or even the Rosenwald Fund: the Works Project Administration (WPA) of the federal government. Most of the writers of the next generation—William Attaway, Ralph Ellison, Margaret Walker, Richard Wright, Frank Yerby—and most of the artists—Romare Bearden, Jacob Lawrence, Charles Sebree, Charles White—would pass that way. There were a few who came out of the Renaissance with enough momentum to maintain their earlier success. Hughes did. So, for a time, did Hurston. McKay and Toomer never stopped trying, although they never approached their first triumphs. The same was true of Harlem.

AARON
DOUGLAS

The Flowering of the Harlem Renaissance: The Art of Aaron Douglas, Meta Warrick Fuller, Palmer Hayden, and William H. Johnson

Harlem, the cultural capital of Black America, has for many decades provided enlightened leadership in the arts, unmatched by other urban communities. Significantly situated in the center of New York City, on the island of Manhattan, Harlem has attracted persons from all walks of life striving to become entertainers in the music, theater, and film worlds. Black poets and novelists have idealized Harlem and implanted its ethos in the soul of every Black American since the 1920s, when the community became a mecca for the exploration of all the arts. Prior to that time, little was known of Black visual artists, other than those who managed to make their reputations in Europe. Few, indeed, were the aspiring artists fortunate enough to be well financed themselves or to be sponsored for a sojourn in Europe, particularly in Paris, then the capital of art in the Western world. For most Black artists who dreamed of practicing their craft in a supportive environment, Harlem seemed a likely place to call home.

As early as 1905, the rush to own property in Harlem began among well-heeled Blacks. Their arrival brought stability to the community and the interest required to create a support system that would sustain Harlem's intellectual and artistic movement in the early 1920s. Yet, the climate the community needed to prove itself worthy of the New Negro's cultural regeneration was the result of forces within and outside Harlem. Before World War I, Black intellectuals were already migrating to Harlem from Philadelphia, Washington, D.C., Chicago, Los Angeles, and the principal cities of the South. They swelled the ranks of Harlem's cultural activists and championed the call for a rebirth of the artistry Black people once had in their native Africa. Simultaneously, the art of Black Africa was beginning to enter American museums and was accessible through the collections of prominent avant-garde art dealers Alfred Stieglitz and J. B. Naumann, and the renowned patron of modern art

■

Fig. 57.
Aaron Douglas. MA BAD LUCK CARD, *for "Hard Luck" by Langston Hughes, in* Opportunity. *October 1926. The Schomburg Center for Research in Black Culture, The New York Public Library*

Albert Barnes. The impact of African designs could also be seen in the art of the premier modernists, including Picasso, Modigliani, and Brancusi. In response to these events, a renaissance of ideas and artistic expressions manifested itself in Harlem by the 1920s. Thereafter, American culture experienced an infusion of Black creativity in the arts unknown since the age of artistic genius in the homelands of Black Africa prior to European colonization.

Most historians accept 1925 as the established date of the New Negro Movement's flowering of artistic expression, later called the Harlem Renaissance. Yet, as early as 1919, when Black soldiers returned from the war in Europe, signs of a changing cultural order appeared in Harlem. There was a proliferation of literary clubs, private and public art exhibitions, and evenings of music, poetry, and dance that existed for the sole purpose of "uplifting the arts within the race." The year 1919 was also the year in which an unusually sagacious, socially determined mind-set developed among the Black intellectuals assembled in Harlem. They espoused political philosophies that interested those Black artists who showed allegiance to their race and who felt the need to participate in the founding of a national movement to enlighten the arts of Black America. The voices that gave direction to the artists, who like their intellectual counterparts came to Harlem from across the nation, represented the best minds that Black America had to offer. Those who encouraged the visual artists to join ideological ranks with their literary counterparts were the leaders of the Harlem Renaissance: eminent philosophers and sociologists, seasoned critics, gallery dealers, and patrons of the arts.

Perhaps no voice was heard and heeded more often than that of Alain Locke. America's first Black Rhodes Scholar, Locke carried the twin banners of aesthetician-philosopher and historian-critic for the New Negro Movement. His dream was to found a "Negro School of Art" in Harlem, which made him the ideal catalyst for the entire Black arts movement. Locke cautioned Black artists against joining the avant-garde circles of New York and Paris and warned them away from modernist trends. He directed them instead to African art as an important source of aesthetics and iconography that would be meaningful for their race. He called for all Black visual artists "to return to the ancestral arts of Africa for inspiration" and instructed painters and sculptors working in Harlem to seek out important art collections that highlighted African art. In this ancestral heritage, Locke saw a new and viable art capable of sustaining the creativity of Black artists and fulfilling the needs of thousands of Black constituents.

Among those who responded to Locke's vision of African visual culture reawakening in America were four Black artists, each of whom, like so many of the Renaissance's leading participants, had either joined the migration to Harlem or were actively engaged in the Harlem art world. Aaron Douglas had come to Harlem from Topeka, Kansas. He chose to observe aspects of African rituals expressed in dance and everyday life and incorporated the iconography into his own work. He selected design elements, particularly from the masks

and figural sculptures of West Africa, to serve as visual signposts in the new art he was creating for Black America.

Meta Fuller's art came to the attention of the leaders of the Harlem Renaissance after she had spent several years working in Paris. As early as 1902, African-inspired themes were evident in the sculpture of Meta Warrick, whose marriage in 1909 to Dr. Solomon Fuller from Liberia, West Africa, was an important event in Black America both socially and culturally. She inventively interpreted African folktales in her sculptures, bringing new insights to the portrayal of neo-African themes in American art.

Palmer Hayden came to Harlem from Wide Water, Virginia, after World War I. He became the principal artist to communicate Black folklore from the South through his paintings and to express visually the native customs of Southern Blacks. He introduced the magic of Black American legends and myths to the Harlem scene and brought them to life with narrative scenes of musicians and dancers colorfully reminiscent of the stories told by his ancestors in ancient Africa.

William H. Johnson migrated to Harlem in the 1920s and gradually established himself as a special interpreter of the culture of Black people in the South and of the primitive peoples of several European countries that he was to visit between the years 1929 and 1938. His self-imposed aesthetic rules and restrictions, relating to what he called "primitive painting," freed him from academic traditions and permitted a lyrical artistry to flow from his brush.

The wisdom, insightful artistry, and creative will of these four artists helped establish a new tradition among Black American artists that affirmed both their individual and racial identities. Each made vital contributions to the development of American art. During the flowering years of the Renaissance the work of these four individuals helped to direct the artistic genius of a people whose place was Harlem.

META VAUX WARRICK FULLER (1877–1968)

Celebrated as a sculptor whose artistic perception and understanding of the Black experience was well ahead of her contemporaries', Meta Fuller was the first Black American artist to draw heavily on African themes and folktales for her subject matter. She was a native of Philadelphia and the product of Black middle-class rearing. She attended the Pennsylvania Museum and School for Industrial Arts (now the Philadelphia College of Art) from 1894 to 1899 and continued her studies at the Pennsylvania Academy of The Fine Arts in Philadelphia from 1903 to 1907. By 1902, however, Fuller was already an established artist in Paris, where her work had been exhibited at S. Bing's famous gallery for modern art and design, l'Art Nouveau. Her art reflects the strong influence of Auguste Rodin, with whom she studied while in Paris, but is free from the Impressionist formulas and preoccupation with visual sensations that informed the work of so many of her contemporaries. In choosing her subject matter, she looked to the songs of Black Americans and to African

folktales for inspirational themes that focused on pathos and joy in the human condition.

Fuller's style echoes the romantic realism commonly seen in French sculpture of the late nineteenth century, but her figures are also imbued with powerful Expressionist characteristics. By modeling in a manner which often permitted the clay to distribute light evenly over the entire surface of a sculpture, she created strong statements in plaster and clay—many of which were later cast in bronze—that implied form rather than delivering total realism.

Fuller introduced America to the power of Black American and African subjects long before the Harlem Renaissance was under way. Until Fuller, the aesthetics of the Black visual artist seemed inextricably tied to the taste of White America; more particularly, perhaps, to subject matter and definitions of form derived from European art. The occasional portrait of a Black subject was painted or carved by an aspiring Black artist, but apart from Edmonia Lewis's *Forever Free* (1867) and Henry O. Tanner's two masterpieces of Black genre, *Banjo Lesson* (1893) and *The Thankful Poor* (1894), few visual statements with a pronounced Black program were created in the nineteenth century.

In 1914, Fuller created a sculpture which anticipated the spirit and style of the Harlem Renaissance. Entitled *Ethiopia Awakening,* it symbolized the emergence of the New Negro—whom Alain Locke was not to acclaim as an established member of Black American society until 1925 (plate 2). The composition reveals a partially wrapped mummy, bound from the waist down but with the hair and shoulders of a beautiful African woman. The suggestion of death, a theme frequently explored by the artist from as early as 1902, is evident in the lower half of the figure, while the upper part of the torso is alive and expressive, evoking the emotions of motherhood, the rebirth of womanhood, and the emergence of nationhood. The woman wears the headdress of an ancient Egyptian queen. She may be derived from a portrait of Queen Tye, the mother of Akhenaton, or perhaps the Queen Mother of the sixteenth-century kings of Benin. But in title and spirit she is unquestionably the image of Ethiopia, mythical symbol of Black Africa.

Ethiopia Awakening was a truly Pan-Africanist work of art. At a time when Picasso and followers of the modernist tradition gleaned design elements from the art of non-Western societies without being responsible for the cultural context out of which the work came, Fuller's art evidenced a hereditary union between Black Africa and Black America. Her desire to awaken Black people to the consciousness of nationhood and anticolonialism is evident in her choice of the African motif: Africa is on the brink of self-propulsion and self-fulfill-ment in *Ethiopia Awakening.* Fuller's work was precocious, communicating a message of hope in what seemed like a hopeless world beset with war and famine which made a travesty of the edict of peace purported to exist among the nations of the Western world. Fuller may well have been articulating in plastic form the biblical prophecy of the psalmist who proclaimed: "Princes shall come out of Egypt. Ethiopia shall soon stretch out her hands unto God"

(a theme also illustrated by Aaron Douglas). The symbol of Africa who reaches forth from bondage to freedom connotes the awakening of the forces of good, truth, and beauty in rebellion against colonialism and European exploitation of African peoples and resources.

Fuller met W.E.B. Du Bois in early 1900 in Paris, and their association revealed her devotion to understanding the full range of race relations at home and abroad. The astuteness of her inquiry into African and Black American politics, to which she was introduced by Du Bois as well as other Black American visitors to Paris during her stay there, is reflected in the artistic subjects she used, like *Ethiopia Awakening,* to comment on the Black experience. Beyond her preoccupation with Black themes, however, arose the somber specter of death and sorrow, both of which were themes that often appeared in her work. Her art was so concerned with subjects of the afterlife that critics often referred to her sculptures as macabre and highly emotional. Yet Fuller was also capable of endowing her figures with gracefulness, as she revealed in *Danseuse, Primitive Man,* and *Oriental Dancer,* which were among many of her sculptures that graced the rooms of S. Bing's gallery. Her works also included images of intimate emotional relationships, including the tenderness of a mother's love for her infant child, portrayed in a bronze composition she began in 1914 (plate 4).

The culminating statement of the artist's career is found in her celebrated work *Talking Skull,* executed in 1937 (plate 27). An African male kneels gently in front of a skull silently communicating his thoughts, undisturbed by the gulf which separates life from death. Dramatic in its appeal to have us reason with ourselves to see our final end, the work, like *Go Down Death* by Aaron Douglas (plate 33), executed about ten years earlier, is convincing in its symbolic, traditional means of communicating the mysteries of life and death.

Best remembered for compositions that represented a macabre and shocking use of Black subject matter, Fuller's art demonstrates her astute observance of history and her insightful understanding that Black subject matter could be meaningful in the work of Black artists. Paris was Fuller's courtly city, Rodin her friend, and she lauded the polite manners of the French. Framingham, Massachusetts, and the city of Boston represented for her the partial fulfillment of the European ideal in America. Indeed, Harlem itself was never home for Meta Warrick Fuller, but the ideals of the Harlem Renaissance were hers in form and spirit. She exhibited in Washington, D.C., with The Harmon Foundation exhibitions of the 1930s and later traveled to New York to serve as a juror for their exhibitions, which presented the most outstanding examples of art by Black Americans at that time. Her early Pan-Africanist approach to art, which she realized in the plasticity of sculpture, provided Alain Locke and the followers of the New Negro Movement with important ingredients for the making of an internationally significant Black statement in the visual arts.

* * *

Aaron Douglas (1899–1979)

Aaron Douglas arrived in Harlem in 1924, armed with a bachelor's degree from the University of Nebraska in Lincoln which certified him to teach art. A year of teaching on the high school level in Kansas City had quickly convinced him, however, that there was a higher calling in art for his services. Soon after arriving in New York, Douglas made the acquaintance of the German artist Winold Reiss, who questioned Douglas's untiring devotion to academic painting and suggested that instead of joining the ranks of realist painters he look to African art for design elements that would express racial commitment in his art.

Douglas closely followed the teachings of Reiss. His exploration of African aesthetics and use of Black subject matter in his work brought him to the attention of the leading Black scholars and activists, including W.E.B. Du Bois and Alain Locke. Du Bois invited Douglas to become a frequent contributor to *The Crisis* magazine, furthering his career as an important illustrator for periodicals, including *Opportunity, Vanity Fair,* and *Theater Arts Monthly* magazines. Locke, who was already deeply committed to encouraging the establishment of a "Negro School of Art" in Harlem, whose artists would draw heavily on design elements from African sculpture, used illustrations by Douglas between chapters of *The New Negro,* his famous anthology of Black writers published in 1925. Locke labeled Douglas a "pioneering Africanist," the first such praise given to a visual artist and a stamp of approval that influenced future historians to consider him "the father of Black American art." Douglas's reputation quickly reached beyond Harlem. He was sought after by patrons in Chicago and Nashville—among the many places his art was exhibited—to paint murals and historical narratives relating to Black history and racial pride.

One of Douglas's most celebrated series of paintings was executed at the wishes of poet James Weldon Johnson for his book of poems *God's Trombones: Seven Negro Sermons in Verse.* He created images for Johnson's book inspired by stories from the Bible, Negro spirituals, recent Black history, and the customs of Africans and Black Americans. The original series was completed in 1927 and included the illustrations *Judgment Day, Let My People Go, Go Down Death, Noah's Ark,* and *The Crucifixion* (plates 30–33). Each work was executed in a flatly painted, hard-edge style that defined figures with the language of Synthetic Cubism and borrowed heavily from the lyrical style of Reiss and the forms of African sculpture. He employed a syncopated flow of circular lines amidst smoothly painted surfaces in each work, and by following this formula he was able to move closer to a personal interpretation of his Black subjects. In fact, Douglas came close to inventing his own painting style by this eclectic combination of elements in his work. As a result of the success of the *God's Trombones'* illustrations, he was invited frequently by other authors to illustrate their literary works. The most notable invitation came from Paul Morand, who requested illustrations by the young artist for his book *Black Magic.*

Douglas's academic training and painterly ambition came through clearly in

his Precisionist-style drawings for *God's Trombones*. While his images visually describe particular themes in the text, they also stand as individual statements and indeed are legitimately fine paintings. Special design concepts are observed, however, for Douglas's works in *God's Trombones* complement the gospel-inspired, poetic sermons that Johnson borrowed from the mouths of illiterate Black poets and preachers and gracefully transformed into his sophisticated prose. His colorful writing captures the spirit and flavor of thousands of unschooled Black voices.

It was Douglas's desire as well to capture the essence of Black expression in a painterly formula. By closely observing the crowds of Black bodies swaying back and forth at the Savoy Ballroom, The Dark Tower, and the many clubs where Black social climbers gathered nightly to see and be seen, the prowling artist began to find the images, if not the subject matter, he needed. The sounds of music were heard everywhere, according to Douglas. The spoken word flared through colorful poetic expressions from the pens of the well-trained writers who now saw Harlem as the most soulful city in the world. Indeed, all of the activities of the White observers and Black participants in the Harlem Renaissance eventually got translated into some form of artistry. Yet, the themes that recurred over a period of years in Douglas's work were not based on Harlem nightlife and Black entertainment. Instead, he chose to review Black history, religion, and myth for the substantive sources that were at the core of the stylized subjects he created during the Harlem Renaissance.

Critics looked upon Douglas's art as a breath of fresh air in what had been a rather stagnant climate. Black imagery in the academic tradition of painting had existed predominantly with paintings that pointed to "African types" as "good" subject matter. There were the almost anthropological studies of Blacks by Cyrus Baldridge, created at the behest of Mrs. John D. Rockefeller. Winold Reiss, too, had done similar paintings of Georgia Sea Island subjects. Forsaking the realism of these interpretations of Blacks and any established forms of iconography associated with persons of African descent, Douglas instead chose to use geometric formulas, creating synthesized compositions. Circles, triangles, rectangles, and squares became the dominant design motifs of Douglas's compositions. Figures were prominently displayed so as to fulfill his principles of highly designed, "meaningful spatial relations." Design concepts were at the core of his art, and the importance of the composition was a lesson Douglas spoke of hearing Mary Beattie Brady, director of The Harmon Foundation, preach over and over again when she saw works by artists she described as "persons of African descent." (Douglas believed it was Miss Brady who made the latter phrase fashionable, as she despised references to "colored" and seldom used the word "Negro.")

Miss Brady, along with the patrons Charlotte Mason and Carl Van Vechten, cheered the stylistic accomplishments of Douglas. They were among the small number of Whites who believed that there was something innate about the way Black artists responded to auditory and visual phenomena. They did not

see themselves as patronizing by encouraging Black artists to "be primitive." Douglas, however, spoke often of his concern that Charlotte Mason, whom he never described as an intellectual, was causing undue harm to the artistry of literary figures such as Langston Hughes and Zora Neale Hurston by her efforts to encourage the primitive elements in their writing. He maintained a close but guarded friendship with Carl Van Vechten throughout Van Vechten's lifetime. With Georgia O'Keeffe and Charles S. Johnson, he was influential in having the art gallery at Fisk University named for Van Vechten in 1946. O'Keeffe donated a sizable part of the Alfred Stieglitz Collection to Fisk University, and The Carl Van Vechten Gallery opened in 1949 on the premier Black campus for the arts. The gallery also housed a large selection of photographs by Van Vechten, including numerous portraits of the Black intelligentsia and key participants in the Harlem Renaissance.

Van Vechten saw himself as a patron and critic of all the arts of the Renaissance. He advised Douglas on the salability of his work to writers and publishing houses. But it was Douglas's own strength of character and inventive artistry that enabled him to have a lasting impact on the future course of Black expression in art. And it was in the series of paintings for *God's Trombones* that Douglas first expressed his commitment to creating a language for Black artists. He adhered closely to the salient principles of design he had learned from Reiss, boldly defining his figures within decisive geometric boundaries. Faces and limbs, however, were carefully drawn to reveal African features and recognizable Black poses.

Nowhere in Douglas's entire oeuvre is the concept of Black humanism more personally and successfully displayed than in *The Crucifixion* (plate 32). James Weldon Johnson's intonement "Jesus, my gentle Jesus, Walking in the dark of the Garden" poignantly reveals the agony of the Savior suffering for all mankind as He walks quietly through Gethsemane. Douglas sought to reinforce the literary message by painting the gentle figure of Jesus walking in the shadow of a towering Black crossbearer. Jesus the Savior is also Jesus the bearer of everyman's burden, particularly the Black man's burden. The central figure in the composition is a Black male, who towers above the crowd, which includes a Roman sentinel representing the White guardianship of Black affairs in America and Africa. The Black man carries a cross much larger than he is, and the strain and agony of his travail is keenly accented on his face. The weight of the world rests also on the shoulders of this Black crossbearer: he is the worker among men, the builder of cities that circumscribe his access. Indeed, he is the legendary Simon, a Black man who took upon himself the yoke of Jesus' cross in order to relieve him of one last earthly misery. It is Simon who received the threats of the Roman soldiers.

The Crucifixion breaks with traditional Christian iconography. A Black subject dominates the Christian theme. Man's inhumanity to man, as seen through Black eyes, is poignantly revealed through cultural disguises. Like the Negro spiritual, which made much of satire and cultural subservience by rewording

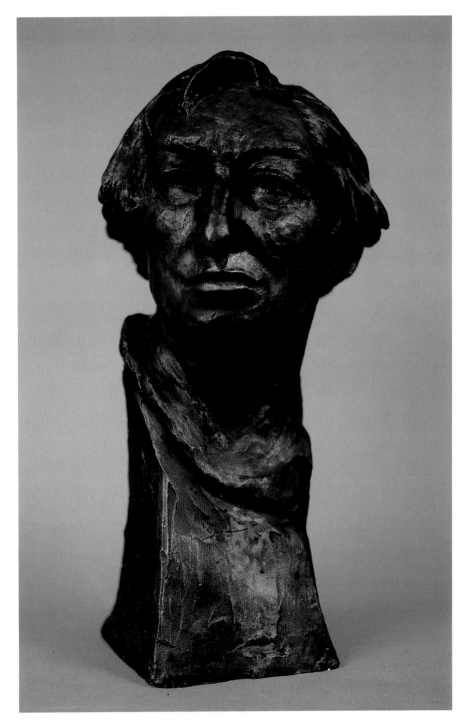

Plate 21.
Meta Warrick Fuller.
HENRY GILBERT. 1928.
Painted plaster, 17½
× 9 × 9". Collection
Solomon Fuller, Bourne,
Massachusetts

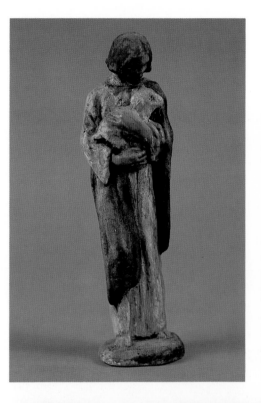

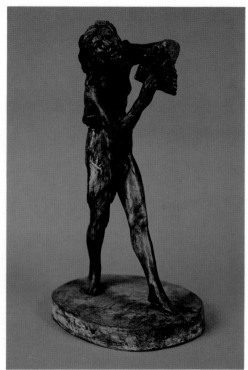

(above: left) *Plate 22.*
Meta Warrick Fuller. THE
GOOD SHEPHERD.
c. 1926–27. Painted
plaster, 7 × 2¹/₂ × 2¹/₂".
Collection Solomon Fuller,
Bourne, Massachusetts

(above: right) *Plate 23.*
Meta Warrick Fuller.
BACCHANTE. *1930.*
Painted plaster, 13 × 8
× 3¹/₂". Collection
Solomon Fuller, Bourne,
Massachusetts

(below) *Plate 24.*
Meta Warrick Fuller.
WATERBOY. *1930.*
Plaster, 13¹/₂ × 4¹/₂
× 4¹/₂". Collection
Solomon Fuller, Bourne,
Massachusetts

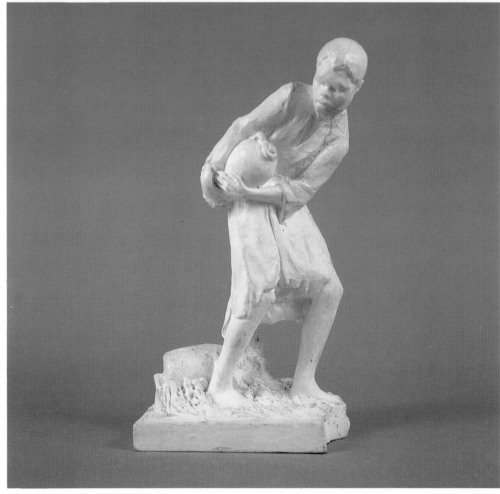

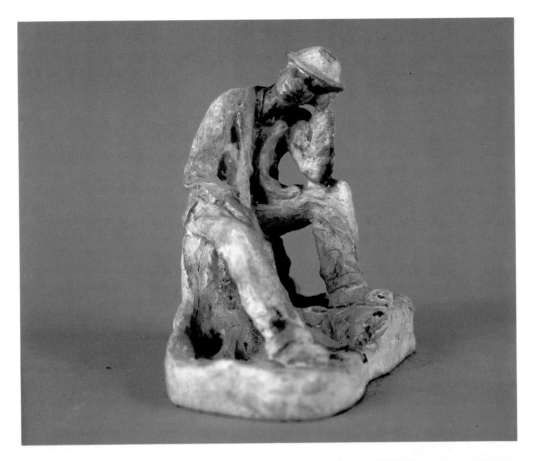

■

Plate 25.
Meta Warrick Fuller.
LAZY BONES IN THE
SHADE. *c. 1937. Painted*
plaster, 7½ × 4½ × 5".
Collection Solomon Fuller,
Bourne, Massachusetts

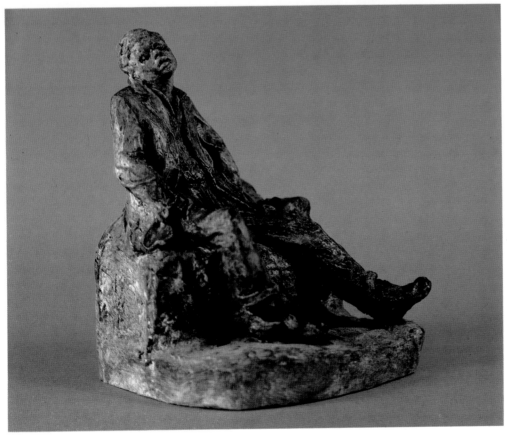

■

Plate 26.
Meta Warrick Fuller.
LAZY BONES IN THE
SUN. *c. 1937. Painted*
plaster, 7½ × 4½ × 5".
Collection Solomon Fuller,
Bourne, Massachusetts

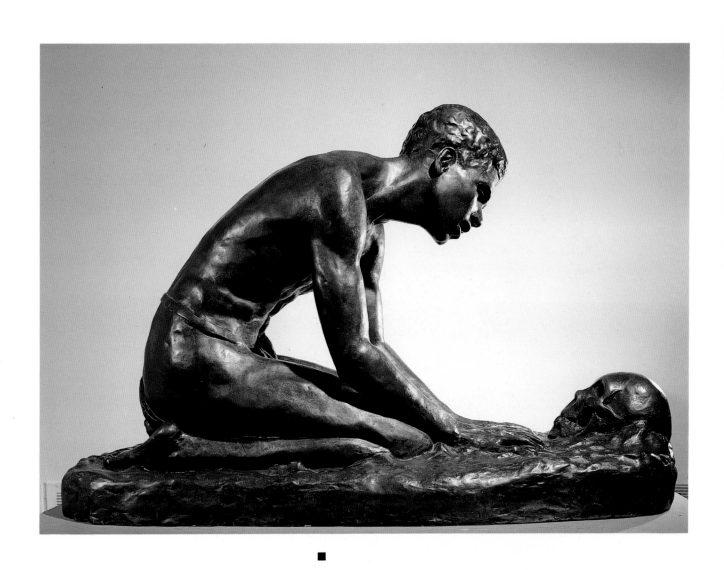

Plate 27.
Meta Warrick Fuller.
TALKING SKULL. *1937.*
Bronze, 28 × 40 × 15".
The Museum of Afro-
American History, Boston

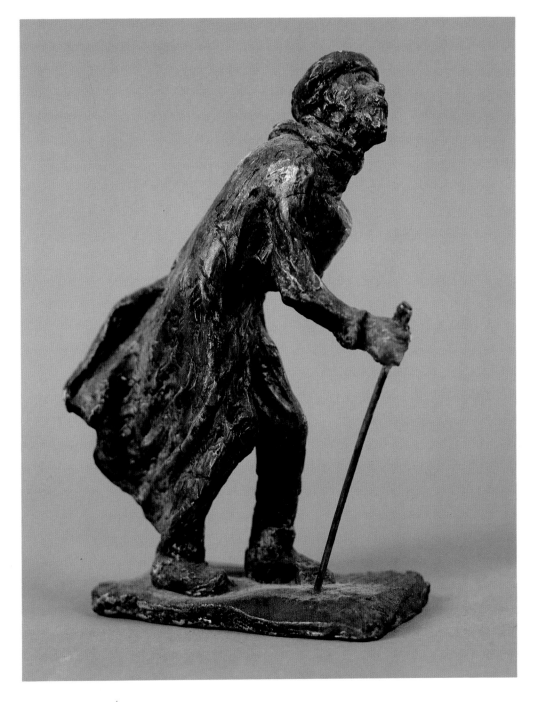

Plate 28.
Meta Warrick Fuller.
REFUGEE. *c. 1940.*
Painted plaster, 8¹/₂ × 5
× 2". Collection Solomon
Fuller, Bourne,
Massachusetts

■

Plate 29.
Meta Warrick Fuller.
JASON. *n.d. Painted
plaster*, 12 × 17 × 8½".
Collection Solomon Fuller,
Bourne, Massachusetts

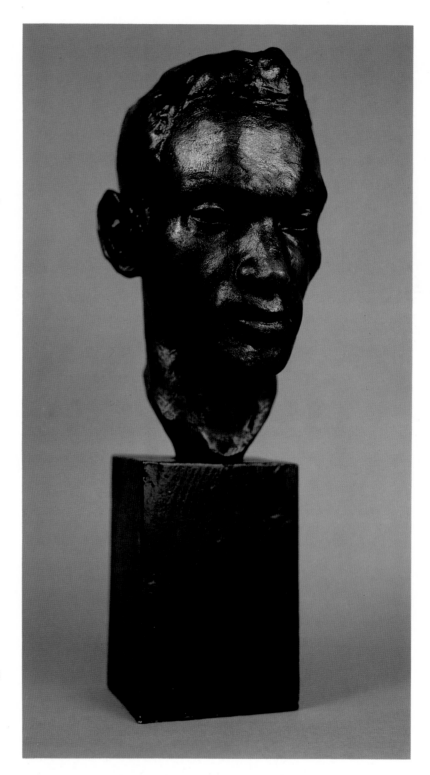

■

(opposite) *Plate 30.*
Aaron Douglas. NOAH'S
ARK. *c. 1927. Oil on
masonite*, 48 × 36".
Fisk University Art
Museum, Nashville

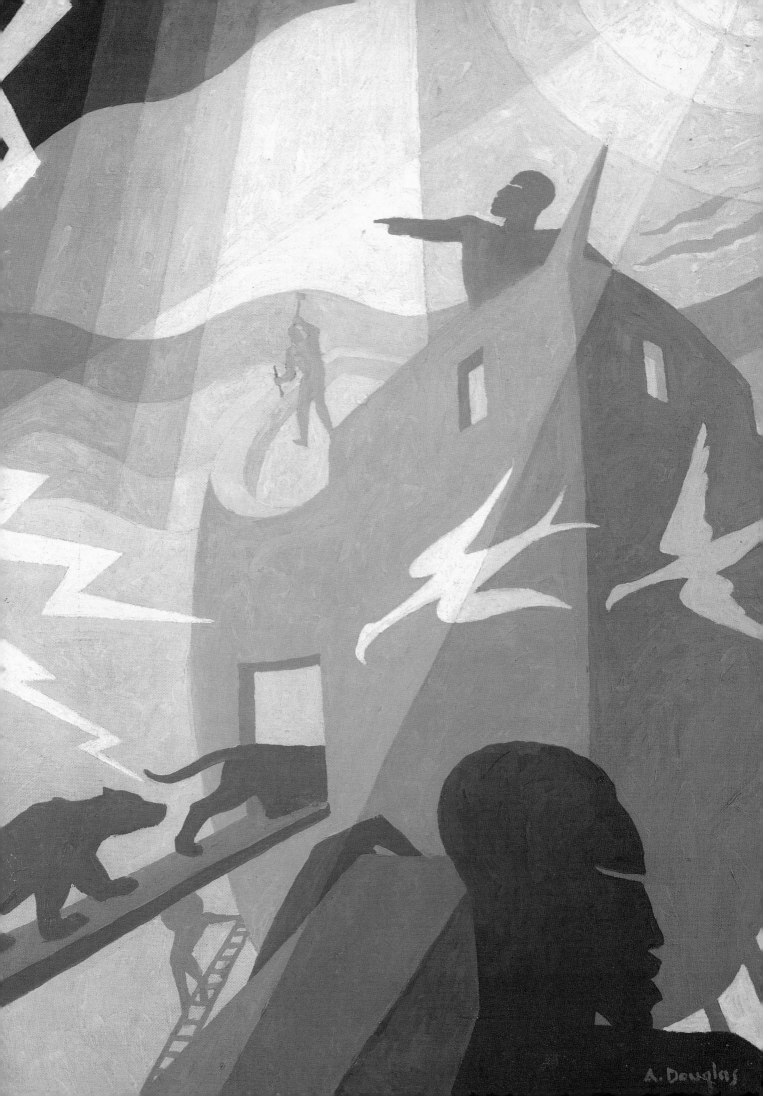

Plate 31.
Aaron Douglas. STUDY
FOR GOD'S TROMBONES.
1926. Tempera on board,
21½ × 17½". Evans-
Tibbs Collection,
Washington, D.C.

Plate 32.
Aaron Douglas. THE
CRUCIFIXION. *1927. Oil*
on board, 48 × 36".
Collection Mr. and Mrs.
William H. Cosby

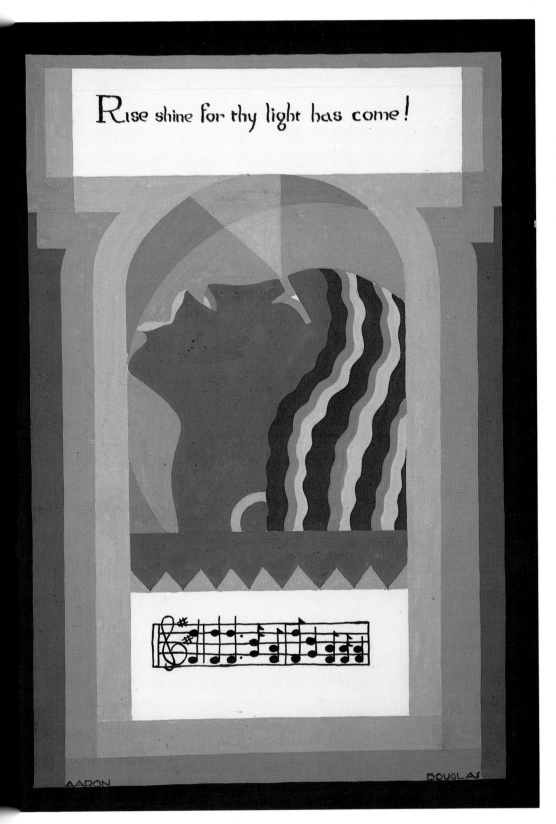

Plate 34.
Aaron Douglas. RISE,
SHINE FOR THY LIGHT
HAS COME. *c. 1930.*
*Gouache on paper, 12
× 9". The Gallery of Art,
Howard University,
Washington, D.C.*

(opposite) *Plate 33.*
Aaron Douglas. GO
DOWN DEATH. *1927.*
*Oil on masonite, 48
× 36". Collection
Professor and Mrs. David
Driskell, Hyattsville,
Maryland*

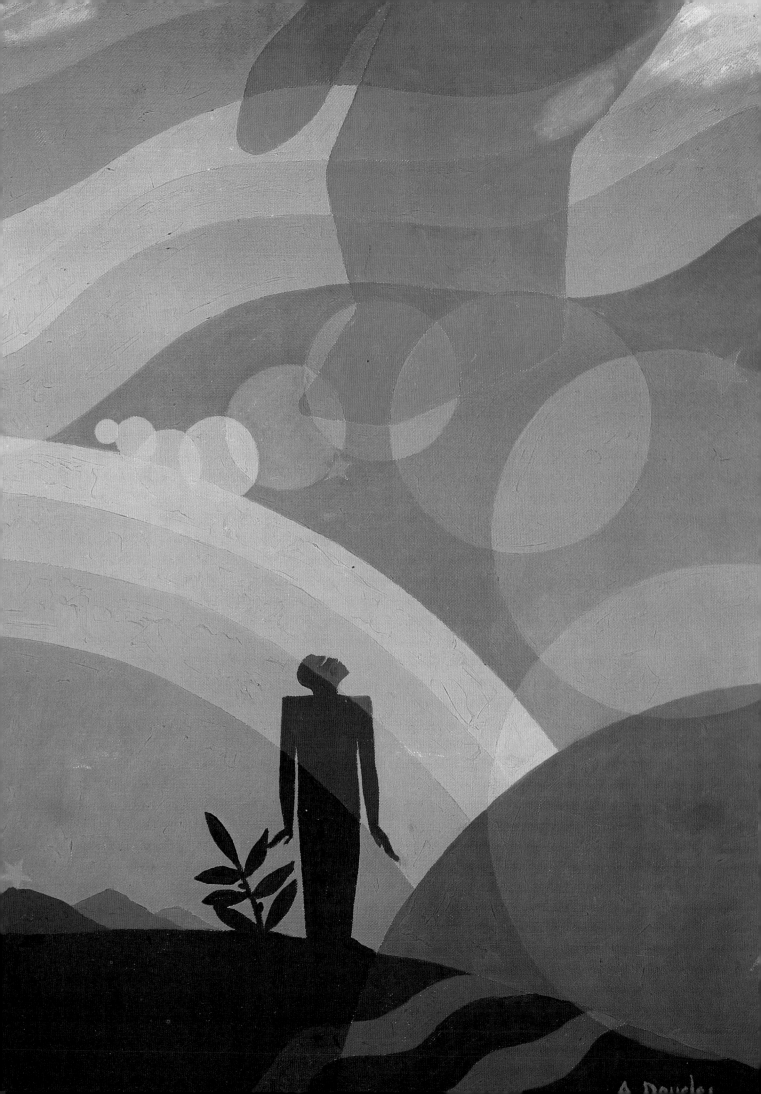

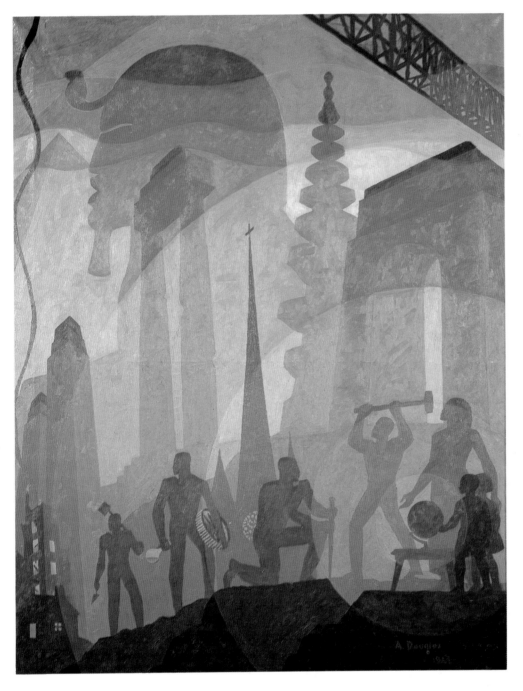

■

Plate 36.
Aaron Douglas.
BUILDING MORE
STATELY MANSIONS.
1944. Oil on canvas, 54
× 42". Fisk University
Museum of Art, Nashville

■

(opposite) *Plate 35.*
Aaron Douglas. THE
CREATION. *1935. Oil on*
masonite, 48 × 36". The
Gallery of Art, Howard
University, Washington,
D.C.

Plate 37.
Aaron Douglas. POWER
PLANT IN HARLEM. *n.d.*
Oil on canvas, 20 × 22".
Hampton University Art
Museum, Hampton,
Virginia

■

Plate 38.
Aaron Douglas. THE OLD
WATERWORKS. *n.d. Oil*
on canvas, 18 × 15".
Hampton University Art
Museum, Hampton,
Virginia

■

Christian dogma through alliterations that spoke to the tragic conditions of Black slavery and human deprivation, Douglas's message comes alive in a visual accord that strikes out at the core of American racism and the denial of the Black man's humanity. The sorrowing, blameless, and lonesome Jesus, about whom Johnson wrote in his poem "The Crucifixion," becomes every Black American of the 1920s.

In *God's Trombones*, Douglas also achieved his early mastery of hard-edge painting (as it is now called). With an agility of line and an economic use of recognizable symbolic features, Douglas was able to bring to life his stiffly painted figures, which he designed to some degree after the prevailing stylistic features of Art Deco. However, unlike the decorative programs of Art Deco, he capitalized on the possibilities of movement—perhaps influenced by the rhythms of Art Nouveau. Each of the paintings executed by Douglas for *God's Trombones* expressed his humanist concerns. In *Judgment Day*, the iconography is again politically divorced from traditional paintings by White artists. A supreme Black figure stands above land and sea and announces the call to Judgment. In the provenance of traditional Christian art, Blacks were omitted completely from God's Creation except as servants, according to Douglas. For this reason he was determined to show Blacks as part and parcel of biblical events. He noted that Johnson had unerringly captured the essence of the Black man's religious ascendancy in his poem "The Creation." And it was his sense of "the spirit made flesh"—specifically the Black man's flesh—that Douglas wanted to present in *God's Trombones*.

In *Judgment Day*, Douglas planned to emphasize the positive appearance of Black power. Gabriel, the archangel, sounds the trumpet to awaken the dead from their spiritual and physical slumber. He is a lean Black man from whom the last earthly vocal sound is heard. The sound, which travels across the world, is the inventive music of the Black man. In his poem "The Last Judgment," Johnson's Gabriel talks with God:

> And Gabriel's going to ask him: Lord,
> How long must I blow it?
> And God's a-going to tell him: Gabriel,
> Blow it calm and easy.
> Then putting one foot on the mountain top,
> And the other in the middle of the sea,
> Gabriel's going to stand and blow his horn,
> To wake the living nations.

The music which awakens all nations, in the words of Johnson, is the song of a bluesman or a famous trumpet player. He is a timeless echo in the universe: the Louis (Satchmo) Armstrong, Miles Davis, or Wynton Marsalis of our time. The musician, consequently the artist, stands majestically in the center of the universe sounding the loud clarion of Judgment Day. He is at once a musician

of earthly note and at the same time a biblical character, the Angel Gabriel.

In *Judgment Day*, Douglas followed Johnson's chronicle and used simplified figures and forms to permit his interpretation of the Black man's place in the Creation and the destiny of the world to dominate the iconographic meaning of a well-known Christian theme. As in *The Crucifixion*, a Black subject is central to God's divinity. Gabriel, who sounds the last trumpet, is already safely called to God and looks down on all others who shall be summoned to submit to a final, irrevocable assembly before God's throne. (Gabriel's stance is repeated in the postures of the blues musician and migrant worker who occupy the central positions in the fourth panel of *Aspects of Negro Life*, a mural Douglas painted for the 135th Street branch of The New York Public Library in 1934.) It is the Black trumpeter in Douglas's painting who is charged by God to sound the colorless requiem to end all earthly acts. Douglas commented that few people knew the "power invested in these Black paintings."

An equally startling message is revealed in *Go Down Death* (plate 33), another painting executed for *God's Trombones*. The message is one of deliverance, as well as one in which the awesome sight of death is softened—indeed it is welcomed by the Black participants who wait for God's call. The work responds to the imagery of James Weldon Johnson's poetry and his account of Death's call on Sister Caroline, who is on her sickbed in wretched pain. When Death comes for Sister Caroline, she welcomes him and gladly goes home to Jesus in the arms of the angels. Douglas reacted against traditional depictions of death, so often portrayed hastening to snuff out the candle of life. In *Go Down Death*, his figure of Death appears astride a swiftly moving horse racing out of the picture plane. Douglas referred to the speed of Death aboard the horse as the "unknown dimension of life." The time to face mortality and reality was meant to be communicated. A large star is within reach of the rider, whose journey is hastened by wings borrowed from Gabriel. Rushing into an exosphere unknown, Death, who makes equals of us all, seems so far away and yet so near.

The language of form Douglas sought to implement in *Go Down Death* was commensurate in spirit with the verbal language of the Negro spiritual, one of the most popular musical forms in the Black community at the time he painted the series of illustrations for *God's Trombones*. It was the Negro spiritual which had retained the vivid language of enslavement, while at the same time providing all of the psychological escape mechanisms needed to affirm Black consciousness. The transfer of this dynamic from verbal to visual expression permitted Douglas to exercise his keen imagination in extending the iconography of death to earthly society. He reasoned that death was to be embraced as relief from the troubles of a segregated and racist world. Death is therefore rendered neutral and colorless in its judgment, but is still a passionate and urgent moment. The awesome sight of Death is softened by earthly tranquillity and the pleasurable experiences of the world. The swiftly moving horse that rushes through time to call on Sister Caroline helps to make Death acceptable and an ordinary occurrence.

When Douglas executed his mural painting series for the 135th Street branch of The New York Public Library in 1934, he had already begun to reconsider the use of realism in his work, responding to the art community's growing interest in portraiture and genre scenes. He roamed New York by day looking for views to paint. The Triborough Bridge, a park in Harlem, even a power plant (plates 37 and 38), all served to kindle the growing interest he felt toward the ordinary aspects of city life. Later in his career, after completing a series of murals for the second floor of the Erasto Milo Cravath Library at Fisk University, Douglas responded positively to the plea of his longtime friend Charles S. Johnson—one of the "midwives" of the Harlem Renaissance who became president of Fisk University in the 1940s—to join the faculty at Fisk. He taught painting there from 1937 until his retirement in 1966.

The attempts by Douglas to combine modernist aesthetics with African ancestral imagery afforded him a chance to stylize his art in a manner which had not been achieved by Black American artists before him. Black heritage and racial themes were the subjects he attempted to paint when he became aware of the interest Black people were developing in their own history and destiny. He was, on one occasion, severely criticized by James A. Porter, the leading Black art historian and critic of the 1940s, for borrowing too often from African art without properly applying these themes to the Black American condition. But had Douglas not led the way in using African-oriented imagery during the Harlem Renaissance, Alain Locke's brief to visual artists to "return to the ancestral arts of Africa for inspiration" would have taken even longer to be realized on the canvases of Black painters. It was Douglas who effected the crucial move toward affirming the validity of the Black experience and thereby made one of America's most worthy contributions to art.

Although Douglas returned from time to time to portrait and landscape painting, his lasting impact on the arts of Black America was his inventive approach to painting themes that related in form and style to the Black experience and consciousness. His death, in 1979, at his beloved Fisk University in Nashville, brought to an end the career of "a pioneering Africanist," whose artistic insight reached far beyond the walls of Harlem.

PALMER HAYDEN (1890–1973)

Palmer Hayden, a name given to the World War I veteran by his White commanding sergeant who could not pronounce his real name (Peyton Hedgeman), was born in Wide Water, Virginia. He is often referred to as a self-trained artist. However, the record reveals he was a student at Cooper Union in New York and pursued independent studies at Boothbay Art Colony in Maine. He studied and painted independently in France, where he lived from 1927 to 1932. Hayden's reputation emanates from his realistic depictions of folklore and Black historical events. He, like Douglas, was also among the first Black American artists to use African subjects and designs in his painting (which helped, in fact, to distinguish between certain ethnic stylistic differences in the

art of Black Africa). His *Fétiche et Fleurs,* a composition of 1926, highlights a Fang mask from Gabon and Bakuba raffia cloth from the Congo (now Zaire), which have been placed in a traditional still-life setting. Locke praised the artist for his modernist approach to painting. But Hayden was not a modernist in his stylistic approach. Instead, he broke with tradition by depicting African art in his paintings.

Hayden spent many years at work for The Harmon Foundation and maintained his loyalty to the ideals of the foundation and a strong friendship with its founding director, Mary Brady. He exhibited in the Harmon exhibitions beginning in 1926. Most of his works depict Black people comfortably situated in the humble surroundings in which they lived. Other images extol the work ethic and Black devotion to public service. He also painted numerous watercolors in the 1930s which are remembrances of Black nurses in the Red Cross and Black soldiers marching to reveille during World War I.

While most critics and art analysts, including James A. Porter, saw Hayden as a naive painter producing racial images that were almost grotesque, some saw him as an original interpreter of Black themes who highlighted Black folklore and certain aspects of the ancestral legacy. Locke specifically praised the pictorial attempts by Hayden to relate to his African past and did not agree with Porter's analysis of how far Hayden had strayed from the ideal, healthy approach to making Black images. In his interpretations of the Black legacy, Hayden saw no reason to refrain from borrowing from the popular images of Blacks by White artists. He often exaggerated Black features, stylizing eyes, noses, lips, and ears, and making the heads of many of his subjects look bald and rounded in form. But he insisted that he was not poking fun at Black people. Some people living in the better sections of Harlem found it hard to believe that Hayden was not being satirical when they saw *Dove of God* (1930) and *The Janitor Who Paints* (plate 13). *Dove of God,* a watercolor executed in a free-flowing style, depicts the spiritual uplift Black people receive in fundamentalist church services. The preacher is shown dramatizing his sermon to the point where the attentive audience demonstrates its empathy with what is being said by an outpouring of emotions. So moved is the spellbound audience by the words of the preacher, who no doubt describes the biblical passage "This is my beloved son in whom I am well pleased" (at which point the dove of God descends from the sky), that little attention is paid to the half-hidden figure of a man who releases the bird from the ceiling. Such scenes were common in Hayden's oeuvre and were derived from a previous era in Black American painting. They recalled the traditional affinity Black artists had with the art of the American mainstream before the Harlem Renaissance. Indeed, it was this affinity which Locke sought to abolish when he encouraged Black artists to look to Africa for inspiration in their work. However, Locke saw positive elements in Hayden's work that the general public did not see.

In an interview at Fisk University, where his John Henry series of paintings was exhibited in February 1970 (plates 14–16), Hayden recounted to me the

experience of trying to explain to an often critical Black public what the subjects were about. Too often, they were classified as Black stereotypes. He spoke of the folk tradition and of its heroes, such as John Henry. He spoke also of the autobiographical *The Janitor Who Paints*. But Hayden's audience was critical of both his subject matter and the stylistic manner in which he worked. Some were so personal in their criticism as to argue that although Hayden served as janitor and handyman at the offices of The Harmon Foundation, he did not return home to a Black family with humble surroundings. But Hayden insisted that he was painting an era, and his works symbolically made reference to the comedy, tragedy, and pleasures of a Black life-style.

In a celebrated composition entitled *When Tricky Sam Shot Father Lamb* (1940), Hayden directs our attention to an act of violence in the Black community. The title suggests "Black on Black" crime—as it is called today— but crime is not the intended emphasis of the painting. Instead, the artist dramatically portrays a concerned crowd: the same type of people who were seen sitting around, strolling along the street, and parading their latest fashions in *Midsummer Night in Harlem* (1936). He offered a smaller, similar audience gazing down at the dead body of John Henry in *He Died with the Hammer in His Hand* (from the John Henry series). The crowd in the street, watching evening events, marching in parades, and experiencing the everyday occurrences of everyday life, were an important part of Hayden's work.

The fashions and manners of the people he painted are important elements in the appeal of Hayden's art. *Just Back from Washington* (plate 40), shows a young, cigar-smoking Black man, majestically posed in a super-dapper outfit, sporting patent-leather shoes, striped pants, Palm Beach hat, white vest, white driver's gloves, silk coat, and bamboo strolling cane. He represents the "city-dude," who was a perennial presence at the night spots of Harlem. A young boy kneels, as if in submission, before the well-groomed man, shining his already polished shoes to a spit-shine quality. Hayden's paintings of the 1930s and 1940s chronicle the various manners of dress found in the Black rural South and Northern urban communities. They are culturally telling depictions of print designs, hairstyles of women, and the flamboyant dress often associated with Northern Black males. Yet the fear of pejorative imagery by a Black artist made some Blacks uneasy. They felt that Hayden's caricature-like images were what White Americans welcomed. He did not, they claimed, define Black imagery that was positive. However critical Hayden's audience was of his interpretation of the Black experience, his lasting impact on Black American painting cannot be denied. His art is positive, born of a true affection for the quality of Black life Hayden knew, believed existed, and dreamed about.

His paintings depicting African themes were not always geographically accurate, but this was not his intention. *Blue Nile* (plate 47) and *African Dancers* (1932) conjure up the prevailing visual attitude of how Africans— without national distinction—live in their native land. Here, again, dress and common customs associated with African peoples are derived from the usual

formulas European artists had applied to the subject. Indeed, some of these subjects were based on themes Hayden had developed while living in Paris in the early 1930s.

Hayden's art cannot be defined as a systematic approach to painting. While he seldom paid strict attention to the rules of academic painting, Hayden never thought of himself as a primitive artist, a label often associated with his work. Instead, he saw himself as an artist whose themes and style of painting were consistent with the time in which he lived. These works he regarded as symbols of the changing order of contemporary American life. Folklore was at the core of many of his compositions, but he was also keenly aware of the plight of rural Blacks making their way to the industrial North in search of a more humane life-style. Industrial America is symbolically dependent on the hands of Black workers in many of his compositions, an observation Hayden frequently made in paintings, such as the John Henry series.

Hayden's love of life and people is paramount in all of his art. His keen observation of nature, the land, and sea is outstandingly represented in oil and watercolor compositions, including many of Boothbay Harbor, Maine (plate 43). His paintings, which chronicled the Black experience, are often without particular reference to a specific time. But one is seldom left wondering from what community Hayden derives his themes of urban life. The place is Harlem, spiritual home of the Black Renaissance.

WILLIAM H. JOHNSON (1901–1970)

William H. Johnson arrived in Harlem when the Renaissance was in the making. He had come to New York in 1918 from Florence, South Carolina, and became a student at the National Academy of Design. He remained there for five years, absorbing the teachings of George Luks and Charles Hawthorne, and readying himself for a career in art that would take him to places in North Africa and Europe in search of a permanent residence. It was through the influence of Hawthorne that Johnson traveled first to Paris in 1926, where he settled, painted, and studied the works of modern European masters.

Johnson's introduction to art had come through the cartoons he saw in a local newspaper in Florence. Little did he dream that one day he would become a seasoned traveler, whose art interests would take him from Tunisia to Norway. But the skills he had acquired in painting at the National Academy of Design stood him in good company with sympathetic European artists, who encouraged him to remain abroad and devote his life to art. By 1929, Johnson's carefully developed style of painting, which borrowed heavily from both realism and Impressionism, was beginning to show signs of change. He had come in contact with the work of Paul Cézanne, Georges Rouault, and Chaim Soutine. He admired the rugged and direct style of painting associated with Vincent van Gogh's work. His mind and eyes were wide open to change as he embraced one style of painting after another in search of a permanent way to express himself through art. By 1930, Johnson began to develop a stable stylistic

consciousness. He became increasingly attracted to the work of Soutine. In Soutine's work, he found a way of removing himself stylistically from the smooth painterly style he had developed under Hawthorne. His compositions became somewhat cumbersome, with emotional displays of elongated, curving forms. Academic realism would no longer play an important role in Johnson's work, as he moved his art closer to the style of painting recently made famous by the German Expressionists (plate 19).

Johnson settled in Denmark in the spring of 1930. He had married Holcha Krake, a local potter, and they made Kerteminde, a small fishing village, their home for the next few years. It was in Kerteminde and its vicinity that many of the landscapes Johnson praised as his best works were painted. He expressed feeling a close kinship with the life-style of the Danish villagers, often describing his own way of living in the rural South as closely related to that of his adopted countrymen. By 1932, he and his wife headed south to explore North Africa and to study the art of the region. Their stays in Tunis, Tangiers, and outlying villages permitted them to learn from local artists about African pottery and the arts and crafts of the region. Johnson continued to formulate his expressive style during his entire stay in North Africa. He was devoted to seeing what he described as the primitive ways of people and once spoke of having learned more from the fishermen of Kerteminde and the Arabs of North Africa than he had in his entire academic career.

Johnson's strong interest in what he described as the primitive life-style of the people inspired him to experiment with his painting, attempting to make his philosophy of art commensurate with his adopted philosophy of life. He wanted to rid himself of the attributes of the trained academic painter and revert to a style of painting that he later referred to as primitive. When asked why he had forsaken the academic style he had mastered in earlier paintings, he responded, "My aim is to express in a natural way what I feel both rhythmically and spiritually, all that has been saved up in my family of primitiveness and tradition." The primitive style to which Johnson referred should not be confused with the more naive form of painting developed upon his return to Harlem in 1938. Instead, the "primitiveness" of Johnson was to manifest itself in his work in ways which celebrated the Expressionism of Edvard Munch, Soutine, and van Gogh. But, by 1938, Johnson had forsaken the Expressionist painting associated with his European sojourn and was concentrating on subjects and themes that celebrated the Black experience.

Johnson's return to America in 1938 provided him with the subjects he needed to make the crossover from Expressionism to a style of painting that bordered on primitivism. It was a difficult task for an artist so well trained in the academic process to forsake all that he had learned and to turn "primitive" overnight. But Johnson was not one to give up easily on his goals. When he returned to Harlem, the cabaret and nightlife scenes so enthralled him that he began working endlessly to capture the spirit and flavor of what he was experiencing in postwar America. For the next six years, he devoted an enormous amount

of energy creating hundreds of compositions that expressed various aspects of the Black experience in the United States. Harlem became the central theme of many works that emanated from his new way of painting.

The style of this new work has often been described as naive, primitive, and folk-oriented. His formula was simple and direct. He applied flat paint to geometrically drawn forms, which were still somewhat dependent on the elements of Expressionism that had dominated his work over the previous ten years. By the late 1930s, Johnson's style had moved permanently in the direction of naive painting, and he had reduced his palette to four or five colors. He became increasingly interested in Black subjects that emphasized Christian themes. Compositions such as *Nativity* (c. 1939), *Descent from the Cross* (c. 1939), and *Mount Calvary* (plate 49) presented an all-Black cast as the family of Jesus.

Aaron Douglas had introduced Black religious subjects into his work in the 1920s. Malvin Gray Johnson (fig. 18) had painted Black religious themes based on Negro spirituals, as had Alan Rohan Crite. But none of these artists had celebrated the theme of Black Christianity with the depth of Johnson's presentations. Douglas's introduction of Black Christian themes came through literary formats acceptable to the Renaissance audience. James Weldon Johnson's poetry, which echoed the voices of untutored Black preachers, seemed a fitting place for Douglas to begin. Malvin Gray Johnson had limited his interpretation of the Christian theme to spirituals. Alan Rohan Crite drew heavily on the iconography of the Italian Renaissance for his interpretation of the Negro spiritual in a series of drawings he completed in 1938.

But William H. Johnson changed the course of artistic interpretations of Black American themes in Christianity. He undertook reinterpretations of many of the familiar subjects by European artists on the life and death of Jesus. *Jesus and the Three Marys* (plate 20)—a theme also painted by Henry O. Tanner—shows the crucified body of a Black Christ before three Black women. The Virgin Mary is shown bent with emotion at the foot of the cross. Interestingly, the scene of the Crucifixion differs little in formal structure from another Johnson painting, of about the same date, in which similar female figures are seen next to the body of a lynching victim.

Johnson always showed great devotion to painting themes that celebrated Black Christianity. *Climbing Jacob's Ladder* (c. 1939) and *Swing Low, Sweet Chariot* (plate 51) are paintings based on a literal interpretation of spiritual occasions. In the former, four female figures are shown in the company of two males, struggling to climb a pyramid-shaped ladder that rises to a sky in which the sun, the moon, and stars are seen. All of the figures are nude and one of the male figures lies sprawled on the ground in front of the ladder. It becomes quite clear to the observer that Johnson was integrating religious and social messages in this painting, a practice he shared with Aaron Douglas. In *Swing Low, Sweet Chariot*, Johnson shows the lyrical finesse of his work and his narrative skill. A chorus of Black angels, who resemble the women seen frequently in Johnson's paintings of everyday scenes, are lined up in midair waiting,

Plate 40.
Palmer Hayden. JUST BACK FROM WASHINGTON. *1938. Watercolor on paper, 15¹/₂ × 12¹/₄". Collection Evelyn N. Boulware, New York*

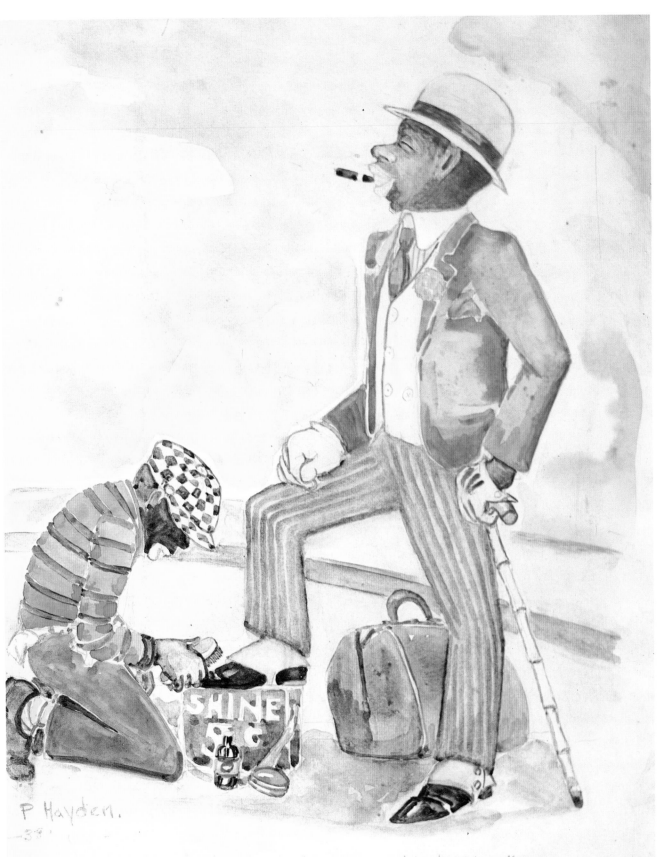

P Hayden.
-3?-

"Just back from Washington"

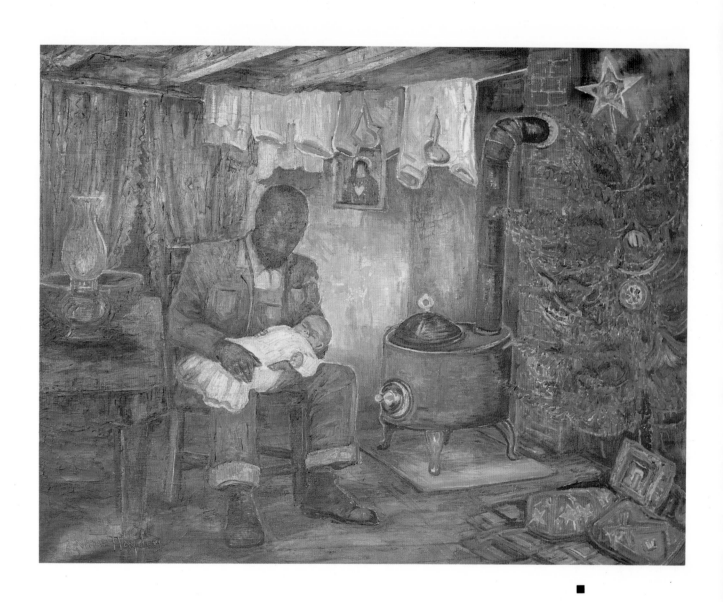

Plate 41.
Palmer Hayden.
CHRISTMAS. *c. 1939–*
40. Oil on canvas,
57 × 34 1/2". Collection
Evelyn N. Boulware,
New York

Plate 42.
Palmer Hayden. THE
DRESS SHE WORE WAS
BLUE, *from the John
Henry series. 1944–54.
Oil on canvas, 29 × 36".
The Museum of African
American Art, Los
Angeles. Palmer C.
Hayden Collection, gift of
Miriam A. Hayden*

Plate 43.
Palmer Hayden.
BOOTHBAY EAST.
c. 1950. Watercolor on
paper, 10×15".
Collection Evelyn N.
Boulware, New York

Plate 44.
Palmer Hayden. BARGE
HAULERS. *c. 1950. Oil
on canvas, 20⅛×33⅛".
Collection Evelyn N.
Boulware, New York*

■

Plate 45.
Palmer Hayden. THE
SUBWAY. *c. 1930. Oil on
canvas, 31 × 26½". The
State of New York/Adam
Clayton Powell, Jr., State
Office Building Collection*

■

Plate 46.
Palmer Hayden. 56TH
STREET. *1953.
Watercolor on paper,
23 × 17¼". Collection
Evelyn N. Boulware,
New York*

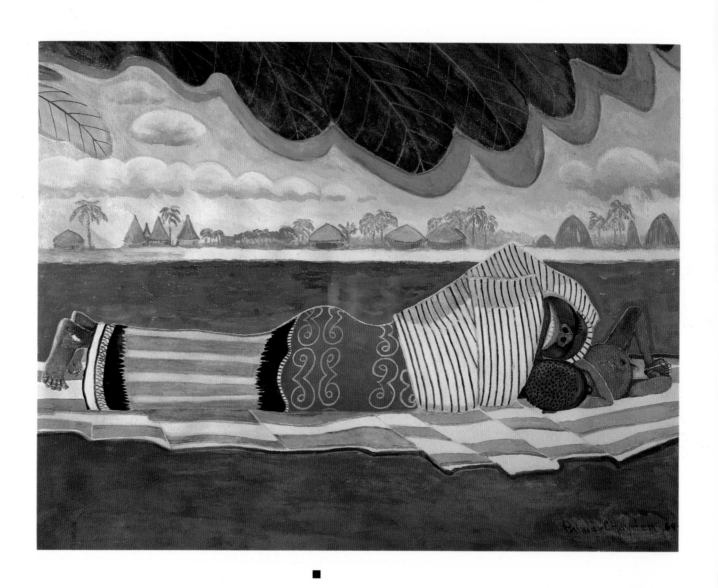

Plate 47.
Palmer Hayden. THE
BLUE NILE. *1964.*
Watercolor on paper, 19
× 26½". Hatch Billops
Collection, Inc., New York

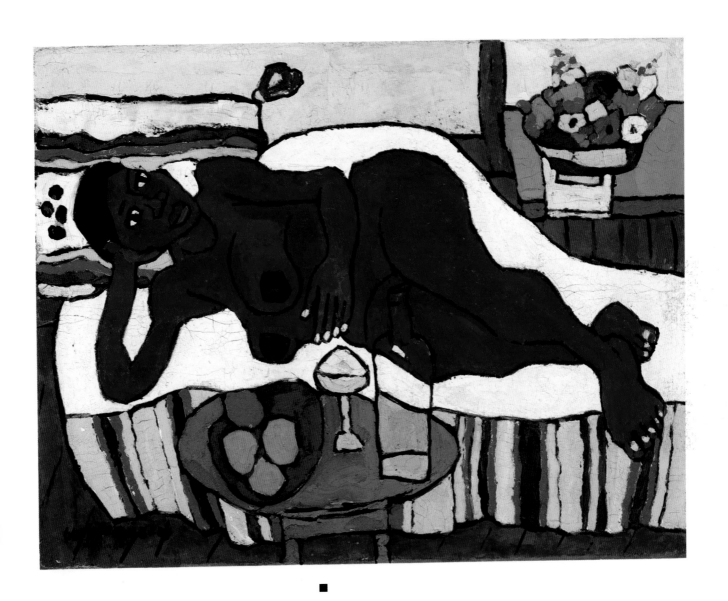

Plate 48.
William H. Johnson.
NUDE (MAHLINDA).
1939–40. Oil on burlap,
29¼ × 38". The
National Museum of
American Art,
Smithsonian Institution,
Washington, D.C. Gift of
The Harmon Foundation

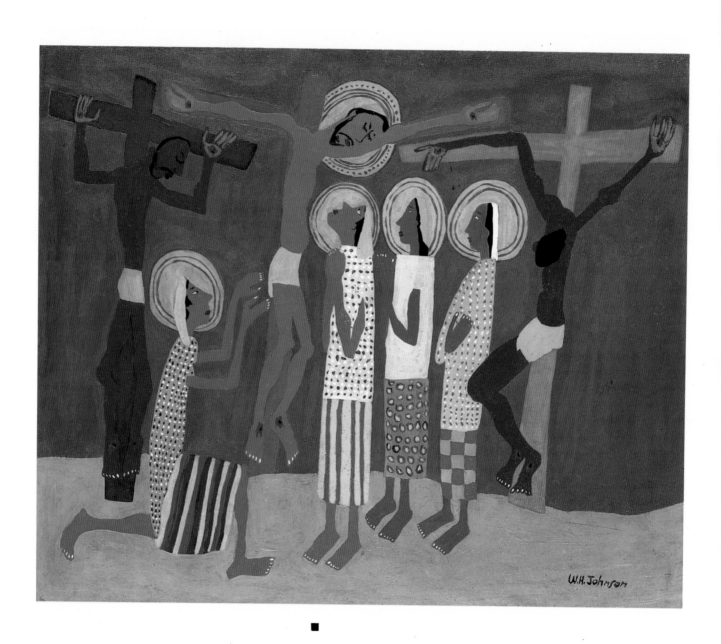

Plate 49.
William H. Johnson.
MOUNT CALVARY.
c. 1939. Oil on board,
27³/₄ × 38³/₈". The
National Museum of
American Art,
Smithsonian Institution,
Washington, D.C. Gift of
The Harmon Foundation

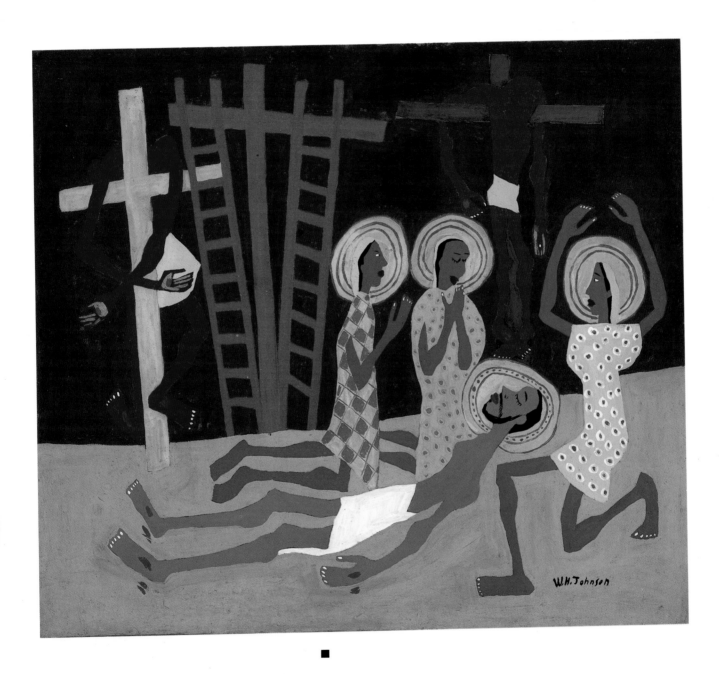

Plate 50.
William H. Johnson.
LAMENTATION. c. 1939.
Oil on board, 29⅛
× 33¼". The National
Museum of American Art,
Smithsonian Institution,
Washington, D.C. Gift of
The Harmon Foundation

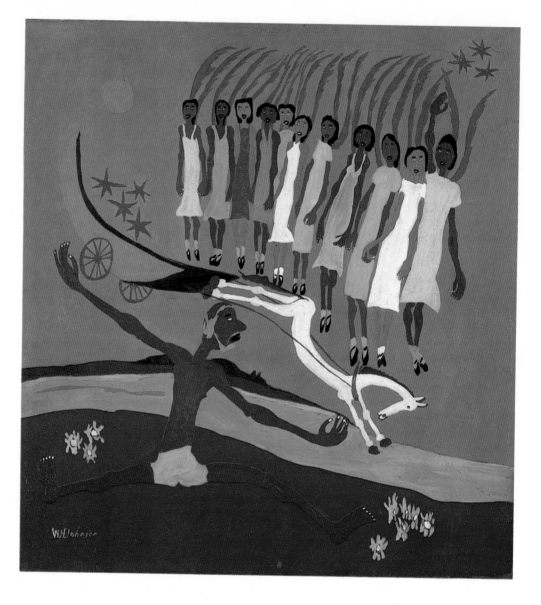

Plate 51.
William H. Johnson.
SWING LOW, SWEET
CHARIOT. *c. 1939. Oil*
on board, 28½ × 26½".
The National Museum of
American Art,
Smithsonian Institution,
Washington, D.C.
Transfer from The
Smithsonian Institution,
National Museum of
African Art

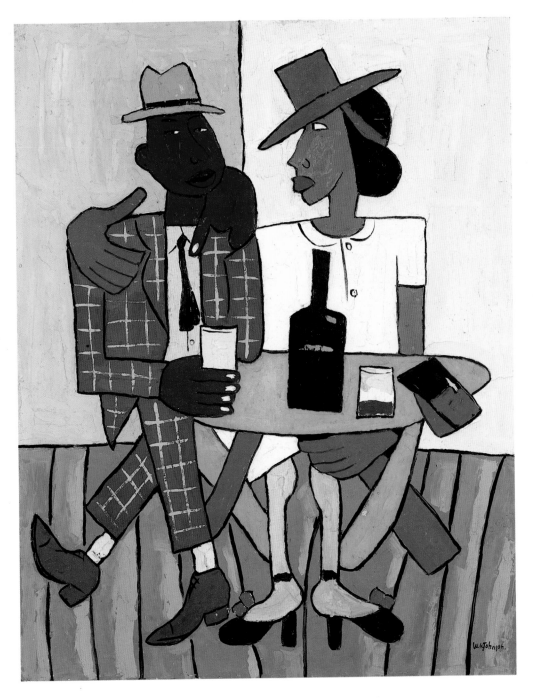

Plate 52.
*William H. Johnson.
CAFÉ. 1939–40. Oil on
board, 36½ × 28⅜".
The National Museum of
American Art,
Smithsonian Institution,
Washington, D.C. Gift of
The Harmon Foundation*

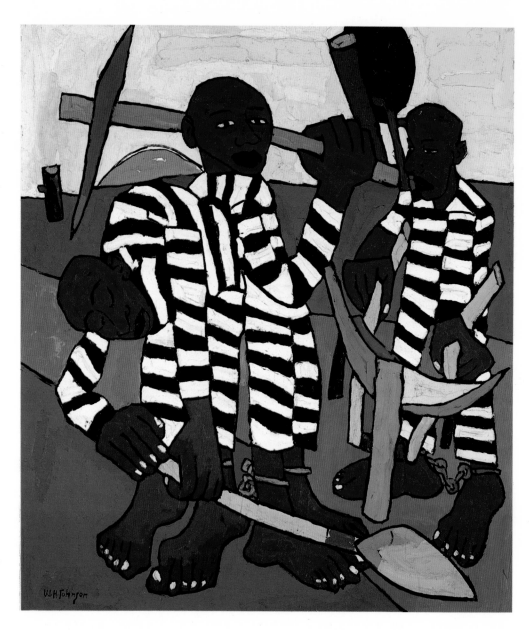

Plate 53.
William H. Johnson.
CHAIN GANG. *1939–40.*
Oil on board, 45½
× 38³⁄₈". The National
Museum of American Art,
Smithsonian Institution,
Washington, D.C. Gift of
The Harmon Foundation

(opposite) *Plate 54.*
William H. Johnson.
YOUNG MAN IN A VEST.
c. 1939–40. Oil on
canvas, 30 × 24". The
National Museum of
American Art,
Smithsonian Institution,
Washington, D.C. Gift of
The Harmon Foundation

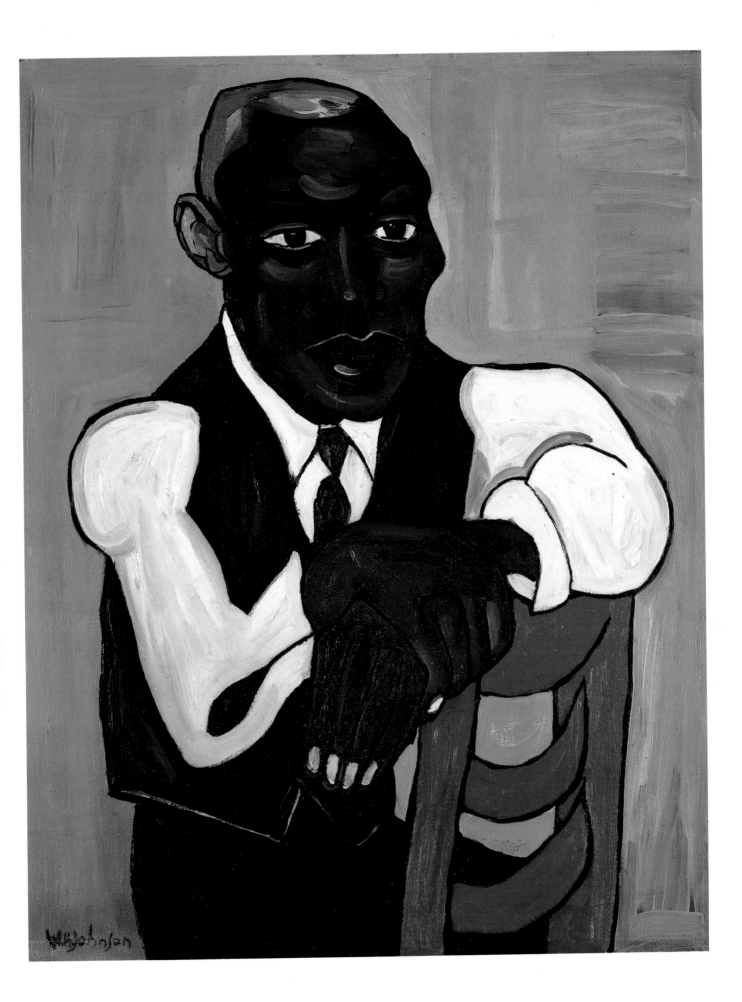

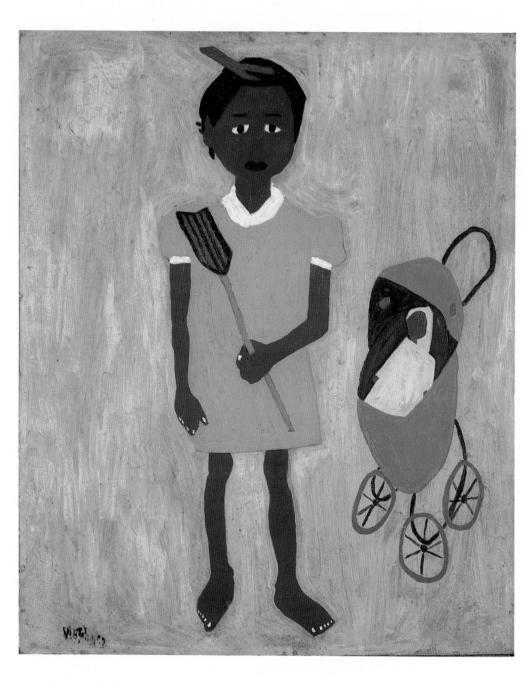

Plate 55.
William H. Johnson. LI'L
SIS. *c. 1944. Oil on*
board, 26 × 21¼". The
National Museum of
American Art,
Smithsonian Institution,
Washington, D.C. Gift of
The Harmon Foundation

with white horse and chariot, to carry home an aging Black male, modestly clothed in short pants, who is about to receive the rewards for his good life. In *Mount Calvary* (plate 49), Mary, the mother of Jesus, is joined by three women dressed in contemporary prints. The figure of Christ is placed slightly above the center of the composition, balanced by the two thieves who receive no attention from the women. Johnson has introduced contemporary human suffering into his story, a way of saying to the observer that Mount Calvary is the legacy of all who live in the contemporary world. The figure of Mary is in the foreground and is separated by the presence of the cross from the other women in attendance. The formula of aligning figures side by side appealed greatly to Johnson. Not only did he look closely at the religious compositions of the Italian Renaissance before painting the series, but he was equally drawn to the study of Byzantine art. The results are evident in the positioning of the figures and their static depiction.

Before Johnson returned to Denmark in 1946, he created a number of paintings that dealt with political and social Harlem. *Café, Chain Gang* (plates 52 and 53), and several works that center around the theme of the Black dancer were executed while Johnson lived in Harlem. He began recounting his experiences of growing up in the South and recorded impressions of families going to church on Sunday mornings in their wagons, farm workers sowing and reaping crops, as well as members of his own family, often referring to them by titles such as *Li'l Sis* (plate 55), *Little Sweet* (1944), and *Mom and Dad* (1944). In *Mom and Dad,* the artist's aging Black mother is seen sitting in a rocking chair in front of a portrait of Johnson's White father on the wall. The artist no doubt meant to make a social statement about the circumstances of his illegitimate birth, the father he was never allowed to know, and the knowledge he had of his family roots.

Johnson also painted subjects that commented on political issues in Harlem. In *Moon over Harlem* (1944), community violence is depicted in a bloody scene which involves policemen and citizens in a night brawl. During the same period, Johnson turned his attention to the depiction of Black heroes, abolitionist figures, and world leaders. He painted George Washington Carver in several poses—accepting awards from dignitaries, working in the laboratory, and displaying the numerous products that he created from peanuts and sweet potatoes. In another work, Chiang Kai-shek, Franklin D. Roosevelt, and Winston Churchill are shown meeting in Cairo, Egypt, on Thanksgiving Day, 1943. Johnson added notes to give historical summations of the people in his late paintings, most of whom could be recognized from the modified portraits from which they were taken. But, by 1945, Johnson's work had begun to lose its ethnic and formal vitality. An unfinished, disorderly feeling was evident in his art. The paintings seldom attained the power and appeal of earlier works such as *Chain Gang* and *Going to Church.* But Johnson insisted on continuing to document historical and social issues in his paintings. Most of these works had but one showing in the United States before the artist packed them up and

sailed again for Denmark in 1946. Thereafter, he became ill and was not able to paint. He returned to America and was confined to a hospital on Long Island until his death in 1970.

Johnson's work represented an important break with tradition. It signaled the beginning of the acceptance of Black subjects as part and parcel of the Christian experience in Western art. Moreover, Johnson did not share the view that art was a gift to be enjoyed only by polite society. He chose to rid himself of elitist views about art. He had worked hard upon his return to postwar America to develop an awareness of the social plight of Black people in America. Harlem was the place for such information, and the Renaissance enlivened his sensitivity to the racial problems of America. His last years of painting in Harlem centered around a plan to bring peace of mind to himself through his art and the creation of works that served to enlighten the Black community about their own history and heritage.

CONCLUSION

Lauded as the most glorious period in the history of Black American culture, the Harlem Renaissance represented the will of a select number of people who felt the time was right for the promotion of the arts of persons of African ancestry. The four visual artists, whose works comprise the exhibition *The Harlem Renaissance,* left a lasting impression on Black artists of the following generations. Their influence should not be diminished in the art world and there is growing interest in defining the roles they played in the broader context of American art.

Meta Fuller's art bridged the gap between a well established Black presence in European art circles and the gradual acceptance of the Black artists' work at home. She labored to uplift the level of visual literacy among her own people to direct their artistic taste to important forms of creative expression within Black culture. Aaron Douglas, Palmer Hayden, and William H. Johnson continued Fuller's legacy. Each of these artists responded favorably to the call by Alain Locke and the founders of the Harlem Renaissance to look among themselves and to the art of Africa for the inspiration needed to create a world-class movement in art that would be lasting in its appeal and interest within the Black community. Harlem, the place, provided the necessary ingredients for such a cultural revolution.

James Van Der Zee

The history of photography in America cannot be considered complete without acknowledging the work of one of Harlem's most celebrated social documentarians and distinguished photographers, James Van Der Zee. In a remarkable photographic career, he captured the life and spirit of Harlem and its people during two world wars, the literary and artistic Renaissance, the hard times of the Depression, and the glorious era of swing.

Born in 1886 in Lenox, Massachusetts, Van Der Zee was only twelve years old when he won a simple box camera by selling twenty packets of perfume. He often experimented with his new acquisition and within a short period of time the young Van Der Zee was adept at using far more complex cameras. Photography intrigued him, but it was not until much later in life that he considered its professional possibilities. In 1906, Van Der Zee arrived in Harlem, where he met and married his first wife, Kate Brown. Shortly after the wedding, the young couple moved to Phoebus, Virginia. Van Der Zee worked as a busboy, and in his spare time he photographed the people of Phoebus and nearby Hampton. By the end of 1906, however, he returned to New York to pursue his true vocation: "My main object all along was music—the violin. When I came to New York I formed the Harlem Orchestra." Also a gifted piano player, Van Der Zee performed at social gatherings, private parties, and with such accomplished musicians as Fletcher Henderson.

Dedicated to his music, Van Der Zee seldom photographed the New York scene, but on frequent trips to his hometown he photographed family and friends, rekindling his love for the art. Over the next eight years he produced a major body of work depicting life in Lenox. These photographs, which use atmospheric effects, soft-focus techniques, and diffused light, were inspired by the style of the Impressionist painters. At the turn of the century, pictorial photography—deliberately artistic photographs imitating the effects of nature— was rapidly gaining recognition as an art form. In America, its chief proponent was the flourishing Photo-Secession group, whose aim was to create photographs of aesthetic merit for publication, exhibition, and discussion. Van Der Zee had no direct contact with the movement, but on his own he was busily producing photographs which shared an affinity with their work.

By 1915, Van Der Zee's career as a musician was languishing. "Along about that time," he said, "they started coming out with radios, phonographs, jukeboxes, and what have you, so I thought, 'I've got to eat three times a day—I might look into photographing again.'" He was hired as a darkroom technician in the Gertz Department Store in Newark, New Jersey, for five

Fig. 58
*James Van Der Zee.
WEDDING PORTRAIT
WITH SUPERIMPOSED
IMAGE OF LITTLE GIRL.
n.d. Silver print. The
James Van Der Zee
Collection*

*Characteristically, Van
Der Zee superimposed an
image of the "predicted
future for the couple"—a
daughter.*

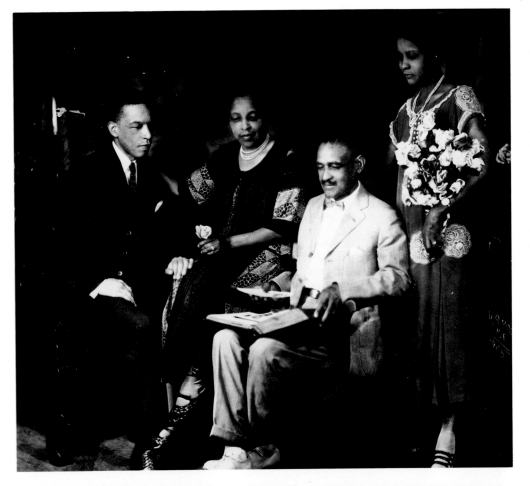

■

Fig. 59.
James Van Der Zee.
PORTRAIT OF FAMILY
LOOKING AT PHOTO
ALBUM. *1925. Silver
print. The James Van Der
Zee Collection*

*Many families flocked to
James Van Der Zee's
studio to have their
portraits made. His
portraits stressed unity
and pride within the
family.*

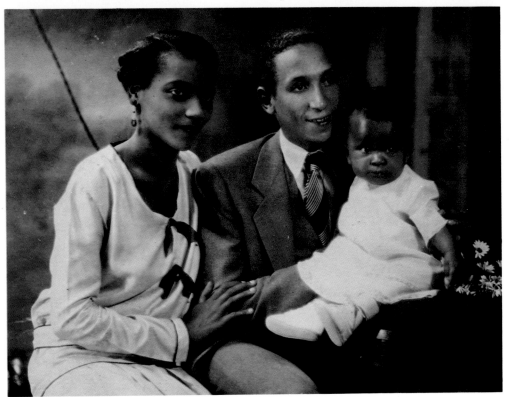

■

Fig. 60.
James Van Der Zee.
PORTRAIT OF YOUNG
COUPLE WITH BABY.
*n.d. Silver print. The
James Van Der Zee
Collection*

(above: left) *Fig. 61.*
James Van Der Zee.
PORTRAIT OF YOUNG
WOMAN AT HER FIRST
COMMUNION. *1930.*
Silver print. The James
Van Der Zee Collection

(above: right) *Fig. 62.*
James Van Der Zee.
PORTRAIT OF YOUNG
GIRL ON THE
TELEPHONE. *1926.*
Silver print. The James
Van Der Zee Collection

Children were favorite
subjects of Van Der Zee.
He was able to make them
appear relaxed and
natural.

(below) *Fig. 63.*
James Van Der Zee.
CHILDREN POSED
AROUND A
REFRESHMENT TRUCK
ON WEST 135TH STREET.
1928. Silver print. The
James Van Der Zee
Collection

In the background stands
the original 135th Street
library, and two buildings
down is Van Der Zee's
studio.

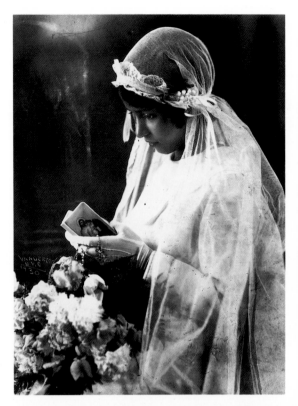

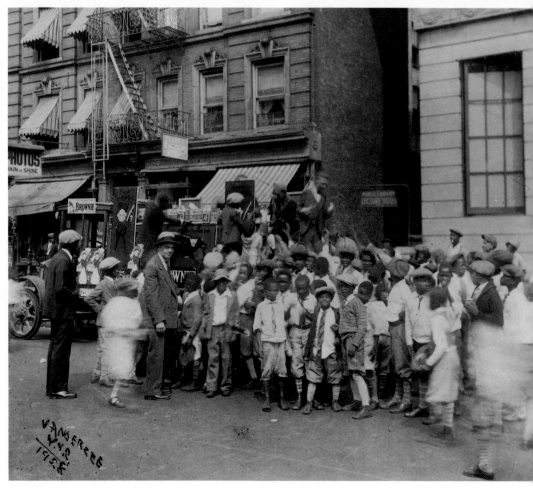

Fig. 64.
James Van Der Zee.
PORTRAIT OF MAN WITH
HAT, CIGARETTE, AND
CANE. 1928. Silver print.
The James Van Der Zee
Collection

Van Der Zee would often
place objects in his
sitter's hands such as a
cigarette or a walking
stick, adding detail to an
otherwise straight
portrait. In this portrait
he also etched the cigarette
smoke into the negative.

dollars a week. Frequently required to fill in as photographer for his employer, Van Der Zee introduced creative poses for his subjects, which made him exceedingly popular among the clientele. The opportunity permitted him to gain invaluable technical experience. As a result, in 1917 he opened his first portrait studio—Guaranty Photo—on 135th Street in New York City, one of Harlem's busiest streets (fig. 70). His unique photographic window displays attracted local residents, as well as curious Harlem visitors. Into his studio came Blacks and Whites, uniformed soldiers, a host of families, and innumerable smartly dressed men and women. His style as a portrait photographer soon made him Harlem's preferred choice (figs. 59, 64).

Thereafter, Van Der Zee earned his livelihood by making portraits. He seemed to have enjoyed considerable success, both artistically and financially. By 1932, he opened a larger shop—GGG Studio—at 272 Lenox Avenue, with his second wife, Gaynella, as his new partner. They specialized in photographing church groups and social organizations (figs. 51—55). In interviews, Van Der Zee explained his success with remarkable candor. His artistry, he claimed, came from an ability to combine his many talents as a painter, studio photographer, and journalist-documentarian; but, above all, from his natural curiosity about people. Moreover, his devotion to the *art* of photography distinguished his from other portrait studios in the area. A number of photographer's studios had opened in Harlem during the 1920s and 1930s, including the shops of R. E. Mercer, Walter Baker, and Morgan and Marvin Smith. Van Der Zee, however, was influenced only by the work of Eddie Elcha, with whom he collaborated closely on several projects. They used various means to attain a desired effect: skillfully painted backdrops, hand-tinting and retouching negatives for beautification and dramatization, and a creative synthesis of design elements and composition (fig. 34). Van Der Zee did not feel his imagery could serve its full purpose when presented purely as a documentary record. Throughout his career, he quietly went about making the kind of photographs he wished to make:

Well, it seems as though I had a personal interest in the pictures . . . sometimes they seemed to be more valuable to me than they did to the people I was photographing because I put my heart and soul into them. I was never satisfied with things the way they looked. I liked working with a big portrait camera so I could make changes. . . . I had one woman come in to see me and say, "Mr. Van Der Zee, my friends tell me that's a nice picture, Daisy, but it doesn't look like you." That was my style, though. Not like other portrait photographers where all you saw was more faces that looked the same.

Yet, Van Der Zee's legacy as the photographer of Harlem lies not so much in the artistic value of his photographs as in his willingness to photograph Harlemites in the studio or on location. There is simply no aspect of Harlem

Fig. 65.
James Van Der Zee.
NUDE STUDY. *n.d. Silver print. The Schomburg Center for Research in Black Culture, The New York Public Library*

(overleaf) *Fig. 66.
James Van Der Zee.*
HARLEM BILLIARD ROOM. *n.d. Silver print. The James Van Der Zee Collection*

that he overlooked. During the 1920s and 1930s, when Harlem flourished as a haven for artists, musicians, politicians, sportsmen, entrepreneurs, and newly migrated Blacks from the South and the West Indies, Van Der Zee photographed all the important residents and events. In his collection are photographs of the first Black Americans in the Army of France to receive the Croix de Guerre, Henry Johnson and Needham Roberts; singers Mamie Smith, Hazel Scott, and Florence Mills; poet Countee Cullen; heavyweight boxing champions Jack Johnson, Joe Louis, and Harry Wills; the religious leaders Adam Clayton Powell, Sr. and Jr., Father Divine, and Daddy Grace; and the heiress and patron A'Lelia Walker, daughter of Madame C. J. Walker, who was the first Black American woman to become a millionaire (figs. 48, 50). As the official photographer for Marcus Garvey and the Universal Negro Improvement Association (UNIA), Van Der Zee photographed the organization's families, conventions, rallies, and parades, and created the most comprehensive documentation of the movement (figs. 51–54).

Regardless, however, of whether his subjects were famous or unknown, Van Der Zee portrayed them with equal importance. Included in his portfolio were Harlem's weddings, church groups, social organizations (Elks, Masons, fraternities), athletic teams, and family gatherings (figs. 30, 35). Indeed, a large proportion of his portraits are of women with children. From early on in his career he was appreciated for his ability to take group portraits and to hold the rigid attention of children of difficult ages. In the 1920s, he began his practice of photographing funerals of Harlem's famous residents, using an eight-by-ten-inch camera. He also created memorial allegories by superimposing family members of the deceased with biblical figures in multiple-image photographs. In a memorial photograph for Blanche Powell, the daughter of Adam Clayton Powell, Sr., he inserted a portrait he had made of the girl when she was alive into a group photograph of the mourners (fig. 67). Through his lens, too, we know how Harlem's early houses were elegantly decorated and even what the barbershops and ladies' salons looked like.

Van Der Zee's favorite subjects were women, and their portraits are particularly beautiful. He usually employed the device of an oval or circular format to frame his subject, and he thrived on women posed in their best dresses and finest jewelry or bridal gowns (figs. 39, 47). By contrast, he also created sensual, melancholy nude studies for sale as artistic work (fig. 65).

In the photography of nudes he began to discover the beauty of light and shade, the power of natural forms and texture, and the sensitive possibilities of the soft-focus lens. In his commissioned works, too, Van Der Zee demonstrated his sentimentality and his interest in creative photography by painstakingly painting elaborate backdrops of outdoor scenes, artificial fireplaces, libraries, and genre scenes with the assistance of his friend Eddie Elcha. He often retouched his negatives, a device controversial in the artistic community (because of its artificiality), but highly popular with his clients. Van Der Zee modified negatives to remove unwanted facial lines and blemishes,

■

*Fig. 67.
James Van Der Zee.
FUNERAL OF BLANCHE
POWELL. c. 1926. Silver
print. The James Van Der
Zee Collection*

*Note the superimposed
portrait of the deceased,
also made by Van Der
Zee.*

■

*Fig. 68.
James Van Der Zee.
FUNERAL PROCESSION
ON SEVENTH AVENUE.
n.d. Silver print. The
Schomburg Center for
Research in Black
Culture, The New York
Public Library*

*Van Der Zee often
photographed the last
rites of Harlem residents
in churches, funeral
parlors, and private
homes.*

Fig. 69.
JAMES VAN DER ZEE.
n.d. Silver print.
Collection Vance Allen,
New York

placing beauty marks on the cheeks of women and actually replacing hair where it was missing by scratching directly on the surface of the negative. He also playfully added musical notes and "amplified sound" from saxophones and trumpets by etching on the photograph and negative (fig. 24).

With the advent of inexpensive cameras in the 1940s and 1950s, Van Der Zee's business started to decline. Limited to occasional commissions, he supplemented his income by offering a mail-order retouching service. Additional financial problems affected his business and resulted in the loss of his house and studio, a forty-three-year investment, in 1960. Fortunately, Reginald McGhee, a researcher at the Metropolitan Museum of Art, met Van Der Zee in the 1960s and managed to preserve the photographer's archives.

In 1969, the Metropolitan Museum of Art presented *Harlem on My Mind,* an exhibition on Harlem in this century. Van Der Zee, whose collection was the largest photographic contribution to the exhibition, was introduced to the public as one of the most important photographers of New York's and America's history. Today, a major portion of his work is being organized under the auspices of The Studio Museum in Harlem into a unique visual archive—The James Van Der Zee Collection—consisting of several thousand negatives and prints that are well documented and of enormous photographic and historical interest. Van Der Zee's own efforts to caption and catalogue his collection are essential to scholars, researchers, educators, and others in need of visual information pertinent to the periods and events he covered in Harlem.

Van Der Zee's photographs are published in several books, including a portfolio of eighteen signed, matted prints, and many articles have been written about his life. In addition, he was the recipient of numerous awards and citations after *Harlem on My Mind,* including an appointment as Fellow of the International Society of Magazine Photographers and an honorary degree from Howard University. His photographs are in public and private collections, notably the Metropolitan Museum of Art, the Lunn Gallery in Washington, D.C., The Schomburg Center for Research in Black Culture, and The Studio Museum in Harlem. In 1980, with the guidance and assistance of his third wife, Donna, he began to photograph once again. Before he died in 1983, he turned his camera to portraiture and continued to capture the charm and magic of contemporary Black personalities, including Lou Rawls, Bill Cosby, and Eubie Blake.

James Van Der Zee's work can be categorized into six major areas or themes: celebrities and personalities, family groups, wedding ceremonies, street scenes and interiors, large organizations, and his record of Marcus Garvey and the UNIA. The excellence of the work of Van Der Zee is in part due to his versatility in the arts as a photographer, painter, and musician. Yet above all, he was a romantic who loved the Harlem community and photographed his subjects to show their beauty, pride, and dignity. The greatest value of his work is the simple fact that he preserved Harlem.

■

(above: left) *Fig. 70.*
James Van Der Zee.
THE PHOTOGRAPHER'S
FIRST STUDIO ON 135TH
STREET. *n.d. Silver print.*
The James Van Der Zee
Collection

■

(above: right) *Fig. 71.*
James Van Der Zee.
THE PHOTOGRAPHER'S
LAST STUDIO AT 272
LENOX AVENUE. *1945.*
Silver print. The James
Van Der Zee Collection

■

(below) *Fig. 72.*
James Van Der Zee.
DRUGSTORE DISPLAY.
n.d. Silver print. The
James Van Der Zee
Collection

Drugstore display with
Van Der Zee photographs
on exhibit, advertising
that reproductions are
available for 59¢.

Chronology of the Harlem Renaissance (1919–29)

1919

The 369th Infantry Regiment of Black American soldiers returns from France and marches up Fifth Avenue to cheers from a huge crowd.

Fig. 73.
James Van Der Zee. PORTRAIT OF SOLDIER. 1930. Silver print. The James Van Der Zee Collection
World War I army officer holding a swagger stick.

U.S. Attorney General A. Mitchell Palmer launches "Red Scare" by creating a special division of the Justice Department, headed by J. Edgar Hoover, to combat and spy on Blacks and radicals, including Marcus Garvey, founder of the Universal Negro Improvement Association (UNIA), a militant Black organization founded in Jamaica in 1914 and launched in Harlem in 1917, whose aims include repatriating African Americans.

The National Association for the Advancement of Colored People (NAACP), founded in 1909, holds a conference on lynching after repeated incidents of lynchings of Blacks occur in 1918 and 1919 and government fails to enact sufficient legislation to stop the violence.

After the conference the NAACP publishes *Thirty Years of Lynching in the United States, 1889–1918,* with evidence from on-site investigations by Walter White.

Twenty-five race riots occur between the summer and the end of 1919 as Whites and Blacks compete for postwar employment and Blacks establish residence in major American cities. The worst incidents occur in Charleston, South Carolina; Longview, Texas; Washington, D.C.; Omaha, Nebraska; and Chicago, Illinois.

The Southern-based Commission on Interracial Cooperation is formed to fight racism.

W.E.B. Du Bois organizes the Pan-African Congress in Paris, with representatives from the United States, the West Indies, and nine African countries, to lobby for the independent administration of Germany's African colonies.

Claude McKay, a Jamaican emigré living in Harlem, publishes a poem, "If We Must Die," in *The Liberator,* a leftist journal. The poem calls for militant self-defense against White rioters.

Henry O. Tanner's works are exhibited in the *Group of American Artists* exhibition at the Knoedler Gallery in New York City. This show later tours other cities. Tanner is the leading Black American painter, but he was first recognized as an important artist and became most successful in Paris, where he settled in 1894.

Richard Lonsdale Brown, a prominent Black American artist, exhibits his work at the Ovington Galleries,

sponsored by Miss Mary White Ovington and the NAACP.

1920

A nationwide steel strike ends in complete capitulation of the workers and a major defeat for organized labor.

Postwar economic boom subsides, ushering in a deep recession.

Marcus Garvey's militant UNIA holds its first annual convention at Madison Square Garden. Hundreds of Blacks attend. Speeches are accompanied by street marches and parades.

Eugene O'Neill's *The Emperor Jones*, starring Black actor Charles Gilpin, is performed for the first time by the Provincetown Players in New York.

The Howard Players, a student drama group at Howard University in Washington, D.C., performs Lord Dansany's *Tents of the Arabs* and Ridgeley Torrence's *Simon the Cyrenian* at the Belasco Theatre. The run marks the beginning of the Black universities' theater movement.

W.E.B. Du Bois's *Darkwater*, a collection of his poetry, addresses, and essays, is published by Harcourt, Brace.

F. Scott Fitzgerald's *This Side of Paradise*, a bawdy novel of college life which glorifies sexual liberation in the Jazz Age, is published by Scribner's.

Meta Warrick Fuller's sculpture is exhibited at the Pennsylvania Academy of The Fine Arts.

1921

UNIA's first mission sails to Liberia. Its goal is to begin the repatriation of African Americans.

Representative L. C. Dyer of Missouri sponsors an antilynching bill in Congress to make lynching a federal crime.

Shuffle Along, the first musical revue written and performed by Blacks, opens in New York and receives exceptional reviews. With music by Eubie Blake and

lyrics by Noble Sissle, the revue launches the careers of Josephine Baker and Florence Mills.

By Right of Birth, a movie about Black American life, is produced by the Lincoln Motion Picture Company.

Countee Cullen's first published poem, "I Have a Rendezvous with Life," appears in the De Witt Clinton High School (New York) literary magazine, *The Magpie*.

Langston Hughes's first published poem, "The Negro Speaks of Rivers," appears in *The Crisis*, the NAACP's journal edited by Du Bois.

The Light, a weekly newspaper for Blacks which also publishes fiction, appears in New York. It is renamed *Heebie Jeebies* in 1925, and then *The Light and Heebie Jeebies* in 1927.

Harry Pace forms Black Swan Records in Harlem. The Black-owned company produces the best-selling "race records" of the 1920s by Mamie and Bessie Smith.

Black artist May Howard Jackson creates a sculpture of Black writer Jean Toomer.

Exhibition of work by Black American artists (including Henry Tanner, Laura Wheeler Waring, W. E. Scott, Meta Fuller, W. E. Braxton) is held at the 135th Street branch of The New York Public Library.

1922

UNIA marches with the NAACP and YMCA in support of Congressman Dyer's federal antilynching bill.

Claude McKay's *Harlem Shadows* is published by Harcourt, Brace. It is his first collection of poems published in America and the first book of poems published by one of the new Harlem Renaissance poets.

James Weldon Johnson's *The Book of American Negro Poetry*, an anthology of contemporary Black American verse, is published by Harcourt, Brace.

Black singer Marian Anderson begins her concert career with a debut at the Town Hall in New York.

King Oliver's Creole Jazz Band takes up residence at the Lincoln Gardens dance hall in Chicago and begins

to play New Orleans jazz in the North. They send for the young Louis Armstrong, who leaves New Orleans to join the band in Chicago.

Strut Miss Lizzie, a Black musical revue, opens in New York.

Goat Alley, a tragedy about Black American life written by the White dramatist Ernest Culbertson, opens on Broadway.

In Washington, D.C., the Howard Players perform *Genefrede,* a play about the life of Toussaint L'Ouverture, the Haitian revolutionary, and *The Danse Calinda,* a Creole pantomime by Ridgeley Torrence.

Meta Fuller's sculpture *Ethiopia Awakening* (plate 2) is exhibited at New York's Making of America Exposition.

The Tanner League of Washington, D.C., holds an exhibition of works by Black American artists (including Meta Fuller) at Dunbar High School.

1923

Economic recovery begins six years of unprecedented growth in corporate profits, consumer products, and stock market prices.

Garvey is arrested for mail fraud and imprisoned for three months before President Harding orders his release.

The Urban League, founded in 1910 to assist Blacks who migrated to the cities, publishes the first issue of *Opportunity* magazine, a literary forum for artists and authors of the Harlem Renaissance.

Jean Toomer's *Cane* is published by Boni and Liveright to critical acclaim.

Runnin' Wild, a musical revue by Blake and Sissle, opens on Broadway and introduces the 1920s to its most famous dance, the Charleston.

Bessie Smith makes her first recordings of "Downhearted Blues" and "Gulf Coast Blues," which catapult her to stardom; King Oliver's Creole Jazz Band makes thirty-seven recordings with Louis Armstrong that usher in jazz's great classical period; and dapper

Duke Ellington arrives in New York City.

The Chip Woman's Fortune by the playwright Willis Richardson opens in May on Broadway. It is the first Broadway play by a Black American.

Eugene O'Neill's *All God's Chillun Got Wings* is performed by the Ethiopian Art Players at Fazi Theatre, Washington, D.C.

Paul Green's *In Abraham's Bosom* is performed by Cleveland's Black theatrical group, the Gilpin Players, at the Karamu Theater, Cleveland.

Henry Tanner is awarded France's Legion of Honor.

Freeman H. M. Murray lectures at the Washington meeting of the American Negro Academy on "Black folk as they have been portrayed in representative American art, sculpture, and painting."

1924

The National Origins Act (or Immigration Restriction Act) is passed, excluding Asian immigration and limiting European immigration by nationality to 2 percent of each country's immigrant population in the United States as of 1890. Passage reflects the political influence of the Ku Klux Klan and the prevalence of Nativism.

The Emperor Jones opens in London with Paul Robeson in the title role of Brutus Jones.

Jessie Fauset's first novel, *There Is Confusion,* is published by Albert and Charles Boni. It is the first novel by a woman of the Harlem Renaissance.

Opportunity magazine hosts a dinner at the Civic Club in New York to honor Fauset's novel and to herald the new school of writing by younger Blacks. The magazine also sponsors the first annual literary contest to discover new Black talent.

Louis Armstrong comes to New York to join the Fletcher Henderson Orchestra at the Roseland Ballroom. With Armstrong as their lead soloist, the Henderson Orchestra becomes the most popular dance band in New York.

Chocolate Dandies, a musical revue starring Josephine Baker, opens on Broadway.

Roland Hayes, a Black vocalist, gives a concert in Carnegie Hall with William Lawrence as accompanist.

Paul Whiteman gives his first concert of classical jazz in New York.

Henry Tanner's religious paintings are exhibited at the Grand Central Art Galleries in New York City.

Fig. 74.
James Van Der Zee. RENAISSANCE BASKETBALL TEAM.
1925. Silver print. The James Van Der Zee Collection
The New York Renaissance, founded in 1923, was one of the earliest organized professional basketball teams. Over a period of twenty years, the Rens won 1,588 games and lost 289.

1925

Garvey is convicted of mail fraud and jailed in the Atlanta Penitentiary.

Black playwright Garland Anderson's *Appearances* opens on Broadway.

Marian Anderson wins the New York Philharmonic singing competition.

Zora Neale Hurston becomes editor of *The Spokesman* and directs the journal toward literature based on Black folklore.

Countee Cullen's first book of poems, *Color,* is published by Harper and Brothers.

Survey Graphic publishes a special issue, "Harlem: Mecca of the New Negro," introducing the poetry, fiction, and social essays of the Harlem Renaissance to the magazine's White literary audience. It is illustrated throughout with Winold Reiss's striking black-and-white pastels of Black Americans. The issue sells out two printings

The New Negro, Alain Locke's expanded book version of the *Survey Graphic* Harlem issue, is published by Albert and Charles Boni. It is illustrated with color pastels by Winold Reiss and black-and-white woodcuts by Aaron Douglas and Miguel Covarrubias.

Recent Portraits of Representative Negroes, an exhibition by Winold Reiss, is held at the 135th Street branch of The New York Public Library.

Sargent Johnson, a leading Renaissance artist, exhibits his work at the San Francisco Art Association.

Archibald Motley (see figs. 13 and 20), another leading Renaissance artist, wins the Francis Logan Medal from the Art Institute of Chicago for his painting *A Mulatress.*

1926

Roland Hayes gives a recital at Symphony Hall, Boston.

Carl Van Vechten's novel of Harlem life, *Nigger Heaven,* is published by Alfred A. Knopf.

The Weary Blues, Langston Hughes's first book of verse, is also published by Knopf.

Langston Hughes, Wallace Thurman, Zora Neale Hurston, Aaron Douglas, and Richard Bruce Nugent launch *Fire!!,* a magazine of the literary and artistic rebels of the Harlem Renaissance. It is illustrated by

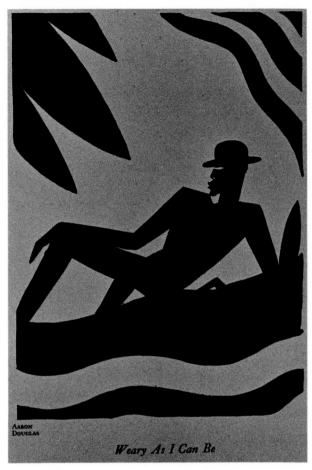

Fig. 75.
Aaron Douglas. WEARY AS I CAN BE, *for "Lonesome Place"
by Langston Hughes, in* Opportunity. *October 1926. The
Schomburg Center for Research in Black Culture, The New
York Public Library*

Aaron Douglas and Richard Bruce Nugent.

Blackbirds, starring Florence Mills, opens in New York
to great acclaim.

The Shadows, a Black American "Little Theatre,"
opens in Chicago for the production of serious Black
drama.

Paul Green's *In Abraham's Bosom* opens at the
Provincetown (Massachusetts) Playhouse. It wins a
Pulitzer Prize.

The Harmon Foundation holds the first of its annual
art exhibitions of painting and sculpture by Black
artists. First juried show is held at the 135th Street
branch of The New York Public Library and is later
shown in Chicago; Palmer Hayden wins the William

E. Harmon First Award and Gold Medal in Fine Arts
for his painting entitled *The Schooner.* The Second
Award is given to Hale Woodruff.

Aaron Douglas completes a series of interpretative
illustrations for *The Emperor Jones* (figs. 1 and 83). Two
of his illustrations are published with a *Theater Arts
Monthly* article, "The Negro and the American Stage."

1927

President Coolidge commutes Garvey's sentence and
deports Garvey from the United States as an undesirable
alien.

Porgy by Dorothy and Du Bose Heyward opens at the
Theatre Guild on Broadway.

Duke Ellington brings his band to the Cotton Club.

Plays of Negro Life, edited by Alain Locke and
Montgomery Gregory and illustrated by Aaron Douglas,
is published by Harper and Brothers.

Countee Cullen's anthology of poetry by Black
Americans, *Caroling Dusk,* is published by Harper and
Brothers. It includes illustrations by Aaron Douglas.

The Blondiau Theatre Arts Collection of African Art
is exhibited at the New York Circle in New York.

Paul Robeson and Lawrence Brown give a benefit recital
for the Harlem Museum of African Art at the Town
Hall in New York.

An exhibition of Black artist W. E. Braxton's
paintings, pastels, and drawings is held at the opening
of the Department of Negro Literature and History in
the 135th Street branch of The New York Public
Library.

Henry Tanner receives the National Bronze Medal at
an exhibition held at the National Arts Club galleries
in New York City.

Aaron Douglas creates interpretative illustrations for
James Weldon Johnson's book of poetry *God's
Trombones: Seven Negro Sermons in Verse* (plates
30–33). Douglas also executes his first mural, *Fire!,*

for Club Ebony at 129th Street and Lenox Avenue in Harlem.

The Negro in Art Week, an exhibition of African sculpture, modern paintings and sculpture, and books, drawings, and applied art, along with "A Night of Music," is sponsored by the Chicago Woman's Club and the Art Institute of Chicago.

1928

Claude McKay's first novel, *Home to Harlem*, is published by Harper and Brothers. The jacket is illustrated by Aaron Douglas.

Rudolph Fisher's first novel, *The Walls of Jericho,* is published by Knopf.

Wallace Thurman founds *Harlem,* a literary magazine to succeed *Fire!!* It includes illustrations by Aaron Douglas and Richard Bruce Nugent.

The *Saturday Evening Quill* appears in Boston. It is published by a group of Black American writers who constitute the Quill Club, founded in 1925.

The Harlem Experimental Theatre opens with a run of *Goat Alley.*

The Exhibition of Fine Arts Productions of American Negro Artists is held under the auspices of The Harmon Foundation at International House in New York. May Howard Jackson wins the Second Award for her sculpture.

Archibald Motley has a one-man exhibition at the Ainslee Galleries in New York.

The Exhibition of African Sculpture and Handicraft from the Travelling Collection of Harlem Museum of African Art of New York City is held at Howard University, Washington, D.C.

Palmer Hayden has a one-man exhibition of his works at the Bernheim-Jeune Gallery in Paris.

Winold Reiss's portraits of Black Americans on St. Helena Island, South Carolina, are published in *Survey Graphic.*

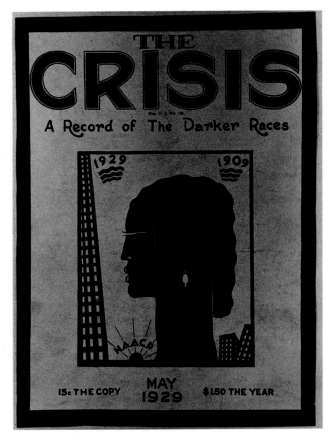

Fig. 76.
Aaron Douglas. Cover for The Crisis. May 1929. The Schomburg Center for Research in Black Culture, The New York Public Library

1929

Alain Locke begins publishing annual reviews of Black literature in *Opportunity* magazine along with announcements of art exhibitions and book illustrations.

Wallace Thurman's first novel, *The Blacker the Berry,* is published by Harper and Brothers. Thurman's play *Harlem* opens on Broadway and draws negative criticism from Black American commentators.

Claude McKay's second novel, *Banjo,* is published by Harper and Brothers. The jacket is illustrated by Aaron Douglas. It receives poor reviews but sells well.

The Black Christ by Countee Cullen is published by Harper and Brothers. His new book of poems receives poor reviews from the critics.

Connie's Hot Chocolates opens *Ain't Misbehavin'* on

Broadway, with music by Fats Waller and with Louis Armstrong in the orchestra.

Richmond Barthe, a leading Harlem Renaissance sculptor, executes an oil portrait of Harold Jackman (see also figs. 10 and 11). Barthe wins a Rosenwald grant and continues his studies of sculpture in New York.

Aaron Douglas is commissioned to paint decorations and mural designs for Fisk University's Erasto Milo Cravath Library in Nashville, Tennessee.

The Harmon Foundation sponsors the exhibition *Paintings and Sculpture by American Negro Artists,* held at The National Gallery in Washington, D.C. Archibald Motley wins the painting award for *The Octoroon.*

The stock market crash on October 23 brings to an end the Jazz Age and marks the beginning of the Great Depression.

Chronologies of the Artists

AARON DOUGLAS

1899
Born in Topeka, Kansas, to Aaron and Elizabeth Douglas, on May 26.

1917
Graduates from Topeka High School.

1922
Receives Bachelor of Fine Arts degree from the University of Nebraska.

1923
Teaches drawing at Lincoln High School, Kansas City, Missouri.

1924
Arrives in New York City and begins studies under Winold Reiss. Develops "geometric symbolism," a style

best evidenced in his murals.

Marries Alta Sawyer on June 18.

1925
Illustrates front cover of *Opportunity* magazine; awarded the magazine's first prize for excellence in art. Illustrates *The New Negro,* a survey of the Harlem Renaissance by Alain Locke.

Receives *The Crisis* magazine's first prize for drawing for his work *The African Chieftain.*

1926
Illustrates and helps to initiate *Fire!!,* Wallace Thurman's lively publication devoted to young Black artists and writers. Completes a series of illustrations for *The Emperor Jones.*

1927
Illustrates *Caroling Dusk,* an anthology of verse by Black poets edited by Countee Cullen; *God's Trombones: Seven Negro Sermons in Verse* by James Weldon Johnson (plates 30–33); *Plays of Negro Life,* edited by Alain Locke and Montgomery Gregory; and the cover for the September issue of *The Crisis* magazine.

Completes *Fire!,* the artist's first mural, for Club Ebony in Harlem.

1928
Awarded a Barnes Foundation scholarship for one year's study of the Barnes Collection of modern and primitive art in Merion, Pennsylvania.

Illustrates book jacket for Claude McKay's *Home to Harlem.*

1929
Begins murals for the Erasto Milo Cravath Library at Fisk University, Nashville, with the assistance of Edwin A. Harleston; and for the College Inn Room at the Sherman Hotel in Chicago. The murals are characterized by images of joyful Blacks, marking the beginning of what is known as his "Hallelujah period."

1931
Sails to Europe to begin a year's study at L'Académie

Scandinave in Paris. Studies under Charles Despiau, Henry de Waroquier, and Othon Frieze.

1932
Returns to New York.

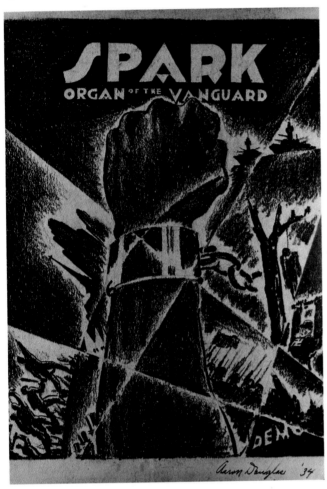

Fig. 77.
Aaron Douglas. Cover illustration for Spark. *1934. The Schomburg Center for Research in Black Culture, The New York Public Library*

1934
One-man exhibition at D'Caz-Delbo Gallery, New York. Work included in an exhibition sponsored by The Harmon Foundation and traveled by the College Art Association.

Completes *Aspects of Negro Life* mural for the 135th Street branch of The New York Public Library in Harlem, under the sponsorship of the WPA (plates 5–10).

1935
Elected president of the Harlem Artists' Guild.

Work included in an exhibition sponsored by The Harmon Foundation and traveled by the College Art Association. Exhibits at the Brooklyn Museum and the Artists Congress.

1936
Completes murals for the Hall of Negro Life, exhibited during the Texas Centennial Exposition in Dallas.

Illustrations included in *The Negro in American Culture,* a book by Margaret J. Butcher, sponsored by The American Artists Congress.

Included in the exhibition *Thirty American Artists* at Findlay Galleries, New York; Douglas is the only Black artist in the exhibition. Work shown: *Power Plant in Harlem* (plate 37).

1937
Joins the staff of Fisk University as chairman and founder of the Department of Education.

One-man exhibition at The Gallery of Art, Howard University, Washington, D.C.

1938
Completes the mural *Education of the Colored Man* at the Atlanta City Housing Project, under the auspices of the Treasury Department's Art Project.

Receives a Julius Rosenwald travel fellowship; tours the South and Haiti.

1939
Exhibits his Haitian paintings at the American Contemporary Art Gallery, New York (April 2–15).

1940
Exhibits at the *Exposition of the Art of the American Negro, 1851–1940* at the Tanner Art Galleries, Chicago (July 4–September 2); the Brooklyn Museum; the Gallery of Modern Art, New York; and Findlay Galleries, New York.

1941
Enters Columbia University's Teachers College. (Receives master's degree in 1944.)

1942
One-man exhibitions at the University of Kansas in

Lawrence; the Municipal Gallery, Topeka, Kansas; the Community Art Center, Topeka; Morril Hall, the University of Nebraska in Lincoln; and the Joslyn Memorial, Omaha. Exhibits at the St. Louis Gallery, St. Louis.

1944

Work included in the *Atlanta University Third Annual Exhibition of Paintings, Sculpture, and Prints* at the Exhibition Gallery (March 25–April 30).

1945

Work included in the exhibition *The Negro Artist Comes of Age: A National Survey of Contemporary American Artists* at the Albany Institute of History and Art, New York (January 3–February 11).

1947

One-man exhibition at The People's Art Center, St. Louis.

1948

One-man exhibition at Chabot Gallery, Los Angeles.

1951

Receives a Carnegie grant-in-aid for the Improvement of Teaching Project.

1955

One-man exhibition at Riley Art Galleries, New York.

1957

Illustrates book jacket of *The Story of the American Negro* by Ina Corinne Browne.

1963

Attends the centennial celebration of the Emancipation Proclamation in the White House, at the invitation of President Kennedy.

1964

One-man exhibition at the University of California, Berkeley.

1966

Retires from Fisk University as professor emeritus.

1967

Work included in the exhibition *The Evolution of Afro-American Artists: 1800–1950*, a landmark survey of Black artists sponsored by the New York Urban League and Harlem Cultural Center, at City College, New York (October 16–November 6).

Work included in the exhibition *The Twenties Revisited* at the Huntington Hartford Museum.

1970

One-man retrospective exhibition at the Mulvane Art Center, Washburn University, Topeka, Kansas.

1971

One-man retrospective exhibition at the Carl Van Vechten Gallery, Fisk University (March 21–April 15). *Triborough Bridge* (a watercolor) included in the exhibition *Black Artists: Two Generations* at The Newark Museum, New Jersey (May 13–September 6).

1973

Receives Honorary Doctorate of Fine Arts degree from Fisk University.

1976

Included in the exhibition *Two Centuries of Black American Art* at the Los Angeles County Museum of Art (September 30–November 21). Works shown: *Building More Stately Mansions, Crucifixion, Go Down Death, Judgment Day, Let My People Go.*

1978

Work included in the exhibition *New York/Chicago: WPA and the Black Artist* at The Studio Museum in Harlem (November 13, 1978–January 8, 1979).

1979

Dies in Nashville, on February 3.

Posthumous Exhibitions

1984

Work included in the exhibition *Since the Harlem Renaissance: Fifty Years of Afro-American Art* at The Center Gallery of Bucknell University, Lewisburg, Pennsylvania (April 13–June 6).

1985

Included in the exhibition *Hidden Heritage: Afro-American Art 1800–1950,* sponsored and traveled by

the Art Museum Association and the Bellevue Art Museum, Bellevue, Washington (September 14–November 10). Works shown: studies for *Aspects of Negro Life, Go Down Death,* and *Noah's Ark.*

META VAUX WARRICK FULLER

1877
Born in Philadelphia, to William H. Warrick and Emma Jones Warrick, on June 9.

1894
Wins a scholarship to attend the Pennsylvania Museum and School for Industrial Arts.

1897
Earns a one-year scholarship at the Pennsylvania Museum for postgraduate work in sculpture.

1898
Her sculpture *Procession of the Arts and Crafts* wins the school's George K. Crozier Prize for best general work in modeling.

1899
Graduates from the Pennsylvania Museum and School for Industrial Arts with honors. Attends the École des Beaux-Arts in Paris where she studies drawing for three years under Raphael Collin, on the advice of Augustus Saint-Gaudens. Also studies at the Académie Colarossi in Paris under Ingelbert Guagui.

1902
Exhibits at S. Bing's L'Art Nouveau. Meets Auguste Rodin, who encourages her artistic talents. Fuller studies under Rodin.

1903
The Wretched and *The Impenitent Thief* exhibited at the Salon in Paris.

Returns to Philadelphia and enrolls at the Pennsylvania Academy of The Fine Arts.

1905
Exhibits at the Pennsylvania Museum and School for Industrial Arts.

1906
Included in the *101st Annual Exhibition* at the Pennsylvania Academy of The Fine Arts (January 22–March 3). Work shown: *Portrait from Mirrors.*

1907
Commissioned by the Jamestown Tercentennial Exposition to execute a tableau. The fifteen-piece work illustrates the "Negro's progress."

1908
Included in the *103rd Annual Exhibition* at the Pennsylvania Academy of The Fine Arts (January 20–February 29). Work shown: *Peeping Tom of Coventry.*

1909
Marries Dr. Solomon Fuller of Liberia. The couple settle in Framingham, Massachusetts, and the artist's activities then revolve around the Boston area.

Gains entrance into the Boston Art Club, the Wellesley Society of Artists, the Women's Club, and the Civil League.

1910
Fire destroys many of Fuller's early works stored in a Philadelphia warehouse.

1915
Receives second prize for *Peace Halting the Ruthlessness of War,* in a competition sponsored by the Women's Peace Party.

1920
Included in the *115th Annual Exhibition* at the Pennsylvania Academy of The Fine Arts (February 4–March 25). Work shown: *Portrait Statuette.*

1921
Work included in an exhibition of Black American art in the public rooms of the 135th Street branch of The New York Public Library.

1922
Exhibits at the Boston Public Library. Work included in an exhibition for the Tanner League held in the studios of Dunbar High School, Washington, D.C. Exhibits *Ethiopia Awakening* (plate 2) at New York's

Making of America Exposition.

1923
Included in the *118th Annual Exhibition* at the Pennsylvania Academy of The Fine Arts (February 4–March 25). Work shown: *Ethiopia Awakening*.

1927
Work included in the exhibition *The Negro in Art Week* at the Art Institute of Chicago.

1930 (?)
Exhibits at the Boston Art Club.

1931
Work included in the *New York Emancipation Exhibit* and in The Harmon Foundation exhibitions in New York and Washington, D.C. (1931–35).

1934
Work included in an exhibition sponsored by The Harmon Foundation and traveled by the College Art Association.

1935
Work included in an exhibition sponsored by The Harmon Foundation and traveled by the College Art Association.

1936
Work included in the *Exhibit of Fine Arts Production by American Negro Artists* at the Hall of Negro Life, Texas Centennial Exposition, in Dallas (June 19–November 9).

1939
Exhibits at the Augusta Savage Studios, New York.

1940
Exhibits at the *Exposition of the Art of the American Negro, 1851–1940* at the Tanner Art Galleries, Chicago (July 4–September 2).

Work included in the exhibition *75 Years of Freedom in Commemoration of the Proclamation of the 13th Amendment to the Constitution of the United States of America,* selected by Alain Locke and Holgar Cahill, at the Library of Congress, Washington, D.C. (December 18, 1940 –January 18, 1941).

1953
Solomon Fuller dies. Meta Warrick Fuller contracts tuberculosis and remains in a sanatorium for two years.

1957
Commissioned by the Afro-American Women's Council in Washington, D.C., to create sculptures of ten famous Black women.

1961
Receives the Silver Medal and a citation at the *New Vistas in American Art Exhibition,* Howard University, Washington, D.C.

1964
Exhibits at the Framingham Center Library, Massachusetts.

1967
Work included in the exhibition *The Evolution of Afro-American Artists: 1800–1950,* sponsored by the New York Urban League and Harlem Cultural Center, at City College, New York (October 16–November 6).

1968
Dies on March 13.

Posthumous Exhibitions

1970
Exhibition at James A. Porter Gallery, New York.

1971
Work included in the exhibition *Black Artists: Two Generations* at The Newark Museum, New Jersey (May 13–September 6), and at the Tuskegee Institute, Alabama.

1973
Framingham, Massachusetts, dedicates a public park in honor of the lifetime efforts and contributions of Meta Warrick Fuller and her husband.

1984
Retrospective exhibition entitled *An Independent Woman: The Life and Art of Meta Warrick Fuller* is held at The Danforth Museum of Art, Framingham,

Massachusetts (December 16, 1984–February 24, 1985).

1985

Included in the exhibition *Hidden Heritage: Afro-American Art 1800–1950,* sponsored and traveled by the Art Museum Association and the Bellevue Art Museum, Bellevue, Washington (September 14–November 10). Works shown: *Ethiopia Awakening* and *Waterboy* (plate 24).

PALMER HAYDEN

1890

Peyton Cole Hedgeman (called Palmer Hayden) born in Wide Water, Virginia, to James and Nancy Hedgeman, on January 15.

1914

Enlists in U.S. Army during World War I. Serves in the Philippines and at West Point.

1919

Arrives in New York and works part-time in Greenwich Village at various odd jobs, including house cleaner, postal clerk, and porter.

Studies art under Victor Perard at Cooper Union.

1925

Studies art at Boothbay Art Colony in Maine under Asa G. Randall.

1926

Awarded the William E. Harmon First Award and Gold Medal in Fine Arts at the first Harmon Foundation exhibition of Black American art. Receives $400 and the medal for his watercolor of the Portland, Maine, waterfront entitled *The Schooner.* Exhibits works from Boothbay Art Colony at the Civic Club in New York.

Completes oil painting *Fétiche et Fleurs,* an unconventional still life demonstrating the artist's increasing preference for depicting subject matter that emphasizes the "mores, myths, and customs" of Black life. (Later works by the artist stress narratives and anecdotal details of Black life.)

1927

Receives $3,000 grant from a private sponsor to study abroad. Travels to France for private instruction under Clivette Lefèvre at the École des Beaux-Arts in Paris. Paints in Paris, Brittany, and Normandy for next five years.

1928

One-man exhibition at the Bernheim-Jeune Gallery in Paris.

Works by the artist continue to be shown at The Harmon Foundation exhibitions. Work included in *The Exhibition of Fine Arts: Productions of American Negro Artists,* sponsored by The Harmon Foundation, at International House, New York (January 6–17).

1929

Work included in exhibition at the Smithsonian Institution, Washington, D.C.

1930

Work included in a group exhibition at the Salon des Tuileries in Paris.

1931

Work included in the *American Legion Exhibition* in Paris. Hayden develops his interest in Black subject matter. He creates his first paintings of Blacks while in Europe and they are included in this exhibition, the first time paintings of "Negro subjects" are introduced to a European audience.

1932

Returns to New York.

1933

Awarded Mrs. John D. Rockefeller Prize for his painting *Fétiche et Fleurs* at The Harmon Foundation's *Exhibition of the Works of Negro Artists* (February 20–March 4). Receives $100 prize.

Work included in the Smithsonian Institution's exhibition *Independent Artists in New York* and the Colonial Exposition Show in Paris. Exhibits at the Cooperative Art Market in New York and at the

Harlem Community Art Center.

1934

Works on U.S. Treasury and WPA art projects for next four years.

Work included in an exhibition sponsored by The Harmon Foundation and traveled by the College Art Association.

1935

One-man exhibition at the New Jersey State Museum, in Trenton.

1936

Work included in the *Exhibit of Fine Arts Production by American Negro Artists* at the Hall of Negro Life, Texas Centennial Exposition, in Dallas (June 19– November 29).

1937

One-man exhibition at Bernheim-Jeune Gallery in Paris. Exhibits at The Gallery of Art, Howard University, Washington, D.C.

1939

One-man exhibition at the Baltimore Museum of Art.

1940

Between 1940 and 1973, Hayden's art becomes more representative of Black life in America. He depicts real experiences of Blacks in the urban North and rural South in paintings such as *Hog Killing Time in Virginia* and *Midsummer Night in Harlem*.

Midsummer Night in Harlem first exhibited at the Rockefeller Center Galleries. Included in the *Exposition of the Art of the American Negro, 1851–1940* at the Tanner Art Galleries, Chicago (July 4–September 2).

1944

Begins major series of twelve paintings about the Legend of John Henry, a Black American hero, completed in 1954 (plates 14–16).

Work included in the *Atlanta University Third Annual Exhibition of Paintings, Sculpture, and Prints by Negro Artists* at the Exhibition Gallery (March 25–April 30).

1945

Included in the exhibition *The Negro Artist Comes of Age: A National Survey of Contemporary American Artists* at the Albany Institute of History and Art, New York (January 3–February 11). Work shown: *The Baptizing*.

1947

Exhibits John Henry series in one-man exhibition at Argent Gallery, New York.

1954

Exhibits John Henry series and other folklore paintings at the 135th Street branch of The New York Public Library. Sponsored by The Harmon Foundation.

1965

Old Paris Prison (a watercolor) receives "Honorable Mention" from the American Veteran's Society of Artists.

1967

Included in the exhibition *The Evolution of Afro-American Artists: 1800–1950*, sponsored by the New York Urban League and Harlem Cultural Center, at City College, New York (October 16–November 6). Works shown: *Le Quai à Port Louis* and *The Janitor Who Paints* (plate 13). Works loaned to the exhibition from the Smithsonian Institution's permanent collection. Exhibits at the Whitney Museum of American Art.

1968

Work included in the exhibition *Invisible Americans: Black Artists of the 1930s* at The Studio Museum in Harlem (November 19, 1968–January 5, 1969). The University of Pittsburgh presents the John Henry series at the Frick Fine Arts Museum.

1970

The Art Department of Fisk University under the chairmanship of David Driskell presents the exhibition *The John Henry Series and Paintings of Afro-American Folklore* (February 22–March 20). Exhibition travels to the Community Church Art Gallery in New York.

1971

Included in the exhibition *Black Artists: Two*

Generations at The Newark Museum, New Jersey (May 13–September 6). Work shown: *Fétiche et Fleurs*.

1973
Awarded fellowship by the Creative Artist Public Service Program (CAPS)—an affiliation of The New York State Council on the Arts—to create a series of paintings depicting Black American soldiers from the American Revolution to the period in World War II when segregated "Negro regiments" were abolished.

Dies in New York on February 18.

Posthumous Exhibitions

1974
Retrospective exhibition entitled *Palmer Hayden: Southern Scenes and City Streets* is held at The Studio Museum in Harlem (March 17–April 21). Exhibition presents a collection of folklore paintings by the artist that includes twenty-four oil paintings and fourteen watercolors.

1976
Included in the exhibition *Two Centuries of Black American Art* at the Los Angeles County Museum of Art (September 30–November 21). Works shown: *Blue Nile, Midsummer Night in Harlem,* and *When Tricky Sam Shot Father Lamb.*

1985
Included in the exhibition *Hidden Heritage: Afro-American Art 1800–1950,* sponsored and traveled by the Art Museum Association and the Bellevue Art Museum, Bellevue, Washington (September 14–November 10). Works shown: *Big Bend Tunnel, Midsummer Night in Harlem,* and *When Tricky Sam Shot Father Lamb.*

WILLIAM HENRY JOHNSON

1901
Born in Florence, South Carolina, to Henry and Alice Johnson, on March 18.

1906–17
Johnson's school attendance is irregular, as he has to support four younger siblings.

1918
Leaves Florence for New York City. Works at a variety of jobs, including a period as a stevedore.

1921
Accepted to the National Academy of Design. Studies under Charles L. Hinton.

Works part-time for next five years as a hotel porter, a cook in a Chinese restaurant, and a stevedore on the New York docks in order to support himself and his family.

1923
Studies under Charles W. Hawthorne during the summers (1923–26) at the Cape Cod School of Art in Provincetown.

1924
Awarded the Cannon Prize of $100 for his efforts in "painting from the nude" and presented the honorable mention award for his achievements at the National Academy's Life School.

1925
Awarded first prize of $100 from the Hallgarten Prize Fund for his accomplishments in the Painting School, and earns the School Prize for his work in the Still-Life School.

1926
Awarded the Cannon Prize again for his work in "painting from the nude" and wins the School Prize for his efforts in the still-life class.

Studies with George Luks in exchange for maintenance work in Luks's studio.

Departs for Paris in the fall after Charles W. Hawthorne raises $1000 for the disadvantaged student. Maintains a studio in Montparnasse during the winter of 1926 and paints still lifes and portraits influenced stylistically by the French modernists Paul Cézanne and Chaim Soutine. Meets Henry O. Tanner.

1927

First one-man exhibition at the Students and Artist Club in Paris.

Moves to Cagnes-sur-Mer in southern France for eighteen months.

1928

One-man exhibition in Nice.

1929

Makes the acquaintance of Holcha Krake, a ceramicist and weaver, at Cagnes-sur-Mer. With Krake and members of her family travels to Corsica, Nice, Paris, through Belgium and Germany, and finally to Odense, Denmark, on the island of Fyn, to visit Krake's family. In late November returns to New York to rent a loft in Harlem.

1930

Awarded the William E. Harmon First Award and Gold Medal (series of 1929) for "distinguished achievement among Negroes," and a prize for his submission of *Self-Portrait* (plate 19) and five other paintings. The award's jury consists of Meta Fuller, George Hellman, Victor Perard, Karl Illava, and George Luks.

Work included in the *Exhibition of Fine Arts by American Negro Artists,* sponsored by The Harmon Foundation and the Commission on Race Relations of the Federal Council of Churches, at the International House, New York (January 7–19). Exhibition traveled.

One-man exhibition at the Peter White Public Library, Marquette, Michigan.

Exhibits three works at the Gumby Book Studio, New York.

Returns to Florence, South Carolina, in March. Censured for painting scenes of the old Jacobia Hotel which had been converted into a bordello. Leaves Florence in mid-April vowing never to return. Before his departure, has two one-man exhibitions at the Florence County Teachers' Institute (April) and the YMCA (April 15). 135 paintings exhibited.

Visits Alain Locke in Washington, D.C.

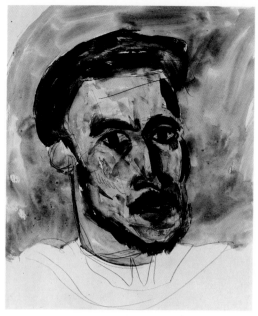

Fig. 78.
William H. Johnson. SELF PORTRAIT. *c. 1931–38. Watercolor on paper, 15 × 11½". Hampton University Museum*

Marries Holcha Krake in May at Kerteminde, Denmark.

Settles in the village of Kerteminde. The couple hold their own two-person exhibitions whenever possible.

Work included in a group exhibition sponsored by the Lyric Theater and The Harmon Foundation at the Lyric Theater, New York (June).

1931

Included in the *Exhibition of the Works of Negro Artists* sponsored by The Harmon Foundation, at The Art Center of New York (February 16–28). Exhibition traveled. Works shown: *Garden—Kerteminde, Landscape with Setting Sun (Florence, South Carolina), Landscape from Florence, South Carolina—Jacobia Hotel, Sonny.*

Exhibits at Kerteminde.

Included in a traveling exhibition organized by Dr. George Cooper with The Harmon Foundation, shown in South Africa (April–May). Works shown: *Cagnes-sur-Mer, Street in France, Negro Woman.*

1932

Travels to Germany, France, and Tunisia. In Nabeul, Krake and Johnson study ceramics. Johnson paints many watercolors and carves woodcuts during the trip.

Included in the *Exhibition of the Work of Negro Artists to Celebrate the Convention of the Washington Branch of the National Association for the Advancement of Colored People,* organized by James V. Herring, at The Gallery

of Art, Howard University, Washington, D.C. (May 18–25). Work shown: *Street in France*.

Work included in the exhibition *Paintings by the New England Society of Contemporary Artists* at the Renaissance Court Galleries, the Museum of Fine Arts, Boston (June 23–30).

Included in an exhibition at the Charles Danforth Memorial Library, Paterson, New Jersey, loaned by The Harmon Foundation (November 13–30). Work shown: *Sonny*.

Holds a two-man exhibition in Odense (end of November–early December); and a two-person exhibition in Kerteminde with Krake.

1933
Included in the *Exhibition of Work by Negro Artists*, sponsored by The Harmon Foundation, at The Art Center of New York (February 20–March 4). Exhibition later shown at the 135th Street branch of The New York Public Library. Work shown: *Jim*.

Holds a two-person exhibition with Krake at Larsen Gallery in Copenhagen (April 18). Includes thirty-seven works.

Work included in a group exhibition, sponsored by The Harmon Foundation, at the Lyric Theater, New York (May).

Included in *A Non-Juried Exhibition of the Work of Negro Artists*, sponsored by the Harlem Adult Education Committee and The Harmon Foundation, at the 135th Street branch of The New York Public Library (May 8–25). Works shown: *Looking from My Balcony* and *Sun Setting over Fishing Boats*.

Included in the *Exhibition of Works by Negro Artists*, sponsored by the Association for the Study of Negro Life and History, at the National Museum of Natural History, Smithsonian Institution, Washington, D.C. (October 31–November 6). Works shown: *Garden, Kerteminde, Denmark* and *Sun Setting over Fishing Port, Kerteminde*.

1934
Work included in group exhibition at Drew Seminary in Madison, New Jersey, sponsored by The Harmon Foundation.

Work included in a traveling exhibition with paintings by Hale Woodruff, sponsored by The Harmon Foundation.

Included in traveling exhibition *The Art of the Negro*, assembled and circulated by the College Art Association (February 15–June 1). Works shown: *Old House* and *Lilies*.

One-man exhibition at Aarhus, Denmark.

Fig. 79.
William H. Johnson. HARBOR UNDER THE MIDNIGHT SUN. *c. 1935–38. Oil on burlap, 27½ × 37¼". The National Museum of American Art, Smithsonian Institution, Washington, D.C. Gift of The Harmon Foundation*

1935
Travels to Norway and Sweden for two years. Work included in a two-man exhibition in Oslo (March).

Exhibits at the Administration Building of West Virginia State College, sponsored by The Harmon Foundation (May 19–June 3).

1936
Work included in an exhibition at the Portland Art Museum sponsored by The Harmon Foundation (May–June).

Included in the *Exhibit of Fine Arts Production by American Negro Artists* at the Hall of Negro Life, Texas Centennial Exposition, in Dallas (June 19–November 29). Works shown: *Lilies no. 48* and *Sonny*.

One-man exhibition in Volda, Norway (fall and winter).

1937
Included in the *Exhibit of Fine Arts by American Negro*

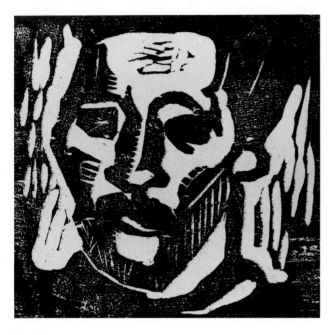

Fig. 80.
William H. Johnson. SELF PORTRAIT. *c. 1935–38 Woodcut, relief print, 9 × 9". Hampton University Museum*

Artists at Dillard University, New Orleans (April 5–19). Work shown: *Flowers*.

Included in a group exhibition sponsored by The Harmon Foundation and the Church of the Ascension, at Memorial Hall, Kansas City, Kansas (April 19–25). Work shown: *Sunflowers*.

One-man exhibition at the Trondheim Art Society in Trondheim, Norway (September). Exhibits in Sweden (November).

1938
Returns to Denmark. Holds two-person exhibition with Krake in Odense.

Returns to New York on Thanksgiving Day.

1939
Exhibits *Watercolors and Woodcuts Colored from Travels in Europe and Africa by W. H. Johnson, and Tapestries and Ceramics by Holcha Krake* at The Artists' Gallery, New York (February 14–28).

Fig. 81.
William H. Johnson.
SELF PORTRAIT (triple).
c. 1939–40. Oil on board, 25½ × 31".
Hampton University
Museum

Included in the *Exhibition of Sculpture and Painting* at The Labor Club, New York (February 12–March 12). Works shown: *Young Poet, Olaf Gynt,* and *Port.*

Joins the mural section of the WPA Fine Arts Project in New York City.

Briefly teaches painting at the Harlem Community Art Center.

Work included in the annual exhibition of the Harlem Artists Guild at the Harlem Community Art Center (June).

Included in exhibition at New York World's Fair. Work shown: *Chain Gang* (plate 53).

Fig. 82.
William H. Johnson. RED CROSS STATION. *c. 1941–42. Gouache, pen and ink on paper mounted on cardboard, 13⅝ × 17⅝". The National Museum of American Art, Smithsonian Institution, Washington, D.C. Gift of The Harmon Foundation*

1940
Included in *The Exposition of the Art of the American Negro, 1851–1940* at the Tanner Art Galleries, Chicago (July 4–September 2). Works shown: *Crucifixion, Flowers of the Teacher,* and *Mother and Child.*

Included in the exhibition *75 Years of Freedom in Commemoration of the Proclamation of the 13th Amendment to the Constitution of the United States of America,* selected by Alain Locke and Holgar Cahill, at the Library of Congress, Washington, D.C. (December 18, 1940–January 18, 1941). Works shown: *Jim, Girl Seated,* and *Sketch for Mural.*

1941
Included in the exhibition *The Creative Art of the American Negro,* borrowed from the New York City Art Project, WPA, at the Library of Congress, Washington, D.C. (February). Works shown: *Street Scene, Street Corner,* and three mural panels.

One-man exhibition at Alma Reed Galleries, New York (May 5–18). Twenty-eight works shown.

Included in the exhibition *Contemporary Negro Art* at McMillen, Inc., New York (October 16–November 7). Works shown: *On a John Brown Flight, Booker T. Washington Legend,* and *Flowers.*

Included in the exhibition *American Negro Art: 19th and 20th Centuries* at the Downtown Gallery, New York (December 14, 1941–January 3, 1942). Work shown: *Jesus and the Three Marys* (plate 20).

1942
One-man exhibition at Faunce House Gallery, Brown University, Providence, Rhode Island. (Works from the Downtown Gallery exhibition.)

Included in the exhibition *American Artists Record of War and Defense: Watercolors, Drawings, and Prints Purchased by the Office for Emergency Management from Entries Submitted to the Section of Fine Arts in an Open National Competition* at the National Gallery of Art, Washington, D.C. (February 7–March 8). Work shown: *Training Camp.*

Awarded certificate of honor for his "distinguished service to America in art," National Negro Achievement Day, New York (June 27).

Included in the first annual *Exhibition of Paintings by Negro Artists of America,* at the Exhibition Gallery, Atlanta University. Work shown: *Jesus and the Three Marys.*

1943
Holcha Krake dies of cancer in January.

One-man exhibition at the Wakefield Gallery, New

York (April 27–May 10).

1944
Included in the *Atlanta University Third Annual Exhibition of Paintings, Sculpture and Prints by Negro Artists* at the Exhibition Gallery, Atlanta (March 25–April 30). Work shown: *Convalescence from Somewhere*.

Included in the exhibition *American Negro Art, Contemporary Painting and Sculpture*, The Newark Museum, New Jersey (April 11–May 3). Works shown: *Jitterbug* and *War Voyage*.

One-man exhibition at the Wakefield Gallery, New York (May 1–13).

Exhibits at The G Place Gallery, New York (June 13–July 14). Work shown: *Red Cross*.

Returns to Florence, South Carolina, for the summer.

Exhibits at Mortimer Brandt Gallery, New York (October 1–November 18).

Holds two-person exhibition with works by Holcha Krake at Marquie Gallery, New York (December 11–31).

1945
Included in the exhibition *The Negro Artist Comes of Age: A National Survey of Contemporary American Artists* at the Albany Institute of History and Art, New York (January 3–February 11). Works shown: *Booker T. Washington Legend* and *Mount Calvary*.

1946
One-man exhibition at the 135th Street branch of The New York Public Library. Twenty-five works shown, including *Fighters for Freedom*.

Returns to Denmark.

1947
One-man exhibition in Kunsthallen, Copenhagen. Seventy-eight works shown, including *Fighters for Freedom*.

Travels to Norway, but confined to hospital in Oslo. Returns to New York in the summer and enters Central

Islip State Hospital. Has paresis for the rest of his life.

1956
All works in the artist's possession acquired by The Harmon Foundation.

One-man retrospective exhibition at the 135th Street branch of The New York Public Library (December 5, 1956–March 1, 1957). 134 works shown.

1957
Exhibits at The Schomburg Collection of Negro Life and History (now part of The Schomburg Center for Research in Black Culture), The New York Public Library (fall–winter, 1957). Work shown: *Fighters for Freedom*.

One-man exhibition at Bennington College, Bennington, Vermont (November 2–10).

One-man exhibition at Nebraska State Teachers College, Chadron (March 1–15).

1958
One-man exhibition at Howard University, Washington, D.C., sponsored by The Harmon Foundation (February 3–28).

One-man exhibition at the Carl Van Vechten Gallery, Twenty-ninth Annual Arts Festival at Fisk University, Nashville (April 23–27).

1960
One-man exhibition at Pocono Art Center, East Stroudsburg, Pennsylvania (November).

1964
One-man exhibition at Junior High School No. 8, Jamaica, Long Island.

Included in the exhibition *The Portrayal of the Negro in American Painting*, at the Bowdoin College Museum of Art, Brunswick, Maine (May 15–July 15). Work shown: *Girl in a Green Dress*.

1965
Exhibits in the American Festival of Negro Arts at Fairleigh Dickinson University, Teaneck, New Jersey.

1967

The Harmon Foundation ceases operations. Foundation gives 1,154 of artist's works to the National Collection of Fine Arts (now part of the National Museum of American Art).

Included in the exhibition *The Evolution of Afro-American Artists: 1800–1950*, at City College, New York (October 16–November 6). Works shown: *Young Man in a Vest* (plate 54), *Descent from the Cross, On a John Brown Flight, Volunteer Workers, Jacobia Hotel, Florence, S.C.*, and *Come unto Me, Little Children*.

1968

One-man exhibition at the College Museum, Hampton Institute, Hampton, Virginia (March 3–April 14).

Included in *An Exhibition of Paintings by Contemporary Black Artists at Wilson College*, Chambersburg, Pennsylvania (October 13–November 1). Works shown: *Portrait of a Man, El Sorite—Tunis, Oslo, Norway, Come unto Me, Little Children, Red Cross Station* (fig. 82), *Harlem Street*, and *On a John Brown Flight*.

One-man exhibition at Taylor Gallery, Bluford Library, North Carolina Agricultural and Technical State University, Greensboro. Works shown: *Ezekiel Saw the Wheel* and *War Voyage*.

Included in the exhibition *Invisible Americans: Black Artists of the 1930s*, at The Studio Museum in Harlem, New York (November 19, 1968–February 2, 1969). Works shown: *Young Man in a Vest, Jacobia Hotel, Florence, S.C.*, and *Danish Boy*.

1969

Included in the exhibition *Afro-American Artists: 1800–1969*, sponsored by the Division of the School District of Philadelphia in cooperation with the Philadelphia Civic Center, at the Municipal Arts Gallery (December 5–28).

1970

Exhibits at La Jolla Museum of Art, California (February 14–March 29). Work shown: *Descent from the Cross*.

1970

One-man exhibition at Spelman College, Atlanta, Georgia (April 7–30).

Dies on Long Island, on April 13.

Posthumous Exhibitions

1971

Exhibition at the University Art Museum, University of Texas, Austin (March 29–May 3).

Retrospective exhibition entitled *William H. Johnson 1901–1970* held at the National Collection of Fine Arts, Washington, D.C. (November 5, 1971–January 9, 1972).

Included in the exhibition *Black Artists: Two Generations* at The Newark Museum, New Jersey (May 13–September 6) and at the Tuskegee Institute, Alabama. Works shown: *Jitterbug* and *War Voyage*.

1972

Exhibition entitled *William H. Johnson, American Artist 1901–1970* held at the South African National Gallery, Cape Town.

1976

Included in the exhibition *Two Centuries of Black American Art* at the Los Angeles County Museum of Art (September 30–November 21). Works shown: *Harbor Under the Midnight Sun, Lamentation, Mount Calvary, Chain Gang, Nude, I Baptize Thee, At Home in the Evening, Early Morning Work*, and *Work Ironing*.

1982

One-man retrospective exhibition *William H. Johnson: The Scandanavian Years* held at the National Museum of American Art, Washington, D.C. (September 17–November 28). 46 paintings, drawings, and prints shown.

1985

Included in the exhibition *Hidden Heritage: Afro-American Art 1800–1950*, sponsored and traveled by the Art Museum Association and the Bellevue Art Museum, Bellevue, Washington (September 14–November 10). Works shown: *Jesus and the Three Marys* and *Swing Low, Sweet Chariot*.

Selected Bibliography

BOOKS

Abramson, Doris. *Negro Playwrights in the American Theater.* New York: Columbia University Press, 1969.

Ashton, Dore. *American Art Since 1945.* New York: Oxford University Press, 1982.

Baigell, Matthew. *Dictionary of American Art.* New York: Harper and Row, 1979.

Barksdale, Richard K. *Langston Hughes: The Poet and His Critic.* Chicago: American Library Association, 1977.

Barthes, Roland (trans. Richard Howard). *Camera Lucida: Reflections on Photography.* Toronto: McGraw Hill, Ryerson, 1980.

Baur, John H. *New Art in America.* New York: Frederick A. Praeger, 1957.

Bearden, Romare, and Henderson, Harry. *Six Black Masters of American Art.* Garden City, New York: Zenith Books, Doubleday and Company, 1972.

Bone, Robert. *Down Home: A History of Afro-American Short Fiction.* New York: G. P. Putnam, 1975.

Bontemps, Arna (ed.). *The Harlem Renaissance Remembered.* New York: Dodd, Mead and Company, 1972.

Brawley, Benjamin. *The Negro Genius.* New York: Dodd, Mead and Company, 1937.

Brown, Ina Corinne. *The Story of the American Negro.* New York: Friendship Press, 1936.

Brown, Milton V. *American Painting from the Armory Show to the Depression.* Princeton, New Jersey: Princeton University Press, 1955.

Brown, Sterling. *Negro Poetry and Drama and the Negro in American Fiction.* 1937. Reprint. New York: Atheneum, 1969.

Butcher, Margaret Just. *The Negro in American Culture.* New York: The New American Library, 1956.

Cederholm, Theresa Dickason (ed.). *Afro-American Artists: A Bibliographical Directory.* Boston: Trustees of the Boston Public Library, 1973.

Charters, Samuel B., and Kunstadt, Leonard. *Jazz: A History of the New York Scene.* Garden City, New York: Doubleday and Company, 1962.

Chase, Judith Wragg. *Afro-American Art and Craft.* New York: Van Nostrand Reinhold Company, 1971.

Cronon, Edmund D. *Black Moses: The Story of Marcus Garvey.* Madison: University of Wisconsin Press, 1969.

Cruse, Harold. *Crisis of the Negro Intellectual.* New York: William Morrow, 1967.

Cunard, Nancy. *Negro: An Anthology Made by Nancy Cunard, 1931–33.* 1934. Reprint. New York: Negro Universities Press, 1969.

Davidson, Abraham A. *The Story of American Painting.* New York: Harry N. Abrams, 1974.

Davis, Arthur P. *From the Dark Tower: Afro-American Writers, 1900–1960.* Washington, D.C.: Howard University Press, 1974.

Dover, Cedric. *American Negro Art.* Greenwich, Connecticut: New York Graphic Society, 1969.

Driskell, David. *Two Centuries of Black American Art.* Los Angeles and New York: Los Angeles County Museum of Art and Alfred A. Knopf, 1976.

Emanuel, James A. *Langston Hughes.* Boston: Twayne Publishers, G. K. Hall and Company, 1967.

Fax, Elton C. *Seventeen Black Artists.* New York: Dodd, Mead and Company, 1971.

Ferguson, Blanche. *Countee Cullen and the Negro Renaissance.* New York: Dodd, Mead and Company, 1966.

Fine, Elsa Honig. *The Afro-American Artist: A Search for Identity.* 1973. Reprint. New York: Hacker Art Books, 1982.

Fleming, Robert E. *James Weldon Johnson and Arna Wendell Bontemps: A Reference Guide.* Boston: G. K. Hall and Company, 1978.

Gallager, Buell G. *Color and Conscience: The Irrepressible Conflict.* New York and London: Harper and Brothers, 1946.

Goodrich, Lloyd and Baur, John I. H. *American Art of Our Century.* New York: Frederick A. Praeger, 1961.

Haskins, James. *The Cotton Club.* New York: Random House, 1977.

Hemenway, Robert. *Zora Neale Hurston: A Literary Biography.* Urbana: University of Illinois Press, 1977.

Henri, Florette. *Black Migration: Movement North, 1900–1920.* Garden City, New York: Doubleday and Company, 1976.

Huggins, Nathan Irvin. *Harlem Renaissance.* New York: Oxford University Press, 1971.

_____ . *Voices from the Harlem Renaissance.* New York: Oxford University Press, 1976.

Hughes, Langston. *The Big Sea: An Autobiography.* 1940. Reprint. New York: Hill and Wang, 1975.

Hughes, Langston, and Bontemps, Arna. *The Poetry of the Negro: 1746–1970.* Garden City, New York: Doubleday and Company, 1970.

Irvine, Betty Jo. *Fine Arts and the Black American.* Bloomington: Indiana University Libraries, 1969.

Johnson, James Weldon. *Black Manhattan.* 1930. Reprint. New York: Atheneum, 1972.

_____ . *God's Trombones: Seven Negro Sermons in Verse.* 1927. Reprint. Viking Press, 1976.

_____ . *St. Peter Relates an Incident— Selected Poems.* New York: Viking Press, 1935.

Jones, Lois Mailou. *Lois Mailou Jones: Peintures 1937–51.* Tourcoing, France: Presses Georges Frère, 1952.

Kellner, Bruce. *Carl Van Vechten and the Irreverent Decades.* Norman: University of Oklahoma Press, 1968.

Larkin, Oliver W. *Art and Life in America.* New York: Holt, Rinehart and Winston, 1949.

Levy, Eugene. *James Weldon Johnson— Black Leader—Black Voice.* Chicago: The University of Chicago Press, 1973.

Lewis, David Levering. *When Harlem Was in Vogue.* New York: Alfred A. Knopf, 1981.

Lewis, Samella. *Art: African American.* New York: Harcourt Brace Jovanovich, 1978.

Lipman, Jean, and Armstrong, Tom (eds.). *American Folk Painters of Three Centuries.* New York: Hudson Hills Press and the Whitney Museum of American Art, 1980.

Locke, Alain. *The New Negro.* 1925. Reprint. New York: Atheneum, 1970.

McCurdy, Charles. *Modern Art: A Pictorial Anthology.* New York: Macmillan, 1958.

McKay, Claude. *Harlem: Negro Metropolis.* 1940. Reprint. New York: Harcourt Brace Jovanovich, 1968.

Martin, Tony. *Race First: The Ideological and Organizational Struggles of Marcus Garvey and the Universal Negro Improvement Association.* Westport, Connecticut: Greenwood Press, 1976.

Morand, Paul. *Black Magic.* Translated from the French by Hamish Miles. New York: Viking Press, 1929.

Munro, Eleanor. *Originals: American Women Artists.* New York: Simon and Schuster, 1979.

Nichols, Charles H. *Arna Bontemps—Langston Hughes Letters: 1925–67.* New York: Dodd, Mead and Company, 1980.

Opitz, Glen B. (ed.). *Dictionary of American Sculptors.* Poughkeepsie, New York: Apollo, 1984.

Osofsky, Gilbert. *Harlem, The Making of a Ghetto: Negro New York, 1890–1930.* New York: Harper and Row, 1966.

Ottley, Roi, and Weatherby, William J. (eds.). *The Negro in New York: An Informal Social History, 1626–1940.* New York: Frederick A. Praeger, 1969.

Parry, Elwood. *The Image of the Indian and the Black Man in American Art, 1590–1900.* New York: George Braziller, 1974.

Peterson, Karen, and Wilson, J. J. *Women Artists: Recognition and Reappraisal from the Early Middle Ages to the Twentieth Century.* New York: Harper and Row, 1976.

Ploski, Harry A., and Marr, Warren. *A Reference Work on the Afro-American: The Negro Almanac.* New York: Bellwether Publishing Company, 1976.

Porter, James A. *Modern Negro Art.* Reprint. New York: Arno Press and *The New York Times,* 1969.

Rodman, Seldon. *Horace Pippin, A Negro Painter in America.* New York: The Quadrangle Press, 1947.

Romero, Patricia. *In Black America.* Washington, D.C.: United Publishing Corporation, 1969.

Rose, Barbara. *American Art Since 1900.* New York: Frederick A. Praeger, 1975.

Rubinstein, Charlotte Streifer. *American Women Artists: From Early Indian Times to the Present.* Boston and New York: G. K. Hall and Avon Books, 1982.

Schoener, Allon (ed.). *Harlem on My Mind: Cultural Capital of Black America, 1900–1968.* New York: Random House, 1968.

Smith, Willie. *Music on My Mind: The Memoirs of an American Pianist.* Garden City, New York: Doubleday and Company, 1964.

Sterling, Dorothy, and Quarles, Benjamin. *Lift Every Voice: The Lives of Booker T. Washington, W. E. B. Du Bois, Mary Church Terrell, and James Weldon Johnson.* Garden City, New York: Zenith Books, Doubleday and Company, 1965.

Taft, Larado. "Harriet Hosmer and the Early Women Sculptors." In *The History of American Sculpture.* New York: Arno Press, 1969.

Vincent, Theodore G. *Voices of a Black Nation: Political Journalism in the Harlem Renaissance.* San Francisco: Ramparts Press, 1973.

Waldron, Edward E. *Walter White and the Harlem Renaissance.* Port Washington, New York: Kennikat Press, 1978.

Wilmerding, John. *American Art.* New York: Viking Press, 1976.

EXHIBITION CATALOGS

Bellevue Art Museum, Washington. *Hidden Heritage: Afro-American Art 1800–1950.* September 14–November 10, 1985. Organized by the Art Museum Association of America. Catalog by David Driskell.

The Center Gallery of Bucknell University, Lewisburg, Pennsylvania. *Since the Harlem Renaissance: Fifty Years of Afro-American Art.* April 13–June 6, 1984.

The Danforth Museum of Art, Framingham, Massachusetts. *An Independent Woman: The Life and Art of Meta Warrick Fuller.* December 16, 1984–February 24, 1985. Joy L. Gordon, Curator.

District of Columbia Art Association,

Anacostia Neighborhood Museum, Washington, D.C. *The Barnett-Aden Collection.* Catalog by Edmund B. Gaither. Smithsonian Institution Press, 1974.

Fisk University Art Museum, Nashville, Tennessee. *Elizabeth Catlett: An Exhibition of Sculpture and Prints.* 1973.

Frick Fine Arts Museum, University of Pittsburgh. *Black American Art.* September 17–October 23, 1977. Organized by the Barnett-Aden Collection, Washington, D.C.; sponsored by The Pittsburgh Chapter of Links.

The Gallery of Art, Howard University, Washington, D.C. *Lois Mailou Jones: Retrospective Exhibition.* March 31–April 21, 1972.

Huntsville Museum of Art, Alabama. *Black Artists/South.* April 1–July 29, 1979. Ralph M. Hudson, Curator.

The Museum of Art, Rhode Island School of Design, Providence. *A Century of Black Photographers: 1840–1960.* March 31–May 8, 1983. Valencia Hollins Coar, Guest Curator.

The Museum of the National Center of Afro-American Artists, Boston. *Reflective Moments: Lois Mailou Jones Retrospective 1930–72.* March 11–April 15, 1973. Catalog introduction by Edmund Barry Gaither.

National Collection of Fine Arts, Washington, D.C. *William H. Johnson 1901–1970.* Adelyn D. Breeskin, Curator. Smithsonian Institution Press, 1971.

The Newark Museum, New Jersey. *American Art in the Newark Museum.* 1981.

————. *Black Artists: Two Generations.* May 13–September 6, 1971.

The New Muse Community Museum of Brooklyn, New York. *The Black Artists in the WPA, 1933–43.* February 15–March 30, 1976. Charlene Chase Van Derger, Curator; George Carter, Assistant Curator.

The Phillips Collection, Washington, D.C. *Horace Pippin.* February 25–March 27, 1977. Catalog essay by Romare Bearden.

The Pittsburgh Chapter of Links. *Black American Art from the Barnett-Aden Collection, Frick Fine Arts Museum, University of Pittsburgh.* September 17–

October 23, 1977.

South African National Gallery, Cape Town. *William H. Johnson, American Artist 1901–1970.* 1972.

The Studio Museum in Harlem, New York. *Hale Woodruff: 50 Years of His Art.* April 29–June 24, 1979. Catalog essays by Mary Schmidt Campbell, Gylbert Coker, and Winifred Stoelting.

————. *Harlem Artists '69.* July 22–September 7, 1969.

————. *New York/Chicago: WPA and the Black Artist.* November 13, 1977–January 8, 1978. Ruth Ann Stewart, Guest Curator.

————. *Palmer Hayden: Southern Scenes and City Streets.* March 17–April 21, 1974. Catalog statement by Joseph Delaney.

————. *Tradition and Conflict: Images of a Turbulent Decade, 1963–73.* January 27–June 30, 1985. Mary Schmidt Campbell, Curator.

UCEN Art Gallery, University of California, Santa Barbara. *An Exhibition of Black Women Artists.* May 5–17, 1975.

Whitney Museum of American Art, New York. *Jacob Lawrence.* May 16–July 7, 1974. Milton Brown, Curator.

PERIODICALS

"Artists in the Age of Revolution, A Symposium." *Arts in Society,* Summer–Fall 1968, pp. 219–37.

"The Arts and the Black Revolution." *Arts in Society,* Summer–Fall 1968, pp. 395–531.

Ashton, Dore. "African and Afro-American Art: The Transatlantic Tradition at the Museum of Primitive Art." *Studio,* November 1968, p. 202.

"Baltimore Art by Negroes." *Art News,* February 11, 1939, p. 17.

Barnes, Albert C. "Negro Art and America." *Survey,* March 1, 1925, pp. 668–69.

Bass, Ruth. "The Vasari Diary—Telling It Like It Was." *Art News,* April 1985, pp. 11–13.

Bement, Alon. "Some Notes on a Harlem Art Exhibit." *Opportunity,* November 1933, n.p.

Berkman, Florence. "Afro-American Exhibit Fosters Understanding of Black Artists."

The Hartford Times, May 24, 1970.

Berman, Avis. "Jacob Lawrence and the Making of Americans." *Art News,* February 1984, pp. 78–86.

"Black Art: What Is It?" *The Art Gallery,* April 1970, n.p.

"Black Lamps: White Mirrors." *Time,* October 3, 1969, pp. 60–71.

Bloomfield, Arthur. "Top Black Artists." *San Francisco Examiner,* November 4, 1970.

Bonosky, Phillip. "Invisible Americans: A Lesson in Black Art." *Daily World,* November 23, 1968.

Boswell, Peyton. "Comment: The Negro Annual." *Art Digest,* April 15, 1946, p. 3.

————. "5th Negro Annual Winners." *Art Digest,* May 1, 1946, p. 11.

Bourne, Kay. "Quiet, Powerful Exhibit." *Bay State Banner,* October 7, 1971.

Bowling, Frank. "It's Not Enough to Say 'Black Is Beautiful.'" *Art News,* April 1971, pp. 53–55, 82.

Brown, Evelyn S. "The Harmon Awards." *Opportunity,* March 1933, pp. 78–79.

Bruner, Miriam. "An Introduction to the Negro in American History." *Arts Magazine,* September 1969, n.p.

Bumiller, Elizabeth. "Upstairs, Downstairs at the Phillips Gallery: In Honor of Lois Mailou Jones." *Washington Post,* October 3, 1979.

Campbell, Mary Schmidt. "Romare Bearden: Rites and Riffs." *Art in America,* December 1981, pp. 135–41.

Catlett, Elizabeth. "A Tribute to the Negro People." *American Contemporary Art,* Winter 1940, p. 17.

Clay, Jean. "The Implications of Negritude." *Studio,* January–July 1966, pp. 51–53.

Davis, Douglas. "What Is Black Art?" *Newsweek,* June 22, 1970, pp. 89–90.

Feelings, Tom. "Memoriam: To Charles White." *Time Capsule,* Summer/Fall 1981, p. 14.

Fine, Elsa Honig. "The Afro-American Artist: A Search for Identity." *Art Journal,* Fall 1969, pp. 32–35.

————. "Mainstream, Blackstream and the Black Art Movement." *Art Journal,* Summer 1971, pp. 374–75.

Fisher, Carolyn. "Art in Atlanta: The Tradition" and "Art in Atlanta: The

Present." *Contemporary Art/Southeast,* August–September 1977, pp. A4–A10.

Flexner, James Thomas. "250 Years of Painting in Maryland." *Magazine of Art,* December 1945, pp. 291–94.

Garver, T. H. "Dimensions of Black Exhibition at La Jolla Museum." *Artforum,* May 1970, pp. 83–84.

Ghent, Henri. "Art Mailbag: White Is Not Superior." *New York Times,* December 8, 1968.

————. "The Museum, Its Role and Responsibility." *Art Gallery,* April 1970, p. 62.

————. "Notes to the Young Black Artist: Revolution or Evolution?" *Art International,* June 1971, pp. 33–36.

Gilliam, Dorothy. "Filling a Black Art Vacuum at Two Separate Exhibitions." *Washington Post,* January 25, 1982.

Glessman, Louis R. "Object: Diversity." *Time,* April 6, 1970, n.p.

Glueck, Grace. "America Has Black Art on Her Mind." *New York Times,* February 27, 1969.

————. "Black Show Under Fire at the Whitney." *New York Times,* January 31, 1971.

Greene, Carroll, Jr. "The Afro-American Artist: A Background." *The Art Gallery,* April 1968, pp. 12–25.

————. "Perspective: The Black Artist in America." *The Art Gallery* (Afro-American Issue), April 1970, pp. 1–29.

Haas, Joseph. "A Big Brilliant and Exciting Exhibition of Black Art." *Chicago Daily News,* January 16, 1971.

Haskell, Ernest, Jr. "Black American Art from Joshua Johnston to Gaither." *Times Record* (Maine), February 10, 1972.

Haydon, Harold. "Coming of Age of Black Art." *Chicago Sun Times,* July 26, 1970.

Herring, James V. "The American Negro as Craftsman and Artist." *The Crisis,* April 1942, pp. 116–18.

Hunsucker, Suzanne. "Lois Jones Pierre-Noel: Female, Black, Talented." *Fort Collins Coloradoan,* February 20, 1973.

Jacobs, Jay. "A Bridge to the Future: The Clinque Gallery." *The Art Gallery* (Second Afro-American Issue), April 1970, pp. 50–51.

_____ . "Two Afro-American Artists." *The Art Gallery*, April 1968, pp. 26–38.

Jewel, Edward Alden. "Stress on Modern." *New York Times*, December 15, 1946.

Kay, Jane Holtz. "Artists as Social Reformers." *Art in America*, January 1969, pp. 44–47.

Koethe, John. "Boston—Black Is Political." *Art News*, October 1970, p. 30.

Kramer, Hilton. "Black Art and Expedient Politics." *New York Times*, June 7, 1970.

_____ . "Black Art Becomes Politics on Canvas." *New London Day* (Connecticut), June 6, 1970.

Landy, Jacob. "William H. Johnson: Expressionist Turned 'Primitive.'" *Journal of the American Association of University Women*, March 1958, pp. 167–70.

Lane, James W. "Afro-American Art on Both Continents." *Art News*, October 1941, p. 25.

Lewis, David Levering. "The Politics of Art: The New Negro, 1920–1935." *Prospects: An Annual of American Cultural Studies*, 1977, pp. 237–61.

Locke, Alain. "Advance on the Art Front." *Opportunity*, May 1939, pp. 132–36.

Long, Richard. "200 Years of Black American Art." *Contemporary Art/Southeast*, April–May 1977, pp. 42–43.

Long, Richard A. "The Negro College Museum." *The Art Gallery*, April 1968, pp. 44–45.

Lowe, Jeannette. "The Passing Shows" and "Four Artists." *Art News*, May 1941, p. 25.

McCausland, Elizabeth. "Jacob Lawrence." *Magazine of Art*, November 1945, pp. 251–54.

Mahal, H. E. "Interviews: Four Afro-American Artists." *The Art Gallery*, April 1970, pp. 36–41.

Masheck, Joseph. "Black Artists at the Visual Arts Gallery." *Artforum*, September 1970, n.p.

Moore, William H. "Richard Barthe—Sculptor." *Opportunity*, November 1928, p. 334.

"The Negro Artist Comes of Age." *Art News*, February 1945, pp. 16, 29–30.

"Negro Artists: Win Top Awards." *Life*, July 22, 1946, pp. 62–65.

"Object Diversity." *Time*, April 6, 1970, pp. 80–87.

Paris, Jean. "Black Experience in Art." *Long Island Press*, June 14, 1970.

Parrent, Mark. "Bearden Artwork Debuts in Metro." *Baltimore Evening Sun*, March 23, 1983.

Pierre-Noel, Lois Jones. "American Negro Art in Progress." *Negro History Bulletin*, October 1967, n.p.

Porter, Dorothy. "James Porter—Artist." *Opportunity*, February 1933, pp. 46–47.

Porter, James A. "Malvin Gray Johnson." *Opportunity*, April 1935, pp. 117–18.

_____ . "Negro Art on Review." *American Magazine of Art*, January 1934, n.p.

Richard, Paul. "The Artist's Universe: Jacob Lawrence's Mural Unveiled at Howard University." *Washington Post*, December 4, 1980.

_____ . "The Integrated Art of Romare Bearden." *Washington Post*, April 26, 1981.

Robbins, Warren. "Tapping Cultural Roots." *The Art Gallery*, April 1970, pp. 55–56.

Rose, Barbara. "Black Art in America." *Art in America*, September–October 1970, pp. 53–54.

"Scandinavians in America." *American Scandinavian Review* (New York City), March 1957, p. 73.

Shapiro, David. "652 Broadway." *Art News*, April 1971, pp. 50–51.

Sherman, Marjorie. "Afro-American Works Score Smash Hit." *Boston Globe*, May 24, 1970.

Siegal, Jeanne. "Robert Thompson and the Old Masters." *Harvard Art Review*, Winter 1967, pp. 10–14.

_____ . "Why Spiral?" *Art News*, September 1966, pp. 48–51, 67–68.

Stevens, Elizabeth. "Bearden Show Enriched by Morgan State Exhibit." *The Baltimore Sun*, June 7, 1981.

Winslow, Vernon. "Negro Art and the Depression." *Opportunity*, February 1941, pp. 40–42, 62–63.

Wolf, Ben. "Bearden Abstracts Drama of the Bull-Ring." *The Art Digest*, April 1, 1946, p. 13.

_____ . "Six Artists Return from the War." *The Art Digest*, May 15, 1946, p. 13.

Young, J. E. "Two Generations of Black Artists, California State College, Los Angeles." *Art International*, October 1970, p. 74.

Young, Mahonri Sharp. "Letter from U.S.A.: To See New Things." *Apollo*, February 1968, n.p.

Bibliography of Book and Magazine Illustrations by Aaron Douglas

Fig. 83.
Aaron Douglas. FLIGHT, *from The Emperor Jones series. c. 1926. Woodcut, 8½ × 5½". Collection Stephanie E. Pogue, Hyattsville, Maryland*

BOOKS: 1925–37

Below is a list of known book illustrations by Aaron Douglas, most of which were executed during the first few years of his residency in New York City (1925–29). Illustrations he published after 1937 have been omitted from this list as they are essentially reproductions of earlier works. Illustration titles are given here only when the illustrations are specifically captioned in the original publications. Otherwise, each illustration is designated by the location or page number where it appears in the original publication.

Locke, Alain. *The New Negro.* New York: Albert and Charles Boni, 1925. 6 illus.: *Meditation,* p. 56; *Sahdji,* p. 112; *The Poet,* p. 128; *The Sun God,* p. 138; *Music,* p. 216; *Ancestral,* p. 268.

Cullen, Countee (ed.). *Caroling Dusk.* New York: Harper and Brothers, 1927. 2 illus.: title page and *xxiii*

Fauset, Arthur Huff. *For Freedom.* Philadelphia: Franklin Publishing and Supply Co., 1927. 2 illus.: silkscreened cover and jacket.

Glenn, Isa. *Little Pitchers.* New York: Alfred A. Knopf, 1927. 1 illus.: jacket.

Hughes, Langston. *Fine Clothes to the Jew.* New York: Alfred A. Knopf, 1927. 1 illus.: jacket.

Johnson, Charles S. *Ebony and Topaz: Collectanea.* New York: Opportunity:

Journal of Negro Life, 1927. 4 illus.: pp. 14, 22, 28, and 130.

Johnson, James Weldon. *The Autobiography of an Ex-Colored Man.* New York: Alfred A. Knopf, 1927. 1 illus.: jacket.

Johnson, James Weldon. *God's Trombones: Seven Negro Sermons in Verse.* New York: Viking Press, 1927. 7 illus.: jacket and opp. pp. 13, 17, 21, 31, 45, and 53.

Locke, Alain L. and Gregory, Montgomery (eds.). *Plays of Negro Life.* New York: Harper and Brothers, 1927. 53 illus.: pp. i, vi, vii, xi, xiii, 1, 3, 25, 27, 51, 53, 69, 71, 97, 99, 117, 119, 139, 141, 165, 167, 187, 189, 205, 207, 215, 217, 235, 237, 253, 255, 269, 271, 287, 289, 301, 303, 321, 323, 333, 335, 373, 375, 387, 389, and opp. pp. 42, 100, 194, 310, 340, 350, 360, and 370.

McKay, Claude. *Home to Harlem.* New York: Harper and Brothers, 1928. 1 illus.: jacket.

McKay, Claude. *Banjo.* New York: Harper and Brothers, 1929. 1 illus.: jacket.

Morand, Paul. *Black Magic.* New York: Viking Press, 1929. 9 illus.: jacket and opp. pp. 3, 31, 53, 73, 93, 139, 177, and 193.

Salmon, André. *The Black Venus.* New York: The Macaulay Co., 1929. 1 illus.: jacket.

McKay, Claude. *Banana Bottom.* New York: Harper and Brothers, 1933. 1 illus.: jacket.

McKay, Claude. *A Long Way from Home.* New York: Lee Furman, 1937. 1 illus.: jacket.

MAGAZINES: 1925–31

Below is a list of known magazine illustrations by Douglas, published between the years 1925 and 1931. After 1931, Douglas often reissued previously published illustrations. Only those illustrations which accompanied articles specifically about Douglas's murals have been excluded. Illustrations are listed in chronological order by title or by article each accompanied.

Johnson, Georgia Douglas. "The Black Runner." *Opportunity,* vol. 3, no. 33

(September 1925), 1 illus.: p. 258.

Self-Portrait. In *Opportunity*, vol. 3, no. 33 (September 1925), p. 285.

Mulatto. In *Opportunity*, vol. 3, no. 34 (October 1925), cover.

"I couldn't hear Nobody Pray" and *"An' the stars belong to fall."* In Fauset, Arthur Huff, "The Negro Cycle of Song—A Review." *Opportunity*, vol. 3, no. 35 (November 1925), pp. 333 and 334.

"Roll, Jordan, Roll." In Locke, Alain, "The Technical Study of the Spirituals—A Review." *Opportunity*, vol. 3, no. 35 (November 1925), p. 332.

Untitled (Head of Man with Cityscape.) In *Opportunity*, vol. 3, no. 36 (December 1925), cover.

Hughes, Langston. "To Midnight Nan at Leroy's." *Opportunity*, vol. 4, no. 37 (January 1926), 1 illus.: p. 23.

Bagnall, Robert W. "Book Review." *Opportunity*, vol. 4, no. 38 (February 1926), 1 illus.: p. 74.

Calverton, V. F. "The Advance of the Negro." *Opportunity*, vol. 4, no. 38 (February 1926), 1 illus.: p. 55.

The Emperor Jones. In "The Negro and the American Stage." *Theater Arts Monthly*, vol. 10, no. 2 (February 1926), 2 illus.: pp. 117–18.

Invincible Music/The Spirit of Africa. In *The Crisis*, vol. 31, no. 4 (February 1926), p. 169.

Scarborough, W. S. "Optimisms in Negro Farm Life." *Opportunity*, vol. 4, no. 38 (February 1926), 1 illus.: p. 66.

Untitled (Two Men at a Forge). In *Opportunity*, vol. 4, no. 38 (February 1926), cover.

Krigwa Players Little Negro Theatre of Harlem. In *The Crisis*, vol. 32, no. 1 (May 1926), p. 19.

Untitled (Man Sitting and Sunset). In *Opportunity*, vol. 4, no. 42 (June 1926), cover.

Untitled (Abstract Design). In *Opportunity*, vol. 4, no. 44 (August 1926), cover.

Tut-Ankh-Amen. In *The Crisis*, vol. 32, no. 5 (September 1926), cover.

Feet o' Jesus. In *Opportunity*, vol. 4, no. 46 (October 1926), cover.

I Needs a Dime for Beer, Ma Bad Luck Card, On De No'thern Road, Play De Blues, and *Weary As I Can Be.* In Hughes, Langston, and Douglas, Aaron,

Fig. 84 .
Aaron Douglas. Cover illustration for
Opportunity (Langston Hughes and
Aaron Douglas issue). October 1926.
The Schomburg Center for Research
in Black Culture, The New York Public
Library

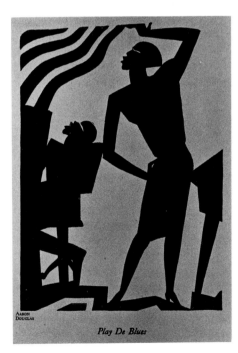

Play De Blues

Fig. 85 .
Aaron Douglas. PLAY DE BLUES, for
"Misery" by Langston Hughes, in
Opportunity. October 1926. The
Schomburg Center for Research in
Black Culture, The New York Public
Library

"Two Artists." *Opportunity*, vol. 4, no. 46 (October 1926), pp. 314–15.

Johnson, James Weldon. "Romance and Tragedy in Harlem—A Review." *Opportunity*, vol. 4, no. 46 (October 1926), 1 illus.: p. 316.

Douglas, Aaron. "Three Drawings." *Fire!! Devoted to Younger Negro Artists*, vol. 1, no. 1 (November 1926), 3 illus.: pp. 30, 31, and 32.

Untitled (Head of Man). In *The Crisis*, vol. 33, no. 1 (November 1926), cover.

Untitled (Profile of Human Head and Sphinx). In *Fire!! Devoted to Younger Negro Artists*, vol. 1, no. 1 (November 1926), cover.

Untitled (Reclining Figure with Bow and Arrow). In *Fire!! Devoted to Younger Negro Artists*, vol. 1, no. 1 (November 1926), p. 28.

"And there were in the same country shepherds abiding in the fields." In *The Crisis*, vol. 33, no. 2 (December 1926), cover.

"Princes shall come out of Egypt; Ethiopia shall soon stretch out her hands unto God." In *The Crisis*, vol. 34, no. 3 (May 1927), cover.

Thurman, Wallace. "Harlem." *American Monthly*, vol. 19/20, no. 3 (May 1927), 4 illus.: pp. 19–20.

Untitled (Mangbetu Woman Copied from L'Exposition de la Croisiere Noire). In *Opportunity*, vol. 5, no. 5 (May 1927), cover.

Untitled (Laborers with Abstract Design). In *Opportunity*, vol. 5, no. 7 (July 1927), cover.

The Burden of Black Womanhood. In *The Crisis*, vol. 34, no. 7 (September 1927), cover.

The Creation. In Auslander, Joseph, "Sermon Sagas: A Review." *Opportunity*, vol. 5, no. 9 (September 1927), 1 illus.: p. 274.

The Autobiography of an Ex-Colored Man. In "Our Book Shelf." *Opportunity*, vol. 5, no. 11 (November 1927), 1 illus.: p. 337.

The Young Blood Hungers. In *The Crisis*, vol. 35, no. 5 (May 1928), cover.

Untitled (Head of a Woman). In *The Crisis*, vol. 36, no. 5 (May 1929), cover.

Forge Foundry. In *La Revue du Monde Noir*, vol. 1, no. 1 (1931), opp. p. 5.

Index

Pages on which black-and-white illustrations appear are in italics. Color plates are listed by plate number.

Abyssinian Baptist Church, Harlem, 35, 91, *94–95*
Afro-American, periodical, 71
All God's Chillun Got Wings, play (O'Neill), 63, 170
Amsterdam News, periodical, 69, 79, 91
Anderson, Charles W., 87
Armstrong, Louis, 129, 170, 174
Art Deco, 129
Art Museum Association of America, 31
Art Nouveau, 129
Atlanta University, 77

Baker, Walter, 160
Baldridge, Cyrus, 111
Bannister, Edward, 53
Barnes, Albert, 29, 39, 106
Barrymore, Ethel, 59
Barrymore, John, 59
Barthe, Richmond, 39, 174
 The Negro Looks Ahead, 38
 The Singing Slave, 37
Battling Siki, 81
Bearden, Romare, 11, 29, 31, 49, 93, 103
Bechet, Sidney, 78
Becton, Rev. George Wilson, 99
Benley, Gladys, 89
Bennett, Gwendolyn, 59, 62, 71
Benton, Thomas Hart, 52, 53
 America Today, 25, 29, 53
 Cotton Pickers, Georgia, 52
Bethune, Mary McLeod, 91
The Big Sea, book (Hughes), 61
Bing, S., 107, 109
The Black Christ, poetry (Cullen), 89, 173
Black Herman, 81
Black Magic, book (Morand), 110
Black Manhattan, book (J. W. Johnson), 87–88
Black No More, book (Schuyler), 89
Black Opal, review, 72
The Blacker the Berry, book (Thurman), 89, 173
Blake, Eubie, 57, 166, 169, 170
Bledsoe, Jules, 91
blues, music, 71, 77
Boni and Liveright, publishers, 60, 67, 69
Bontemps, Arna, 57, 69, 89
Boothbay Art Colony, Maine, 131
Boston, 109
 Quill Club, 72
Bradford, Roark, 88

Brady, Mary Beattie, 111, 132
Brancusi, Constantin, 106
Brawley, Benjamin, 27, 63, 69
Brooks, Jonathan H., 69
Brooks, Van Wyck, 62
Broun, Heywood, 61
Brown, Sterling, 63, 69, 88, 93
Bruce, Roscoe Conkling, 87
Bucknell University, 31
Burchfield, Charles, 52
Burke, Selma, 39
 Jim, 16

Cachemaille, Enrique, 87
Campbell, E. Simms, 87
Cane, book (Toomer), 67, 170
Capdeville, Ollie, 87
Carver, George Washington, 153
Century, periodical, 63
A Century of Black Photographers:
 1840–1960, book, 36
Cézanne, Paul, 134, 181
Chaplin, Charles, 59
Chestnut, Charles, 72
Chestnut, Helen, 72
Chiang Kai-shek, 153
Chicago, 78, 105, 110
Chicago Defender, periodical, 69, 72, 91
The Chinaberry Tree, book (J. Fauset), 93
Churchill, Winston, 153
Citizens' League, 97
civil rights movement (1960s), 14, 15–16
Cleveland, Ohio, 72
Color, poetry (Cullen), 67, 171
Columbia University, 57
Communist party, 97, 102, 103
Connelly, Marc, 88, 89
Cooper Union, New York, 131
Cosby, Bill, 166
Cowley, Malcolm, 62
The Crisis, periodical, 27, 60, 63, 79, 110
 illustrations by Douglas in, *173,* 193
 as NAACP organ, 16, 29, 61, 63, 71
Crite, Alan Rohan, 136
Cubism, 29, 110
Cullen, Countee, 59, 62, 63, 69, 71, 88, 99, 164
 photo of (Van Vechten), *73*
 political leanings, 97, 103
 written works, 67, 74, 89, 93, 169, 171, 173
Cuney, Waring, 71
Curry, John Steuart, 52

The Danforth Museum of Art, 27
Dark Princess, book (Du Bois), 67
Dark Tower, Harlem, 35, 69, *74,* 74–75, 78, 111
Davis, Arthur, 57
Davis, Miles, 129

DeCarava, Roy, 29
Democratic party, 15, 87
Demuth, Charles, 29, 52
Depression (1930s), 29, 85, 88, 91, 102
Dewey, John, 57
Divine, Father, 97, 164
Dodge, Mabel, 72
Douglas, Aaron, 27–30, 39, 50, 74, 110–12, 129–31, 174
 African heritage emphasis, 31, 33, 38, 106–7, 109, 110, 112, 131, 154
 Black religious themes, 129, 136
 chronology, 174–77
 Egyptian art concepts and, 27, 67
 mentioned, 11, 13, 89, 91
 photo of, *28*
 works:
 Alta, pl. 39
 Aspects of Negro Life, 29, 49, 52, 130, 175, 177; pls. 5–10
 book illustrations, 171, 173, 174, 192
 Building More Stately Mansions, 176; pl. 36
 The Creation, pl. 35
 The Crucifixion, 110, 112, 129, 130, 176; pl. 32
 Defiance, 12
 Emperor Jones series, *12,* 172, 174, *192*
 Flight, 192
 From Slavery through Reconstruction, 29; pl. 9; study for, 29; pl. 5
 Go Down Death, 109, 110, 130, 176, 177; pl. 33
 God's Trombones, 29, 110–12, 129, 130, 172, 174; pls. 30–33
 An Idyll of the Deep South, 29; pl. 8; study for, 29; pl. 6
 Judgment Day, 110, 129–30, 176
 Let My People Go, 110, 176
 Ma Bad Luck Card, 104
 magazine illustrations, *104,* 171–74, *172, 173, 175,* 192–93, *193*
 The Negro in an African Setting, 29; pl. 7
 Noah's Ark, 110, 177; pl. 30
 The Old Waterworks, pl. 38
 Play de Blues, 193
 Power Plant in Harlem, 175; pl. 37
 Rise, Shine for Thy Light Has Come, pl. 34
 Song of the Towers, 29, 53; pl. 10
 Weary As I Can Be, 172
Driskell, David, 31
Du Bois, W. E. B., 39, 63, 67, 69, 71–72, 97
 as *Crisis* editor, 16, 71, 110
 Harlem residence, 85, 87
 Krigwa Players and, 57, 59

mentioned, 74, 93
Pan-Africanist philosophy of, 27, 52, 109
photo of (Van Vechten), 36, *59*
Dunbar News, periodical, 87

Eakins, Thomas, 55
Egyptian-style art, 27, 67
Elcha, Eddie, 160, 164
Ellington, Duke, 60, 77, 78, 170, 172
Ellison, Ralph, 103
Emancipation Day, 33
The Emperor Jones, play (O'Neill), 59, 62, 170
Europe, James Reese, 77
Expressionism, 108, 135, 136
Eyck, Sadella Ten, 87

Fairclough, Lewis H., 87
Fauset, Arthur Huff, 71, 93
Fauset, Jessie, 59, 61, 72
 written works, 62, 67, 89, 93, 170
Fine, Elsa Honig, 50
Fire!!, periodical, 69, 71, 89, 171–72
Fire in the Flint, book (W. White), 67
Fisher, Rudolph, 59, 69, 79, 85, 89, 173
Fisk University, 31, 112, 131, 132
Flight, book (W. White), 67
Ford, Arnold, 99
Framingham, Massachusetts, 109
Frank, Waldo, 62
Frazier, E. Franklin, 63
Fuller, Harriet, 27
Fuller, Meta Warrick, 25–27, 31, 33, 37, 39, 107–9, 154
 chronology, 169, 170, 177–79, 182
 mentioned, 11, 13, 91
 photo of, *26*
 works:
 Bacchante, pl. 23
 Danseuse, 109
 Ethiopia Awakening, 27, 49, 52, 108–9, 170, 177–78, 179; pl. 2
 The Good Shepherd, pl. 22
 Henry Gilbert, pl. 21
 Jason, pl. 29
 Lazy Bones in the Shade, pl. 25
 Lazy Bones in the Sun, pl. 26
 Man Eating Out His Heart, pl. 1
 Mary Turner (A Silent Protest Against Mob Violence), 27, 49, pl. 3
 Mother and Child, 109; pl. 4
 Oriental Dancer, 109
 Primitive Man, 109
 Refugee, pl. 28
 Talking Skull, 49, 109; pl. 27
 Waterboy, 179; pl. 24
Fuller, William T., 27
Fuller, Dr. Solomon, 25, 27, 107, 178
Fuller, Solomon Jr., 27

Gale, Zona, 62
Garvey, Marcus, 15, 16, 52, 57, 67
 mail fraud conviction, 81, 170–72
 photo of, in parade, *58*
 UNIA and, 35, *58*, 81, 164, 166
Garveyism, 97, 99
Gauguin, Paul, 29
Gauthier, Eva, 91
Georgia, Sea Islands, 111
German Expressionists, 135
Gershwin, George, 61
Gilbert, Henry, portrait of (Fuller), pl. 21
God Sends Sunday, book (Bontemps), 89
God's Trombones, see under Johnson, James W.; Douglas
Gogh, Vincent van, 35, 134, 135
Goodman, Benny, 77
Gordon, Joy L., 27
Gould, Jay, 81
Grace, Daddy, photo of (Van Der Zee), *96*, 164
Granny Maumee, play (Torrence), 62
Green, Paul, 88, 170, 172
Green Pastures, play (Connelly), 88, 89
Grimké, Angelina, 57
Guggenheim fellowships, 73, 75, 91
Guinan, Texas, 59

Hallelujah!, film, 88
Hamid, Sufi Abdul, 97
Hammond, Dr. Leslie King, 35
Hampton Institute, 88
Hampton University Art Museum, 31
Handy, W. C., 59
Hapgood, Emily, 62
Harlem
 as black cultural center, 7, 11, 16, 39, 72, 75, 105
 Black Jews in, 81, 99
 churches, 35, 91, *94–95*, 97, 99
 Dark Tower, 35, 69, *74*, 74–75, 78, 111
 hospitals, 85
 nightclubs, 59–60, 75, 77, 78, 88–89, 111
 in 1920s, described, 35–36, 57–61, 73, 75, 79, 85
 politics, 87, 97
 poverty statistics, 78–79
 residences, 85, 87
 Seventh Avenue, 57, *82–83*, *105*
Harlem Renaissance
 art, 11, 13–14, 31, 49, 55, 106–12, 129–36, 153–54; *see also specific artists*
 dates of, 11, 13, 14, 72, 106
 drama, 57, 59, 62–63, 88
 end of, 87–89, 102–3
 literature, 11, 61–64, 67, 69, 71–72, 89, 93

music, 77–78
 naming of, 7
 origins, 14–16, 61, 105
 patrons of, 13, 36, 39
 theme and legacy, 13, 25, 31, 52, 53, 67, 69
Harlem Renaissance, book (Huggins), 50
Harlem Shadows, poetry (McKay), 67, 169
Harmon, William, 39
The Harmon Foundation, 13, 91, 109, 111, 132, 133
 award winners, 31, 39, 172, 173
 criticism of, 49, 50, 93
Harper's magazine, 29
Harrison, Hubert H., 57
Harrison, Richard B., 88
Harvard University, 38, 73, 87
Hawthorne, Charles, 134, 135, 181
Hayden, Miriam, 33
Hayden, Palmer, 31, 33, 35, 50, 107, 131–34, 154
 chronology, 172, 173, 179–81
 as Harmon award winner, 39, 172
 mentioned, 11, 13, 91
 photo of, *30*
 works:
 African Dancers, 133
 Bal Jeunesse, pl. 11
 Barge Haulers, 33; pl. 44
 The Big Bend Tunnel, 33, 181; pl. 16
 Blue Nile, 133, 181; pl. 47
 Boothbay East, 33, 134; pl. 43
 Christmas, 33; pl. 41
 Dove of God, 132
 The Dress She Wore Was Blue, 33; pl. 42
 Fétiche et Fleurs, 132, 179, 181
 56th Street, pl. 46
 He Died with the Hammer in His Hand, 133
 His Hammer in His Hand, 33; pl. 14
 The Janitor Who Paints, 33, 52, 132, 133, 180; pl. 13
 John Henry series, 33, 49, 132–34, 180; pls. 14–16
 Just Back from Washington, 133; pl. 14
 Midsummer Night in Harlem, 133, 180, 181
 Nous Quatre à Paris, pl. 12
 The Subway, pl. 45
 When Tricky Sam Shot Father Lamb, 133, 181
Haynes, George Edmund, 87
Henderson, Fletcher, 57, 77, 78, 87, 155, 170
Henry, John, *see under* Hayden
Herskovits, Melville, 85
Heyward, Du Bose, 89, 172
Hill, Wesley, 88

Holstein, Caspar, 61, 62, 85, 103
Holt, Nora, 91
Homer, Winslow, 55
 A Visit from the Old Mistress, 55
Home to Harlem, book (McKay), 71–72,
 173
Hoover, President Herbert, 79
Hopkins, Claude, 60
Hopper, Edward, 11, 52
 Early Sunday Morning, 53
Horne, Frank, 63
Houenou, Prince Touvalou, 91
House of Connelly, play (Green), 88
Howard University, 38, 50, 61, 166
 Gallery of Art, 31
Huggins, Nathan, 50
Hughes, Langston, 49–50, 69, 89, 103,
 112
 as communist, 93, 102
 mentioned, 52, 62, 89
 Opportunity and, 63, 69, *104, 172*
 photo of (Van Vechten), 36, *60*
 as poet, 31, 65, 67, 75, 169, 171
 quoted, 11, 61, 67, 71, 91
Hurst, Fannie, 71
Hurston, Zora Neale, 52, 63, 71, 75,
 103, 112, 171
 mentioned, 11, 89
 photo of (Van Vechten), 36, *63*
 written works, 71, 99

Impressionism, 107, 134, 155
Infants of the Spring, book (Thurman), 49,
 93
International House, New York, 39
International Labor Defense (ILD), 97
Inter-State Tattler, 69, 91
Italian Renaissance art, 136, 153

Jackman, Harold, 88–89
Jackson, Jesse, 16
Jacobs, Joe, 31
jazz, 15, 29, 52, 73, 77–78
Jews, Black, in Harlem, 81, 99
Jim Crow laws, 14, 29, 69
John Henry series, *see* Hayden
Johns Hopkins University, 35
Johnson, Charles Spurgeon, 61–63, 78,
 112, 131
Johnson, Eastman, 55
 My Old Kentucky Home, 55
Johnson, Georgia Douglas, 57, 72
Johnson, Hall, 69, 88
Johnson, Helene, 69
Johnson, Henry, 164
Johnson, Holcha, 135, 182
Johnson, Jack, 164
Johnson, James P., 60, 77
Johnson, James Weldon, 57, 61–63, 77,
 136, 169

*God's Trombones: Seven Negro Sermons
 in Verse,* 29, 110, 112, 129, 130,
 172, 174; illustrations for, *see under*
 Douglas
 mentioned, 72, 73
 photo of (Van Vechten), *57*
 quoted, 85, 87–88
Johnson, Malvin Gray, 39, 136
 Orphan Band, 54
 Postman, 50
Johnson, Sargent, 39, 91, 171
Johnson, William H., 14, 33, 35, 40, 49,
 50, 134–36, 153–54
 chronology, 181–87
 as Harmon award winner, 31, 39
 mentioned, 11, 13, 91
 photo of, *32*
 primitivism of, 33, 35, 53, 107, 135
 works:
 Café, 153; pl. 52
 Chain Gang, 153, 185; pl. 53
 Climbing Jacob's Ladder, 136
 Descent from the Cross, 136
 Going to Church, 153
 Harbor under the Midnight Sun, 183
 Jesus and the Three Marys, 136, 185;
 pl. 20
 Lamentation, pl. 50
 Li'l Sis, 153; pl. 55
 Little Sweet, 153
 Mom and Dad, 153
 Moon over Harlem, 153
 Mount Calvary, 136, 153, 186; pl. 49
 Nativity, 136
 Nude (Mahlinda), pl. 48
 Red Cross Station, 185
 Self-Portrait (four pictures): *1929, 52,*
 182; pl. 19; *c. 1931–38, 182;*
 c. *1935–38, 184; c. 1939–40, 184*
 Still Life, pl. 17
 Swing Low, Sweet Chariot, 136; pl. 51
 Young Man in a Vest, pl. 54
 Young Pastry Cook, pl. 18
Johnston, Mary, 62
Jonah's Gourd Vine, book (Hurston), 99
Jones, Lois Mailou, 31, 39
Josephson, Matthew, 62
Julian, Hubert Fauntleroy, 81

Kaufman, Rabbi Ishi, 99
Kellogg, Paul, 63
Kerlin, Robert T., 69
Kerteminde, Denmark, 135, 182
King, Martin Luther Jr., 15–16
Knights of the White Camelia, 14
Krigwa Players, Harlem, 57, 59
Ku Klux Klan, 14

La Guardia, Fiorello, 87, 97
Larsen, Nella, 67, 89
Lawrence, Jacob, 29, 31, 103

Lewis, Edmonia, 53
 Forever Free, 108
Lewis, Dr. Samella, 33
Lewis, Ted, 59
Lincoln, Abraham, 33
Lincoln University, 88
Lindbergh, Charles, 81
Locke, Alain, 38–39, 61, 63, 77, 108,
 109
 African heritage emphasis of, 38, 50,
 106, 131, 154
 as critic, 89, 93, 99, 132
 mentioned, 16, 62, 72, 78, 97
 The New Negro and, 11, 15, 29, 38,
 39, 67, 69, 110, 171
 photo of (Van Vechten), *08*
Los Angeles, 33, 105
Los Angeles County Museum of Art, 31
Louis, Joe, 164
Lovett, Robert Morse, 62
Luks, George, 35, 134, 181, 182
Lyles, Aubrey, 57, 62

McClendon, Rose, photo of (Van
 Vechten), *75*
McGhee, Reginald, 166
McKay, Claude, 61, 75, 103
 photo of (Van Vechten), *61*
 published works, 67, 71–72, 168, 169,
 173
Mama's Daughters, book (Heyward), 89
Marsh, Reginald, *The Bowery, 40,* 53
Martin, Prophet, 81
Mason, Charlotte, 111–12
Matheus, John, 63
Matisse, Henri, 29
Matthew, Wentworth Arthur, 99
Mencken, H. L., 62
Mercer, R. E., 160
Messenger, periodical, 67, 69, 79
Metropolitan Museum of Art, 36, 166
migration, of Black Americans, 15, 61,
 105
Miller, Flournoy, 57, 62
Miller, Loren, 93
Mills, Florence, 164, 169, 172
 photo of (Van Der Zee), *92*
Modern Negro Art, book (Porter), 50
modernism, 29, 38, 106, 108, 131, 132
Modigliani, Amedeo, 106
Moore, Alderman Frank R., 87
Morand, Paul, 110
Morris, Philip, 7
Morton, Ferdinand Q., 87
Motley, Archibald, 39, 91, 171, 173, 174
 Jockey Club, 40, 53
 Woman Peeling Apples, 53, 55
Moton, Dr. Robert Russa, 87
Munch, Edvard, 35, 135
Murat, Princess Violette, 91

Museum of African American Art, Los Angeles, 33
Museum of Modern Art, New York, 14

NAACP, 15, 59, 69, 71, 73, 85, 97
 Crisis as organ of, 16, 29, 61, 63, 71
Nance, Ethel Ray, 59
The Nation, periodical, 50, 69
National Academy of Design, New York, 35, 134
National Museum of American Art, 14, 33, 35
National Peace Congress, 81
Naumann, J. B., 105
Nebraska, University of, 27, 110
Negro Industrial and Clerical Alliance, 97
The New Masses, periodical, 97
The New Negro, anthology, 29, 38, 67, 69, 110
 quoted, 11, 15, 39, 171
New Negro Movement, 13, 15, 16, 35, 36, 39, 72, 106, 108, 109
New York Public Library, 93, 130, 131
 Schomburg Center, 27, 29, 31, 59, 166
New York Times, periodical, 27, 63, 91
New York University, 57, 73
Nigger Heaven, book (Van Vechten), 36, 71, 88, 89, 91, 171
Noone, Jimmy, 78
Not Without Laughter, book (Hughes), 89
Nugent, Richard Bruce, 71, 74, 75, 89, 93, 171–73

O'Keeffe, Georgia, 112
Oliver, King, 77, 169–70
O'Neill, Eugene, 57, 59, 62, 63, 170
One Way to Heaven, book (Cullen), 89, 93
Opportunity, periodical, 49, 60, 79, 89, 93, 110
 illustrations for (Douglas), 104, 172, 193
 prizes awarded by, 61, 63, 67, 69
 as Urban League organ, 29, 61, 71

Pan-Africanism, 27, 52, 108, 109
Paris, France, 31, 61, 91, 105–7, 109, 134
Passing, book (Larsen), 89
Paul Robeson, Negro, book (E. Robeson), 91
Pennsylvania Academy of the Fine Arts, Philadelphia, 107
Pennsylvania Museum and School for Industrial Arts, 25, 107
Perry, Edward, 91
Philadelphia, 61, 72, 105, 107
Philadelphia College of Art, 107
Photo-Secessionists, 155
Picasso, Pablo, 29, 106, 108
Pig Foot Mary, 79, 81

Pius XI, Pope, 97
Plum Bun, book (J. Fauset), 89
Pollard, Myrtle, 85
Porgy, play, 88, 89
Porter, James A., 50, 91, 131, 132
Powell, Rev. Adam Clayton Sr., 35, 91, 164
Powell, Rev. Adam Clayton Jr., 97, 164
Powell, Blanche, funeral of, 164, 165
Powell, Richard, 35
Prampin, Harry, orchestra of, photo (Van Der Zee), 78
Precisionism, 29, 111
primitivism, 29, 31, 134
 of (W. H.) Johnson, 33, 35, 53, 107, 135
 in literature, 72, 112
Princeton University, 61
Prophet, Elizabeth, 91
Provincetown, Massachusetts, 35
 Playhouse, 59

Quicksand, book (Larsen), 67

Radcliffe College, 27
Randolph, Asa, 67
Ravel, Maurice, 78
Rawls, Lou, 166
Rector, Eddie, 77
Reiss, Winold, 38, 110–12, 171, 173, 174
Report to the Committee on Negro Housing (1931), 79
Republican party, 15, 33, 87
Rhode Island School of Design, Museum of Art, 31
Rhodes Scholars, 63, 106
Rhone, Arthur "Happy," 59
Richardson, Willis, 57, 170
The Rider of Dreams, play (Torrence), 62
Rivera, Lino, 102
Roberts, Needham, 164
Robeson, Essie, 87, 91
Robeson, Paul, 57, 63, 69, 71, 87, 91, 102
 in The Emperor Jones, 59, 62, 170
 photo of (Van Vechten), 36, 62
Robinson, Bill "Bojangles," 85
 photo of (Van Vechten), 77
Robinson, Warren, 99
Rockefeller, John D., 87
Rockefeller, Mrs. John D., 111
Rodin, Auguste, 25, 107, 109, 177
Roosevelt, Franklin D., 16, 97, 153
Rose, Ernestine, 59
Rosenwald Fund, 73, 103
Rouault, Georges, 134
Run Little Chillun, play (H. Johnson), 88

Saturday Evening Quill, periodical, 72

Savage, Augusta, 39, 91
 Gamin, 37
Savoy Ballroom, Harlem, 75, 77, 78
Schomburg, Arthur, 52
Schomburg Center, see New York Public Library
Schuyler, George, 50, 67, 89
Scott, Edward, 39
Scott, Hazel, 164
Scottsboro Boys case, 97
Sebree, Charles, 103
Shaw, Artie, 77
Sheeler, Charles, 11, 29, 52
 River Rouge Plant, 53
Shuffle Along, play, 62, 88, 169
Simon the Cyrenian, play (Torrence), 57, 62, 169
Sissle, Noble, 57, 59, 169, 170
Sitwell, Sir Osbert, 73, 74
Sloan, John, The Lafayette, 53, 54
Smith, Bessie, 71, 169, 170
 photo of (Van Vechten), 79
Smith, Mamie, 164
Smith, Marvin, 160
Smith, Morgan, 160
Smith, Willie "the Lion," 59, 60
Socialist party, 97
Soumbatov, Prince Michel, 91
Southern Road, poetry (S. Brown), 93
The Southern Workman, periodical, 69
Soutine, Chaim, 35, 134, 135, 181
Spark, periodical, cover illustration (Douglas), 175
Spence, Eulalie, 57
Steffens, Lincoln, 62
Stieglitz, Alfred, 105
The Studio Museum, Harlem, 7, 11, 13, 33, 36, 166
Survey Graphic, periodical, 63, 67
Synthetic Cubism, 110

Taboo, play (Wiborg), 62
Tandy, Vertner, 81
Tanner, Henry O., 31, 53, 136, 168–72, 181
 Banjo Lesson, 108
 The Thankful Poor, 108
Theater Arts Monthly, 110
There Is Confusion, book (J. Fauset), 62, 67, 170
Thurman, Wallace, 67, 69, 71, 99, 171
 novels by, 49, 89, 93, 173
Toomer, Jean, 11, 61, 62, 69, 103, 169
 written works, 67, 170
Torrence, Ridgely, 57, 62, 169, 170
Tropic Death, book (Walrond), 69
Trotter, William Monroe, 81
Turner, Mary, 27

UNIA, 15–16, 27, 57, 81

photos by Van Der Zee, 35, *58, 98, 100, 101,* 164–66
United Colored Democracy, 87
Urban League, 15, 69, 73, 78–79
 magazine of, 29, 61, 71

Valdosta, Georgia, 27
Van Der Zee, Donna, 36, 166
Van Der Zee, Gaynella, 160
Van Der Zee, James, 13, 35–36, 155–56
 photos of, *34, 166*
 studios of, 160, *167*
 works:
 Black Cross Nurses Watching a UNIA Parade, 98, 160, 164
 Booker T. Washington University, UNIA, 101, 160, 164
 Children Posed Around a Refreshment Truck, 158
 Daddy Grace, 90, 164
 Dinner Party with Boxer Harry Wills, 64–65, 164
 Drugstore Display, 167
 Florence Mills, 92
 Funeral of Blanche Powell, 164, *165*
 Funeral Procession on Seventh Avenue, 165
 Group Portrait in the Dark Tower, 74
 Harlem Billiard Room, 102–03
 Harry Prampin's Orchestra, 78
 Musicians Onstage, 58, 166
 Nude Study, 101, 164
 Parade on Seventh Avenue, 82–83
 Portrait of a Well-Dressed Man, 56
 Portrait of Couple, Man with Walking Stick, 70, 160
 Portrait of Couple with Raccoon Coats, 102
 Portrait of Family Looking at Photo Album, 157, 160
 Portrait of Lester Walton, 86
 Portrait of Man Smoking, 80
 Portrait of Man with Hat, Cigarette, and Cane, 159, 160
 Portrait of Soldier, 108
 Portrait of Woman Seated at Piano, 90, 164
 Portrait of Woman Standing Near Window, 77, 164
 Portrait of Young Couple with Baby, 157
 Portrait of Young Girl on the Telephone, 158
 Portrait of Young Woman at Her First Communion, 158
 Religious Club, 101, 160
 Renaissance Basketball Team, 171
 Theresa Bar and Grill, 84
 Two Men Reading, 66
 Two UNIA Members, 100, 160

 UNIA Parade, 98, 160, 164
 UNIA Parade with Marcus Garvey, 58
 Unity Athletic and Social Club, 72, 164
 Wedding Portrait with Superimposed Image of Little Girl, 156
Van Der Zee, Kate, 155
Van Der Zee Institute, 36
Van Doren, Carl, 62, 63
van Gogh, *see* Gogh
Van Vechten, Carl, 36, 63, 69, 88, 89, 91
 as patron of Black art, 111, 112
 photo of, *67*
 works:
 Alain Locke, 68
 Bessie Smith, 79
 Bill "Bojangles" Robinson, 77
 Claude McKay, 61
 Countee Cullen, 73
 James Weldon Johnson, 57
 Langston Hughes, 36, 60
 Nigger Heaven (book), 36, 71, 88, 89, 91, 171
 Paul Robeson, 36, 62
 Rose McClendon, 75
 W. E. B. Du Bois, 36, 59
 Zora Neale Hurston, 36, 63
Vanderbilt, Mrs. Cornelius, 73
Vanity Fair, periodical, 29, 79, 110
Vidor, King, 88
Villard, Oswald Garrison, 62

Walker, A'Lelia, 35, 69, 72–75, 85
 death, 91
 mother of, 81, 91, 164
Walker, Margaret, 103
Waller, Fats, 57, 60, 174
The Walls of Jericho, book (Fisher), 69, 173
Walrond, Eric, 62, 63, 69
Walton, Lester, 87
 photo of (Van Der Zee), *86*
Waring, Laura Wheeler, 39, 91, 169
Washington, Booker T., 87, 93
Washington, D.C., 61, 72, 105, 109, 166
Waters, Ethel, 57, 59, 77, 91
The Weary Blues, poetry (Hughes), 67, 75, 171
When Africa Awakes, book (H. Harrison), 57
Whipper, Leigh, 87
White, Charles, 103
White, Clarence Cameron, 87
White, Stanford, 73
White, Walter, 62, 67, 73, 75, 85, 89, 93
 as NAACP official, 61, 97
White Citizens' Council, 14
Whiteman, Paul, 77, 171
Whitney Museum of American Art, 14
Wiborg, Mary Hoyt, 62
Williams, Bert, 59

Williams, Corky, 60
Williams, Fess, 77
Wills, Harry, photo of (Van Der Zee), *64–65,* 164
Wood, Grant, 52
Woodruff, Hale, 31, 39, 91, 172, 183
World War I, 15, 31, 61, 81, 106, 131, 132
WPA, 39, 49, 103
Wright, Louis T., 85
Wright, Richard, 103

Yale University, 35, 57, 61
Yerby, Frank, 103
Young Communist League, 102

Photograph Credits

The following photographs taken by Carl Van Vechten are reproduced from hand gravure prints by Richard Benson. © 1983 The Estate of Carl Van Vechten and Eakins Press Foundation: figs. 22, 25–29, 33, 36, 38, 40, 42.

Unless otherwise indicated, figure numbers are listed first, followed by color plates (cpls.)

Vance Allen: 69. Anacostia Neighborhood Museum, Smithsonian Institution: 1, 83–85; cpls. 2, 31, 34. Dawoud Bey: 10, 11, 57, 75–77; cpls. 1, 21–26, 28, 29, 45, 47. Reuben U. Burrell: 78, 80, 81. The Center Gallery, Bucknell University: cpl. 35. Geoffrey Clements: 16, 17. Chris Eden: cpls. 5, 6, 30. Equitable Life Assurance Society of the United States of America: 3. Solomon Fuller: 4. Jarvis Grant: cpl. 20. Hampton University Art Museum: cpls. 37, 38. Rick Lambert: cpls. 36, 39. The Metropolitan Museum of Art: 12, 15, 19; cpl. 12. The National Museum of American Art, Smithsonian Institution: 7 (H. and H. Jacobsen), 79, 82; cpls. 13, 17–19, 48–55. Rudolph Robinson: cpls. 3, 27. The Schomburg Center for Research in Black Culture, The New York Public Library: 2, 5, 6, 8, 9, 13, 14, 18, 20, 21, 32, 48, 50–52, 65, 67, 68, 70, 71; cpls. 7–11. Armando Solis: cpls. 14–16, 42. David Stansbury: cpl. 32. Chuck Stewart: cpls. 40, 41, 43, 44, 46. Willard Traub; cpl. 4. The James Van Der Zee Collection: 23, 24, 30, 31, 34, 35, 37, 39, 41, 43–47, 49, 53–56, 58–64, 66, 72–74.

Text Acknowledgments

The essay "Harlem My Home" is adapted in part from material published in *When Harlem Was in Vogue* By David Levering Lewis. © 1979 and 1981 by David Levering Lewis. Reprinted by permission of Alfred A. Knopf, Inc.

Lines of "Youth" from *The Dream Keeper and Other Poems* by Langston Hughes are reprinted by permission of the publisher. © 1932 by Alfred A. Knopf, Inc., and renewed 1960 by Langston Hughes.

Lines of "Judgment Day" from *God's Trombones: Seven Negro Sermons in Verse* by James Weldon Johnson are copyright 1927 by the Viking Press, Inc. Copyright renewed 1955 by Grace Nail Johnson. Reprinted by permission of Viking Penguin, Inc.

Excerpt from "The Negro Artist and the Racial Mountain" by Langston Hughes is published courtesy of Harold Ober Associates, Inc. © 1926 by Langston Hughes.

Excerpts reprinted from "Parties" (p. 91) and "When the Negro Was in Vogue" (p. 61) are from *The Big Sea* by Langston Hughes. Copyright 1940 by Langston Hughes. Copyright renewed © 1968 by Arna Bontemps and George Houston Bass. Reprinted by permission of Hill and Wang, a division of Farrar, Straus, and Giroux, Inc.

Excerpt from *The World of James Van Der Zee: A Visual Record of the Black Race* by Reginald McGhee (New York: Grove Press, 1969) is reprinted by permission of the James Van Der Zee Estate.

200

The Studio Museum in Harlem

BOARD OF TRUSTEES

Charles A. Shorter
Chairman

Nancy Lane
First Vice-Chairperson

Major E. Thomas, Jr.
Second Vice-Chairperson

Charles E. Inniss
Treasurer

Henry McGee, III
Secretary

Coral Aubert
Dr. Leon Banks
J. Max Bond, Jr.
Carl Bradford
Marie Dutton Brown
Pamela Carlton
Janet Carter
Evelyn Cunningham
Gordon J. Davis
Jacques A. DeGraff
Melvin Edwards
Leroy F. Fykes
Louis Ganz
Sandra Grymes
J. Newton Hill
Arthur J. Humphrey, Jr.
Bertina Carter Hunter
Moonyene S. Jackson
Harley Jones
George Knox
Therese M. Molloy
Joel Motley
Corine Pettey
William Pickens, III
Ute Stebich
Michael Winston

Hon. Bess Myerson
Commissioner of Cultural Affairs
(ex officio)

CURATORIAL COUNCIL

Romare Bearden
Roy DeCarava

David C. Driskell
Adolphus Ealey
Jacob A. Lawrence
Richard A. Long
Elizabeth Catlett Mora
Merton Simpson
Hughie Lee-Smith

BOARD OF VISITORS

James Biddle
Ed Bradley
Charles Cowles
Ernest Crichlow
Peter Duchin
Paul Giddings
Jewell Jackson McCabe
Mal Woolfolk

CURRENT STAFF

EXECUTIVE

Dr. Mary Schmidt Campbell
Executive Director

Kinshasha Holman Conwill
Deputy Director

Daniel Robinson
Director of Operations

Alfred Bolton
Comptroller

Patricia Cruz
Development Director

CURATORIAL

Grace Stanislaus
Associate Curator

Joan Hendricks
Registrar

Alfred Cucci
Art Director

Deirdre Scott
Assistant to the Curator

EDUCATION

Stanley Tarver
Director of Education

Nadine Delawrence-Maine
Artist-in-Residence

Kerry Marshall
Artist-in-Residence

Floyd Newsum
Artist-in-Residence

Cheryl Byron
Intern

Debra Priestly
Intern

DEVELOPMENT

Karen Hunter-Shay
Membership Coordinator

Carol Martin
Administrative Assistant

MUSEUM SHOP

Joan Deroko
Manager

Claudette Brown
Assistant Manager

ADMINISTRATION

Cheryl Bruce
Public Relations Coordinator

Linda Fallin
Executive Secretary

Mursaleen Khan
Accountant

Patricia Lee
Administrative Assistant

Jonathan Dewberry
Administrative Assistant

Madeline Lewis
Administrative Assistant

Diane Alexander
Receptionist

SECURITY AND MAINTENANCE

George Sanders
Senior Security Officer

Simon Golson
Maintenance Supervisor

James Franklin
Custodian

Jonah Wilson
Custodian

Cathy Alston
Security Officer

Hardine Hendrix
Security Officer

William Jones
Security Officer

Zennie Mitchell
Security Officer

Ovella Richardson
Security Officer

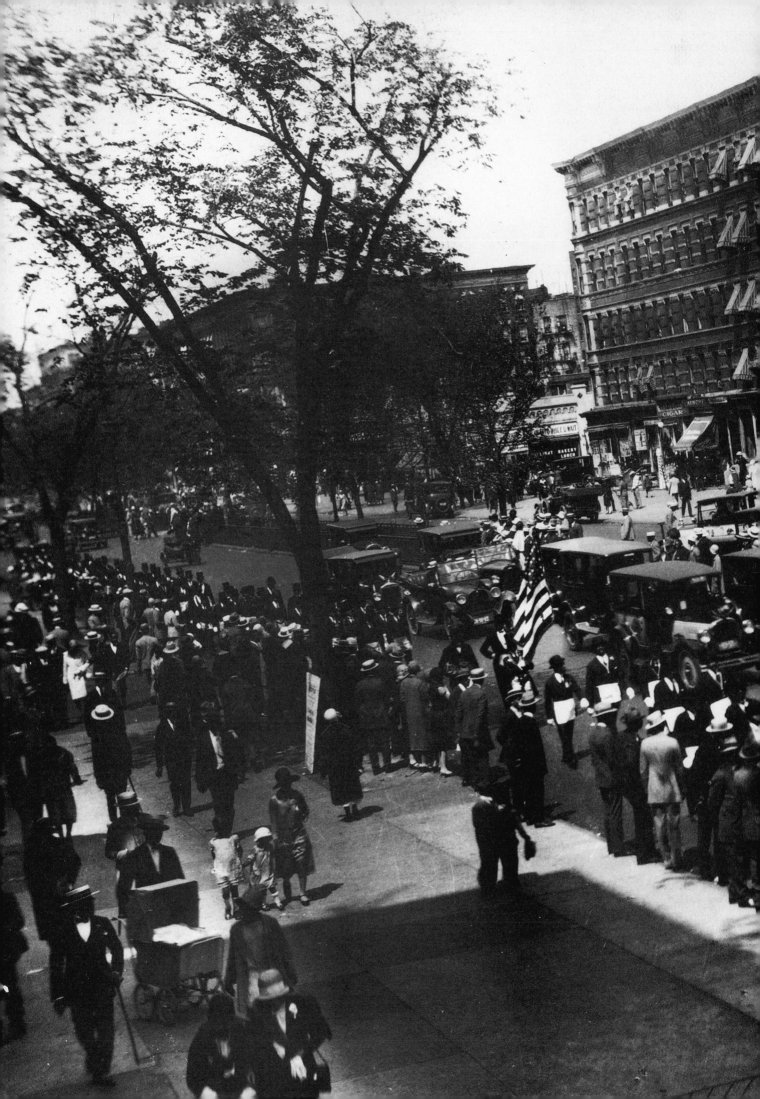

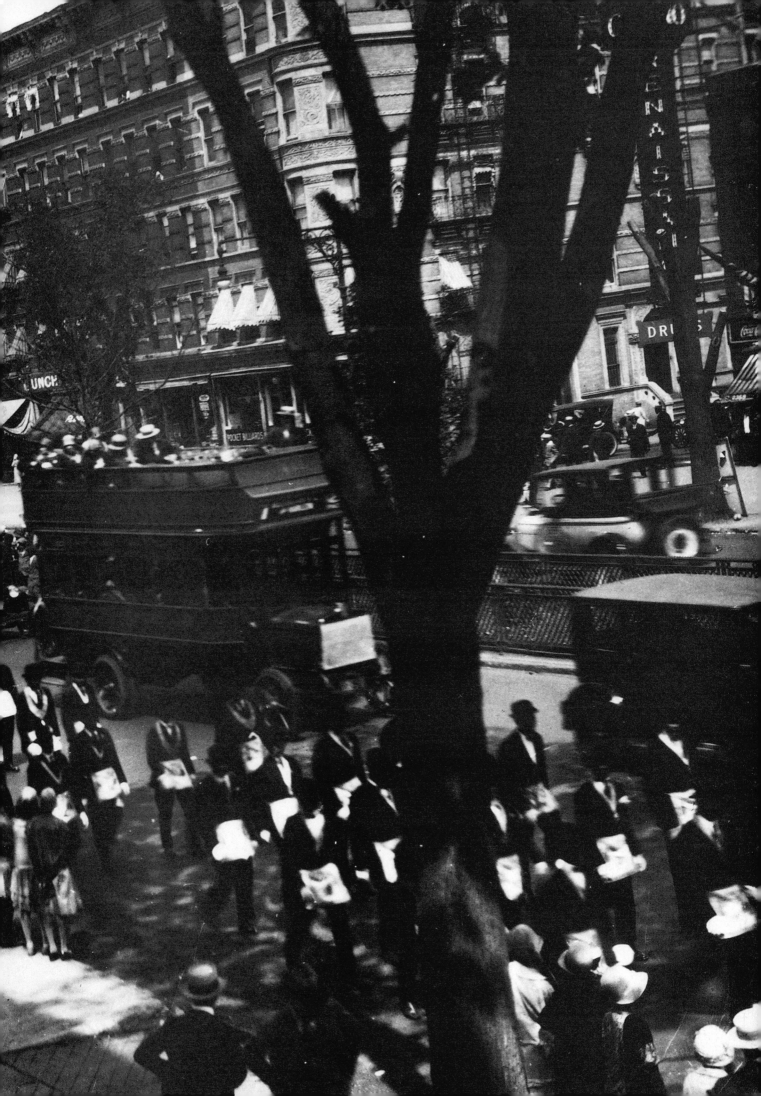